Art and Disability

Previous Publications

The Art of Necessity: Pictures of Lives Reclaimed from Trauma. *Art Education, 57*(1), 2004.

Book Review: Interdisciplinary Art Education: Building Bridges to Connect Disciplines and Cultures. Mary Stokrocki, Editor, *Studies in Art Education, 48*(2), 2007.

Bringing Image and Language Together: A Workshop at the Lehman College Art Gallery. *Art Education, 54*(4), July 2001.

GRACE Notes: A Grass Roots Arts and Community Effort. *Studies in Art Education, 46*(3), 2005.

Identity Politics of Disability: The Other and the Secret Self. *Journal of Social Theory in Art Education* (25), 2005.

Koorah Coolingah—Children Long Ago: Art from the Stolen Generation of Australia. *Studies in Art Education,* 2009, Winter.

Museum Culture and the Inequities of Display and Representation. *Visual Arts Research, 33*(1), 2007.

Painting Their Way Out: Profiles of Adolescent Art Practiced at the Harlem Horizon Art Studio. *Studies in Art Education, 43*(4), 2002.

Reading Objects: Collections as Sites and Systems of Cultural Order. *Journal of Social Theory in Art Education* (26), 2006.

The Sensuous Role of the Arts in an Era of Standardization. *Journal of Social Research and Art Education, 22,* 2004.

A Theory for Living: Walking with Reggio Emilia. *Art Education, 57*(6), 2004.

Art and Disability

The Social and Political Struggles Facing Education

Alice J. Wexler

Foreword by
art historian
Roger Cardinal

palgrave
macmillan

ART AND DISABILITY
Copyright © Alice J. Wexler, 2009.

Cover Illustration © Jonathan Lerman, 2002. Untitled 24 × 19 in. Charcoal on paper.

Foreword © Roger Cardinal, 2009.

First published in 2009 by
PALGRAVE MACMILLAN®
in the United States—a division of St. Martin's Press LLC,
175 Fifth Avenue, New York, NY 10010.

Where this book is distributed in the UK, Europe and the rest of the world, this is by Palgrave Macmillan, a division of Macmillan Publishers Limited, registered in England, company number 785998, of Houndmills, Basingstoke, Hampshire RG21 6XS.

Palgrave Macmillan is the global academic imprint of the above companies and has companies and representatives throughout the world.

Palgrave® and Macmillan® are registered trademarks in the United States, the United Kingdom, Europe and other countries.

ISBN: 978–0–230–60629–6

Library of Congress Cataloging-in-Publication Data

Wexler, Alice, 1942–
 Art and disability : the social and political struggles facing education /
Alice J. Wexler ; foreword by art historian Roger Cardinal.
 p. cm.
 Includes bibliographical references and index.
 ISBN 0–230–60629–6
 1. Children with disabilities—Education—United States. 2. People with disabilities—Education—United States. 3. Art—Study and teaching—United States. 4. Arts and society—United States. I. Title.

LC4025.W49 2009
371.9'0445—dc22 2009008633

A catalogue record of the book is available from the British Library.

Design by Newgen Imaging Systems (P) Ltd., Chennai, India.

First edition: September 2009

D 10 9 8 7 6 5 4 3

Printed in the United States of America.

*This book is dedicated to Barry and Dan Lebost and
the students who made invaluable contributions*

CONTENTS

ILLUSTRATIONS

FOREWORD

The linked fields of disability and art making make up a rich and fascinating territory, albeit one whose exploration remains incomplete. Whereas our ideas about the value of art education and of creative activities have evolved rapidly over recent decades, there still remains a persistent list of unanswered questions and unresolved conflicts. Those special populations that have been defined in terms of perceived anomalies (such as learning disabilities, behavioral, and neurological disorders) have attracted the attention of a markedly diverse range of commentators—neurologists, psychologists, and clinical theorists, followed by art therapists, artists, technical facilitators, enlightened observers, and art collectors. Those who are active in the field of art education, or who participate directly in programs designed to encourage creativity, bring a great variety of life-experiences to their work. Some have studied in an art school, others are self-taught artists; yet, others have had specialist clinical training; many rely on intuition, while others adhere to strict ground-rules. The theorists include those physicians, philosophers, and aestheticians who attempt to blaze paths of certainty across a very tricky terrain. Each of these commentators contributes to the fund of our collective knowledge and to the debates that it continues to generate. How deeply does the activity of picture making affect the individual? What exactly does art produce that exceeds the bare fact of its visible traces? What channels of communication and dialogue does it open up? Who is sending messages to whom? What sort of language is being used? And where does aesthetic appreciation come in? The proliferation of interesting yet divergent viewpoints has created a situation where no one map of the territory seems likely to win general assent.

One major stumbling-block has been the enshrined practice of clinical labelling. All too often, the legitimate human concern with the ways in which certain individuals diverge from neurological or behavioral

norms has been to impose a rigid system of classification shaped by the implied notions of lack, impairment or disorder. Diagnosis is facilitated by an established repertoire of medical symptoms, and the act of authoritative categorization tends to give rise to a recognized program of treatment. The problem with this approach is that subtle mental or neurological conditions are being defined and described in essentially crude and negative terms. Once notions of deviance, inappropriateness, or inadequacy are emphasized, the diagnostic terminology fills out the space of our attention with a fog of negativity. There is then a real risk of our being blinded to the fuller picture, for our capacity to notice things tends to narrow. Rather than trust received ideas, we should be seeking to identify the positive qualities that flourish alongside the supposed gaps and lacks. There is, as it were, always *something else* worthy of our attention, even in cases where a disoriented individual appears to have lost all sense of contact with his/her material and social environment. It is here that spontaneous manifestations of creativity come into play: for it is art that offers the subtle key to liberate the confined person. This is why it is important, as Alice Wexler argues, to focus on strengths rather than on defects.

Our understanding of what transpires in the art workshop or studio might embrace not only those completed constructions and compositions that offer aesthetic pleasure to a wider audience, but also the fleeting expressions, gestures, casual comments, sketches, and original perceptions of the world that are available to the empathetic observer in the busy room. It is salutary to witness the joy of an individual as he/she faces the challenge of processing an idea or translating a mental image into a visible, communicable form. The expression on the face of someone in the grip of the creative frenzy can even be a little scary, given that he/she is unlikely to respect the niceties of social etiquette. Some individuals grunt and moan, rock or tremble, as if deliberately broadcasting their difference from "normal" people. Yet it would be misleading to ascribe negative meaning to such behavior. Equally it would be misleading to treat the products of such behavior as confirmations of a measurable deficit. For all their strangeness, the artworks produced by autistic persons, for instance, are often highly imaginative and affirmative. A latent intentionality and potential for communication is almost always on the verge of manifesting itself. The elusive signs of an individual's positive investment in a creative process should be picked up, encouraged, and revered. Then it is that the fullest import of the artwork can begin to be appreciated and become a measure of the integrity and dignity of the person.

An important starting point from which to develop our understanding of the art making enterprise, and of its attendant physical, mental, and spiritual benefits, is to consider individual creators in terms of their physical presence, or more precisely: in terms of their subjective awareness of their own unique body. As human beings, we build and enrich our self-image on the basis of the primary image we construct of our own body. That entity, which involves the fundamental anatomical structures but equally the unconscious physical reflexes, the complex neurological networks, and the mysterious patterns of intellectual and emotional life, is in effect the ground of all our being, the fulcrum of self-awareness and the necessary foundation of the self-confidence we strive to establish in our lives, as we pursue our relation to externality and Otherness. As Alice Wexler contends, "we lose our connection to our sensory system at our own peril." Those who forfeit even some small functional part of these subtle relational systems can quickly lapse from the social norm and be branded defective: for example, an injury to a limb and *a fortiori* to the brain can bring about a devastating change in an individual's sense of integrity, and leave him/her baffled, feeling isolated and marginalized. It should be the ideal of all therapy to provide such an individual with a means of self-understanding and a prospect of self-composure and self-fulfilment.

Dozens of physical treatments, including drugs, surgery, and other clinical interventions, have been essayed through history in an effort to encourage (or enforce) an adherence to the norms of social existence. Such attempts seek, as it were, to shove or nudge the "disturbed" person back on track, to counter a negative leaning-away and thus restore equilibrium. But, by and large, the more successful treatments have been those that attend to the person as an interrelated psychophysical and emotional totality, not as a faulty engine that has ground to a halt. The successful alleviation of a condition of depletion must consist not in mechanically "filling a gap" but in awakening those innate resources that will themselves generate fresh patterns of coherence.

What is original and even miraculous about art making is that it represents a mode of therapy whereby the individual no longer functions as a hapless sufferer, the passive object of "treatment" at the hands of other people, but becomes the intentional manager of his/her own reconstitution, an *active subject* who is substantially "in charge" of the reconstructive process. Of course, there exists certain occasions where the educator or therapist feels it necessary to be the driving force, the one who holds the steering-wheel and controls the speed of development. Yet a prearranged syllabus, a fixed set of themes to be successively

tackled, a single correct way of holding brush or pen, or of selecting colors, these are the telltale signs of an approach whose intention may be thought praiseworthy yet whose effect could well be counterproductive, not to say disastrous. Art cannot be taught in the way that clinical symptomatology can be taught. Art is *par excellence* an activity that thrives on freedom, on noncoercive learning whereby the creator becomes in effect both student *and* instructor.

As a practicing artist and educator, Alice Wexler has given thought to the many issues arising within the urgent and often confusing sites of contact where those who fall short of society's intellectual and behavioral standards meet those who, confronting the conundrum of extreme *differentness*, seek to establish a dialogue by way of the creative media, and especially through art making. Her book represents a lively survey of many still-topical developments in the fields of art education and art therapy, and it includes summaries of the ideas of outstanding theorists and practitioners. It should be said that few theorists of stature lack direct experience of the practicalities, whereas not all practitioners have the time or inclination to concern themselves with theory. This book may help rectify the situation, thanks to its implicit argument that it is always beneficial to be aware of one's limits and one's realistic purposes, and to try to draw out wider meaning from one's pragmatic workshop observations. Each student, educator, or therapist ought to recognize the importance of implementing day-to-day intuitions and discoveries as well as ideas taken from books.

The present volume devotes a chapter apiece to what are arguably the most prominent neurological and mental disabilities affecting Western societies, including autistic spectrum disorders, attention deficit and hyperactivity, learning disabilities, emotional and behavioral disorders, impairments of sight and traumatic brain injury. The author is aware that clinical labeling is an imperfect system, but concedes that these groupings are convenient, if only as chapter-headings. The various conditions are made known to us through both general description and revealing example. Wexler's brief case-histories tend not only to illustrate theory but also to encourage the sense that theorizing can be an immediate and engrossing activity in its own right, a creative adjunct to routine that conduces to insight and subtler response. Progress consists in considering a wide range of evidence before making up one's mind. Thus Wexler consults such disparate figures as David Abram, Joseph Amorino, Judith Bluestone, Antonio Damasio, Ellen Dissanayake, Kurt Goldstein, Daniel Goleman, David Henley, Viktor Lowenfeld, Maurice Merleau-Ponty, and Oliver Sacks, setting their findings alongside case

studies and even direct personal communications from affected indi-
viduals. Her approach is cumulative and reflects a wise attentiveness to
a range of voices, gradually orienting her reader to the fact that, despite
the many intractable thickets, there is indeed an avenue of clarity lead-
ing through the forest. The distinction between "abstract" and "con-
crete" perceptions of the world may seem obvious, but in the context of
autism it is essential to remember that the individual may be construing
the world from an almost exclusively visual and spatial perspective. In
the case of children with learning disabilities, Wexler finds that it is
necessary to honor their idiosyncrasies—their daydreaming, their lack
of concentration rather than expecting conformity. Those with atten-
tion deficit hyperactivity disorder, she argues, should be encouraged
to engage in imaginative play, learning how to interact with reality
at large while succumbing to the surface seductions of the art making
session. And although art is enjoyable, she points out that it is also a
discipline, in that its materials impose certain unavoidable and there-
fore predictable laws. Such things as the speed at which paint dries or
the relative pliancy of paper need to be witnessed and assimilated. The
pleasurable tinkering with the limits of material possibility becomes a
valuable metaphor for the gradual understanding of the conformations
of one's private being, and may eventually help to sharpen one's con-
sciousness of the social world.

As an educator, Wexler has visited schools and workshops that reject
the routines of traditional pedagogy. She refers to her experience of
the pioneering preschools at Reggio Emilia in Italy, and to the arts
programs mounted by the Northeast Center for Special Care (NCSC)
at Lake Katrine, the Creative Growth Art Center in Oakland, and the
Grass Roots Art and Community Effort (GRACE) in Vermont. What
Wexler has come to reject is the numbing rigidity of traditional class-
room teaching, which is entirely inappropriate to the problems of dis-
ability. Instead she advocates an approach that calls upon the teacher's
versatility and patience. A lot of time is needed if divergent thinkers
are to accommodate their perceptions within a coherent and com-
municable format. Engaging in shape and color is an indirect way of
concretizing and coordinating the revelations of subjective impulse.
Wexler contends that, if education is truly about constructing a mature
and integrated person, it cannot be solely an enterprise of social con-
trol. Teachers who simply force their pupils into conforming to pre-
ordained standards are doing nothing more than fulfill a custodial
function, stifling the imagination and the creative spark. Disruptive
behavior has somehow to be accommodated; it should at least become

comprehensible if the teacher is sensitive to the emotional signalling that underlies the behavior. Of course, understanding another person's emotional signals is an art in itself.

A common thread of fluency and empathy links these wide-ranging discussions and draws the book into coherent focus. Within the workshop setting, the educator or therapist must recognize that the individual needs space and time to develop a particular creative undertaking, and that as much freedom as is practical must be encouraged. What looks like wild disorder could prove to be nothing less than another kind of order, as yet ill-understood. Art making hastens intentionality and self-awareness, and thus fosters expression, message making, and dialogue. To glimpse the hidden form beneath the garbled surface may not be easy at first, but it is a necessary stage in the understanding of the Other. Art making is nothing if not a journey toward fluency, and its articulations inform all meaning and understanding. I take Alice Wexler's message to be that there is potential creativity within the most distraught and fettered minds. Art can and must be allowed to release the flow of inventiveness to help individuals accede to self-knowing, and thus to conscious life.

Roger Cardinal

Roger Cardinal is the author of *Outsider Art* (1972) and coauthor of *Marginalia. Perspectives on Outsider Art* (2001). He has written extensively about self-taught artists from Europe and North America and has co-curated exhibitions of Outsider Art in Britain, France, Germany, Slovakia, Switzerland, and the United States. Cardinal is also an authority on French Surrealism and the early modern avant-garde. He is Emeritus Professor of Literary & Visual Studies at the University of Kent, Canterbury, England.

ACKNOWLEDGMENTS

Many individuals and organizations have made significant contributions and generously given their support. They include Joseph Amorino, David Abram, Judith Bluestone, John Bramblitt, Francois Deschamp, Caren Haines, David Henley, Dan Labbato, Mary Stokrocki, Carol Putnam and the artists and staff at GRACE, Bill Richards, Annette Wiltshire, Gallery Socco, K&S Art Gallery, Pure Vision, and especially the artists and staff at the NCSC and the students of SUNY New Paltz.

Introduction

> Moreover, I myself have reached an age at which my failing flesh
> reminds me at every moment that the ultimate questions about
> mortality, normality, and identity are ones which, though we
> cannot finally answer them, whatever our area of expertise, it is
> incumbent on us, for the sake of our common humanity, to keep
> on asking.
>
> —Fiedler, 1996, p. xvi

Among the many important philosophies of art, education, and disability, I often allude to Howard Gardner's theory of multiple intelligences because it explains so aptly the reason why some of us are strong in certain skills and not in others. Of Gardner's eight intelligences, schools and society favor two; linguistic and logical thinking are considered to have the greatest intellectual value. Children who are not particularly strong in these two intelligences are generally labeled "at risk" and referred to special education services.

I also refer to the Reggio Emilia preschool educators in Italy who I believe most effectively teach with the multiple intelligences in mind by attending to the sensory and artistic learning of young children. The teachers of Reggio Emilia are also fully aware of how they co-construct learning with children and thus break through cultural paradigms. Founder Loris Malaguzzi's approach is to acknowledge limitations and then go beyond them. If limitations are perceived as functions of the inevitable cultural paradigms—or human constructions—then they can be turned upside down.

From March 2 to 7 in 2003, I joined other North Americans for a week of study at Reggio Emilia. Only twelve days later on March 19, the United States would declare war on Iraq. Thus the political obstacles that the study team spoke about that month had particular meaning.

During the seminar, the Reggio educators tried to inhibit their opposition to the war so not to offend their North American guests. Most of us were there because we believed in education for peace, and not at all offended. Reggio educators taught us that education for peace meant avoiding the dangers of dualities, which included such polarities as the heart versus the head, teaching versus learning, and self versus environment. In such an environment cold logic will always reign over wisdom, not only in education, but in most social and political institutions as well.

Regrettably, children who flourish when engaged in autonomous acts of discovery, experimentation, and hypothetical thinking rather than passive submission to expository teaching, might not necessarily succeed in school. Schools traditionally omit affect in favor of logic creating boredom, monotony, and repetition. "Nothing without Joy" was the leitmotif during the week of study, and also posted on the entrance of one of the several Reggio Emilia schools. I took this refrain back with me and posted the memorandum on my office door.

Although the Reggio Emilia schools do not specialize in disabilities, they nevertheless demonstrate how each member of the school community plays a respect worthy and irreplaceable role. In this endeavor, the first paradigm they toppled was the image of the child as a social and political construction. Efforts toward this goal would have to include the examination of systematic devaluation of children with labels. Reggio educators prefer to call children with special needs, children with special rights. If children have legitimate rights, they say, they should then also have opportunities to develop their intelligence and identity.

Reggio Emilia's mission is a declaration against the betrayal of children's potential. Given this belief, room must be made for unpredictability, uncertainty, and risk-taking. Teachers will also need to relinquish their favored position in the center, their predilection for monodirectionality, and their passive consumption of preexisting models of education. I think of Marin Alsop, music director and principle conductor of the Baltimore Symphony Orchestra who said that the greatest power a conductor has is to enable her musicians to be better than they are. Once she has achieved this power, she can step aside and become almost invisible. Teachers can also become invisible; once they set the stage children can become the co-directors of their own learning.

In this scenario children become protagonists, builders of their destiny, central actors, and authors. Teachers will need to respect that

children construct knowledge in a different way than adults, that learning is a process that cannot be standardized. Children build their own theories, and teachers will need to build on them too. Reggio Emilia teaches us that teaching is an attitude for life, not merely pedagogy. It is part of the development of the human being to find the meaning of her life, and this can be the meaning of school.

I am also indebted to Viktor Lowenfeld and David Henley. Like the Italian mothers who built Reggio Emilia, Lowenfeld emerged from World War II intent on building a more hopeful future for children. He introduced disability to the field of art education when it was not considered the responsibility of public schools to educate children who were other than the dominant group's standard of normality. Lowenfeld made a paradigmatic shift in the field to embrace disability, not only by his humaneness but also because of the importance he placed on the infinite variety of our species; and with his embrace of variety, we now see the contribution that this attitude has on our human development. David Henley, whose mentors were Lowenfeld and Edith Kramer, embarked on the much needed crossing of borders that separate art therapy from art education. He brought empathy and experience to art education that did not have a system to support the new population of students in its care.

Postmodernism has not only had an effect on the fields of art and education, but on disability as well. No longer can we use the terms in this book with certainty or authority. Personal, intellectual, and physical borders have become anachronistic and an ethical dilemma in the twenty-first century. The division between "us" and "them" is the ongoing challenge we face in the education of children with disabilities in what we would like to think of as a just society.

Regrettably, the social and political systems that drive education in the United States often produce the very disabilities that we set out to "cure." Rather, disability is a mutual construction among researchers, teachers, administrators, and other professionals, and accepted by parents and community. Therefore, it is important to pay equal attention to the dynamics that are inherent in making the label. Self-conscious construction, writes James Paul (1996), is essential.

Most of us have had teachers who loved us and made our lives better. Some of us may have been protected from labels or even rescued from deviant careers by such a caring and competent teacher. Most of us also have been hurt and even damaged by thoughtless and, perhaps, less caring teachers. We spend a long time in school

under the care and watchful eyes of teachers. Not all of those eyes
see the same things. (p. 300)

Ambivalence with severe physical and mental abnormality runs deep
in pedagogy, but it is only a reflection of an historical ambivalence in
Western culture. The dichotomy of such terms as normal/abnormal
sets the stage for the domination of the majority of so called normals.
Leslie Fiedler (1996) refers to the abnormal as the "ultimate other."
The historic division between normal and other has deep roots in the
collective unconscious, so it is to archetypes, myths, and legends that
Fiedler turns. The fear that we might appear "abnormal" to someone
else lies in our dormant adolescent unconscious only to be activated at
the site of physical and mental deviation. Thus it is with wonder and
awe that we look at the exception from the norm, or the other. But
far from reassuring us that we are normal, the other is "really a reve-
lation of what in our deepest psyches we recognize as the Secret Self"
(Fiedler, 1996, p. 152).

The acceptable and self-conscious term *other* became popular at a
time when such terms as *handicapped* were rejected, as well as a clear
and nontransferable divide between *us* and *them*. The political correct-
ness of *other* appears to make deviation a matter of degree rather than
of kind. Fiedler challenges political correctness as a thin veneer behind
which remains long held fears, myths, and fantasies about disability.

Having said all that, I have nevertheless chosen to head the chapters
of the book by disability. I do so only for convenience while knowing
that it is an imperfect system.

In chapter one, I offer an overview in which I lay out the principles
underlying my theories about the importance of emphasizing the sen-
sory nature of the arts, and specifically the visual arts, in establishing
deeper communication and the dismantling of boundaries. Endemic to
the need in breaking down barriers is the way disability is perceived by
the field and the community. The groundbreaking work of Lowenfeld
brought a humanistic philosophy of disability to the field of art educa-
tion long before the federal laws established the rights of this popula-
tion to a free and equitable education.

In chapter two, I emphasize the mystery of autistic spectrum dis-
orders (ASD) and what it teaches us. Several dynamic spokeswomen,
who are autistic, such as Temple Grandin, Judith Bluestone, and Sue
Rubin, have given us great insight into not only the logic of autism, but
also its pain. Several advocates, such as Oliver Sacks, Clara Park, Lorna
Selfe, Valerie Paradiz, and Lyle Rexer have, with their humanistic

understanding, helped to form better theories about autism's causes and "cures." The sensory nature of the visual arts mentioned in chapter one is essential in establishing communication with many nonverbal and socially estranged children with ASD.

Chapter three attempts to do justice to the highly complex attention deficit hyperactivity disorder (ADHD). Like most disorders designated by their negative attributes, the label ADHD is not helpful in revealing the highly gifted nature of children and adults. Usually placed in inclusion classes, they attend the kind of schools described earlier that do not reward them for their individualism. Regrettably, their oppositionality, lack of social skills and confidence prevent them from succeeding, and instead they become further marginalized. The innate structure of the visual arts, which teaches the sometimes hard lesson of cause and effect, lays a bridge between their nonconventional gifts and the conventions of the social order.

ADHD is considered a spectrum disorder in which learning disabilities (LD) may be included. They share many characteristics, one of which is the need for self-organization. One limitation specific to children with LD, however, is their inability to build knowledge as a result of a compromised memory system. In chapter four, I suggest that the simultaneous concrete and abstract qualities of the visual arts allow for the understanding that has eluded children with LD, and which can translate into academic learning.

Emotional and behavioral disorders (E/BD) reveal most completely the inextricability between our social order and the disabilities it produces. Even when environmentally caused, E/BD results in possibly immutable effects in the emotional brain. I refer to the theories of Daniel Goleman, Stanley Greenspan, Stuart Shanker, Joseph LeDoux, and others to describe how environment and body inevitably affect each other. The several arts have proved to be effective in reawakening lost emotions and trust within self-contained classrooms to which children with E/BD are designated, as well as in arts community organizations.

In chapter six, the blind and visually impaired population is explored through Oliver Sack's narrative, the autobiography of Lisa Fittapaldi, and the work of Viktor Lowenfeld. I examine how the haptic and visual-mindedness of children might direct teachers toward effective projects. To offer greater independence to this population, more ingenuity is required from teachers, which makes the issue of the least restrictive environment (as outlined in Public Law 92–142) particularly meaningful. The stories of artists such as Lisa Fittapaldi and John Bramblitt

reveal how the visual arts help us in this search, and also enrich life by stimulating, storing, and maintaining visual memory.

The Northeast Center for Special Care (NCSC), a facility for traumatic brain and spinal cord injury, is the subject of chapter seven. Bill Richards founded the art studio in 1999 and remained its director for four years. As an artist his approach with the neighbors, as they are called, is to create an environment in which painting is a serious enterprise rather than a therapeutic activity as practiced in most institutions.

The NCSC and the Grass Roots Art Community Effort (GRACE) are similar in their approach, which is to intervene less and encourage independence. Chapter eight is divided into two sections. In the first section, I describe the experiences of student interns from the State University of New York at New Paltz who were placed at NCSC for field study in an elective course. Their observations illuminate the process of making art with this population: how it encourages the breakdown of boundaries and creates enduring relationships between people with traumatic brain injury and so called normals. In the second section, a diverse population seeks to become accomplished artists at GRACE, a community organization founded by Don Sunseri. Also an artist, Sunseri shared Richards's democratic beliefs about making art and also found an effective strategy and environment for potential to be realized.

In the final chapter, I suggest concrete ways of structuring lesson plans so that children with disabilities become the owners of their own art work and the makers of their own discoveries. Sensory motivation and dialogue are emphasized as the direct path that leads children to become protagonists and coauthors of learning. I analyze the structure of the lesson plan and offer several examples from preservice teachers.

CHAPTER ONE

Overview

Introduction

Our several senses...reach far beyond us. They're an extension of the genetic chain that connects us to everyone who has ever lived; they bind us to other people and to animals, across time and country and happenstance.

—Ackerman, 1991, p. 308

The Tyranny of the Normal is the title of a book by literary critic and maverick, Leslie Fiedler. I often return to this phrase because of its dead on precision and inherent irony. I believe in order to really work with the *other*—anyone who is not like us in appearance, mind, and behavior—we need to look at who is doing the judging and labeling. It is imperative to resist the primitive urge to separate ourselves by labeling the *other* for our own safety and comfort if we are to have any hope of making a difference in another's life. Current events in the world remind us that we all carry anger and blame toward what is not us. And if we are not in our rational mind for even a moment, then we might reveal a cautiously guarded contempt that stems from the primitive emotion of fear; for our primitive emotions are never far from the surface.

The concept of disability is defined by the dominant group that considers itself normal. Generally speaking, the individuals within this group feel comfortable with the social structure that has been devised for us, and they participate in the devising. We are normal if we can cope, and even thrive in nine to five office jobs, have the same dreams for our life that our parents and siblings have, and have desires that

are appropriate to our culture and the expectations of others. What happens to the individual who does not fit in because of her physical, emotional, psychological, or neurological "ab-normalities?" When does difference and excess become abnormal? How much will normals tolerate? How much are normals willing to change to accommodate difference?

I argue that disability is a matter of degree and our normality tenuous at best. Having worked with traumatic brain injury (TBI), I am aware that our bodies and brains are vulnerable to the hard and fast moving objects in our environment. We will get old, we will need glasses after forty, and we will lose much of our short-term memory. We need to remind ourselves of our own fragility so that we might find a kinship with our fellow humans who have differently shaped bodies, unpredictable behavior and emotions, or have lost—or never had—sight or hearing.

All the arts are helpful in creating a bridge between us and the other. I happen to be a visual artist so that is what I know best. However, I try to include music, movement, and drama in everything I do with children because the various arts stimulate different parts of our sensory system. The sensory system is so rudimentary that it often becomes invisible as we go about what we habitually and intellectually do. However, the sensory system has the power to break down the wall that we construct between the self and the world and, of course, everyone in it (who is not like us, which tends to be most of the people in the world).

If the arts are a biological need (Ackerman, 1991; Dissanayake, 1990, 1995; Howell, 1977), then it makes sense to begin with the sensory system. "Making sense" is itself derived from the idea that common sense begins, first and foremost, with our sensual perception of the world. The senses are the surest way to reach the selfhood of a child whose identity has been mitigated by the kind of loss mentioned earlier. Disability takes innumerable forms and the *Diagnostic and Statistical Manual of Mental Disorders-Fourth Edition* (DSM-IV)[1] has the official list of disabilities compiled in 1994 with clarification of the categories added in the 2000 text revision.

How do we reach a child who has no speech, erratic behavior, cannot move, will not listen, cannot hear or see? What happens to the self that is isolated within a body and mind and stigmatized by the social world? The body-self is the most logical place to begin. No matter how fragmented they might be, or how much loss has been sustained, the remaining senses can and should be stimulated. It is now common

knowledge in the medical field that when one system is lost, another compensates for it. Cortical connections in individuals who are blind, for example, that were once part of the visual cortex are now transferred to the auditory cortex. Therefore, with individuals who are deaf and blind, the senses that remain are more highly sensitive and responsive than in normative brains.

It has been our job since infancy to make *sense* of the world through order, regularity, and predictability. We also do this graphically in the visual arts, temporally in music, and spatially in dance. We use repetition and rhythm as ultimate order by controlling time and space. No wonder, as Diane Ackerman (1991) says in *The Natural History of the Senses*, we created an art form for each of our senses. Art is not only a pleasurable activity, but also a necessary one in learning to negotiate and integrate with our world. It was, therefore, created by us ultimately for our survival. In evolutionary terms, art might be called an adaptive behavior—a behavior that has selective value for the species. Art as a behavior, championed by Ellen Dissanayake (1990, 1995), is qualitatively different than art made for dealers, curators, critics, and the rest of the relatively small Euro-American art world. Art as a behavior fulfills a human need; it is a way to reach into the biological memory of the human species, which is why it can so powerfully transform us.

Self-Organization

Organization, the deep human imperative, is begun in the body. Contrary to common belief, our body remains the most discernable means of organizing the world in adulthood. Our verbal rational mind, however, leads us to believe otherwise. Our rational mind is, in fact, the outer layer under which lies years of now automatic bodily responses, and to which we pay little attention. Much of what we register about the world is not available to the left side of the brain—our linguistic interpretation of the world—and so it is not fully conscious. We are always recording and processing nonverbal information, but it is overshadowed by the loudness of our verbal rational mind. Our most embedded biological memory stored at this layer is all but forgotten until we are caught off guard by a whiff of a remembered scent or the luminosity of a shaft of light. Then memories, once lost to us, flood in.

In a similar way, the sensuous materials of the visual artist, the bodily movement of the dancer, and the most direct of all art forms,

music, hijacks us from our verbal reverie and places us full square in the moment. The power that the arts have is that they awaken us—we who make them and view them—to our bodily self. Regrettably, we depend on the artist to be the designated collective voice, stopping us in our tracks as the work, if authentic, makes a direct hit to the layer beneath the rational mind. How much have we sacrificed to the god of culture so that we can enjoy our wireless Internet and multitasking cell phones? We lose our connection to our sensory system at our own peril.

Self-organization through the body is a way to learn how to learn. For children who have been socially isolated as a result of physical limitations or stigmatization, the body becomes the point of departure (Henley, 1992; Lowenfeld, 1987). If a child is totally disconnected from her environment, as several of Viktor Lowenfeld's subjects were, then the body becomes her world. In this circumscribed environment, it is the challenge of the mentor/teacher to find the point of departure through which the child's experience can be extended. Viktor Lowenfeld wrote passionately about this strategy in a chapter called *The Therapeutic Aspects of Art Education*, deleted after the third edition of his well-known text book, *Creative and Mental Growth*. Isolation, to a greater or lesser degree, is a universal effect of all disabilities. Although disability creates some degree of detachment in and of itself, the daily social marginalization of the child is ubiquitous. For example, a wheelchair-bound child is entirely dependent on others for transportation, and since most social-ization occurs after school, this might leave little opportunity to play with other children. The structure of this child's day is so rigid that aberrations like play dates become daunting undertakings. Needless to say, the child who is blind or deaf will be excluded from dominant forms of communication. The neurological disabilities have their own behavioral issues that make friendships difficult at best. However, if we come to a child knowing nothing about him except that he is *different*, we can be confident that we will be working with a child who has missed important socialization, an experience that most of us have the good fortune to take for granted, and that comes with growing up in a welcoming society. Social marginalization simply creates less opportu-nity to grow, to know oneself, and to form a strong identity.

The Power of Metaphor

Paul Ricoeur (1981) distinguishes visual metaphor as the first language stemming from our visual memories before acquiring verbal language.

According to Jerome Bruner (1979), metaphors are particularly effective in their ability to convey maximum content and meaning in the minimum of form. The metaphorical language of the visual arts construct a bridge between preverbal and verbal knowing, particularly for children who find verbal communication challenging because of its abstractness. All the arts offer the means to construct and convey meaning from the concrete to the highly conceptual.

George Lakoff and Mark Johnson (1999) follow in the tradition of Maurice Merleau-Ponty and John Dewey who understood experience as grounded in the body, or in the favored term of Merleau-Ponty, "the flesh of the world" (as cited in Lakoff & Johnson, 1999, p. xi). The embodied and highly subjective experience of life is the source of metaphor, and it connects us intellectually and biologically to other living beings in the "meaning, context, perception, emotion, memory, attention, action, and the dynamic nature of communication" (p. 6). Metaphor is a way for us to make the link between earthy concrete meanings and the abstractions that arise from them. Much of our deeper metaphorical constructions are unconscious, even our conception of self that comes from the same unconscious metaphors. The formation of categories is also a product of unconscious sensorimotor and muscular movements of our bodies. Metaphor is the liaison between concrete categories and the conceptual categories that make reasonable sense of them or, in other words, conceptualized subjective experience.

Metaphors make abstract thought possible (Lakoff & Johnson, 1999). The locus of the process begins early in life when, for example, the feeling of affection is *associated* with the warmth of being held and creates permanent neural pathways between disparate domains (Lakoff & Johnson, 1999), association being the modus operandi of the unconscious. Lakoff and Johnson suggest hundreds of what they call primary metaphors that result from such associations, such as how *more* is equated with the physical, sensori-motor experience of *up* (as in *rise, skyrocket, high, peak*) because of the verticality of our bodies. Similarly, we make the same associations between *less* and *down (as in fall, plummet, low, dip)*, by crossing over the two separate domains of physical experience and cognitive subjective judgment.[2]

As mentioned earlier, the spatial and temporal structures of the arts harken back to preverbal and presymbolic origins. In the nonverbal world of infancy, sensory modalities crisscross without the distinction-making rational mind. Metaphor does this too, which is why it is so powerful in helping children make connections to their psychic issues

while also working on the formal issues of the art work. Metaphor res-
onates with us because we make deep connections and links between
mental and physical domains, which is particularly easy for young chil-
dren. This externalization and formalization of inner feelings, particu-
larly the bodily sensations and muscular movement in which they first
arise, is how we, since our early prehistoric beginnings, have embed-
ded ourselves in the world. Interpenetration of self and world lays the
foundation for aesthetic empathy.

In *Emotional Intelligence* (1995), Daniel Goleman writes that

> The logic of the emotional mind is *associative*; it takes elements that
> symbolize a reality, or trigger a memory of it, to be the same as that
> reality. That is why similes, metaphors, and images speak directly
> to the emotional mind, as do the arts—novels, film, poetry, song,
> theater, opera. (p. 294)

Goleman goes on to say that spiritual teachers, such as Buddha and
Jesus, have also employed the *language of emotion* by using parables and
fables. He calls metaphor and the like "the vernacular of the heart"
(p. 294), and the emotional mind the logic of poetry and dreams, tak-
ing verbal language close to the nonverbal level of being.

> If the emotional mind follows this logic and its rules, with one ele-
> ment standing for another, things need not necessarily be defined
> by their objective identity: what matters is how they are *perceived*;
> things are as they seem. What something reminds us of can be far
> more important than what it "is." (p. 294)

Goleman's last sentence is an important one. In a few words he explains
why we, as teachers, find ourselves in a bewildering situation as we
try to parse out the words and behaviors of our "special" students.
Children are reacting to historical events that dredge up old feelings
while they are in the here and now, talking, playing, or observing.
This phenomenon can work for us if we recognize it and then quickly
transform it into art.

To the emotional mind "everything is black and white, with no
shades of gray" (p. 295). All it takes to activate a past emotion is an
event that shares with it at least one striking feature. The emotional
mind then indiscriminately connects what is current with that striking
feature. "Another sign of this childlike mode is *personalized* thinking,
with events perceived with a bias centering on oneself, like the driver

who after an accident, explained that 'the telephone pole came straight at me'" (p. 295). Goleman's statement is packed with implications about qualities that many disabilities, while diverse, share to a greater or lesser extent depending on the individual and her circumstances. Two of these characteristics are self-absorption and victimization that often go hand in hand. When one's world is isolated, whether by choice or necessity as in the case of autistic spectrum disorders (ASD), attention deficit hyperactivity disorder (ADHD) and the emotional behavioral disorders (E/BD), the world appears to *happen*. There is little evidence that the events of life arise by choice, but rather, intrude and threaten. The associative aspect of the emotional mind confirms the perception that the self exists in opposition to the world and must protect itself at all costs.

Goleman calls this thinking, *self-confirming*, in which memories that undermine irrational beliefs are pushed to the background while those that support them are brought to the forefront. The emotional mind creates an infallible system that cannot be argued. "Feelings are self-justifying, with a set of perceptions and 'proofs' all their own" (p. 295). The rational mind, on the other hand, searches for objective evidence that will either support or dismantle beliefs.

He explains why our best efforts to sooth a distraught child through verbal dialogue is often useless. In the heat of the moment, the child who is in touch with her past trauma is, in effect, living in the past. What we might be talking about at the moment misses the point and our words do not reach the traumatized child, "it carries no weight if it is out of keeping with the emotional conviction of the moment" (p. 295). These children are reliving a treacherous moment in the past that had once put them in danger, and so they feel that their life is now in danger. What might seem to us as innocuous words or events are, to the child, the past returning again to threaten his survival. This scenario is typical for children with E/BD. Other disabilities, such as the complex ADHD and Asperger's syndrome (AS), also have their share of emotional associations.

Of course, new teachers in particular must be sensitive and cautious when entering into territory in which they might potentially lose control. It is wise, therefore, to spend time observing children and set up opportunities for free conversations to take place before the teacher/mentor embarks on a serious project. Most importantly, teachers must know that there are no formulas, only good models. They need, first of all, to know themselves, know at what they are best and most capable. Timing, pacing, patience, and empathy are the rule of thumb. Change takes place slowly and incrementally or might appear not to take place

at all. Teachers, therefore, need to be flexible when setting their expec-
tations. Setting them too high will discourage the teacher, setting them
too low will discourage the children. Projects need to be appropriately
challenging to capture the children's interest. If they are not, children
will know that the project is not worthy of their participation. If it is
too complex, they will act out or become defensive.

When art is necessary another kind of art is made, the kind that is
not only life-enhancing, but also life-serving. This kind of art is made
by self-motivated artists who are emotionally invested in their work.
How to achieve such art making is explored throughout the book.

Play and the Transitional Object

As mentioned earlier, fragmentation of self is a function universally found
in illness. Loss is the nature of illness and disability that then creates
imbalance within the body and mind. Balance is restored when the lost
function of the body/mind is compensated by another part of the body/
mind that ordinarily performs a different function. The flexibility of our
body/mind that seeks to restore health is in part a function of the human
ability to symbolize self. Since we have the unique characteristic of (self)
consciousness, we can consciously adapt to loss by creating symbolic sub-
stitutes. This process has been described by child psychologist Donald
Winnicott (1996) with his seminal theory of the transitional object. This
concept has had far reaching consequences in understanding the bio-
logical and human need to represent self as the source of art making. It
explains not only human survival, but also the creation of culture.

The transitional object stands as the first human symbol and arises
out of a need to substitute the comforting "mother," thus helping the
infant in her efforts toward individuation. When the infant first under-
stands that she is separate from her mother, some anxiety ensues. To
accommodate the disappearance of the mother and remain secure in
one's separateness, a substitute object is endowed with qualities of the
caretaker. Symbolic representation then begins before language and,
therefore, makes for powerful emotional and sensory associations over
the life span. As infants grow they continue to use the same method—
endowing objects with symbolic power—to establish intimate and sig-
nificant human relationships. As we will see, children on the autistic
spectrum are generally unable to establish intimate relationships with
other human beings and, rather, find significance in inanimate objects.
Separation from caretakers compels "normative" infants to find comfort

in soft objects that share the same qualities as the caregiver, such as blankets and stuffed animals. The child with ASD does not share this need, but rather finds comfort in the object for its own qualities, rather like a permanent substitution. The normative child reconstructs the relationship with an "other" in that other's absence. As the infant grows and develops, the original need to substitute mother disappears, but the need to represent self in the world at greater complexities remains. It has been argued that making art has a direct relationship with these early representations (Henley, 1992).

Like Winnicott's transitional object, the art object functions as a bridge between self and world, satisfying the need for homeostasis. Children who did not make attachments to their caregivers are missing this early development with considerable consequences. This missing part of development becomes both the cause and consequence of a child's inability to play, which requires the ability to imagine and construct these primitive abstract concepts and representations of self and world. We see that children's first representations are invariably of mother, father, siblings, and other important people in their lives, serving to stabilize their rapidly changing world into categories and classifications. If a child on the autistic spectrum is capable of making representations, he will usually not be compelled to represent people in his life, for he will find alternative ways to stabilize his world. Often children with ADHD share the inability to play and represent significant people. This inability, or lack of need, results in egos that have not made healthy connections between themselves and others in terms of identity, gender, role, and image. Symbolism of self, therefore, is an indication of growth.

Lowenfeld said that art making is in itself learning because in the act of making art we engage with our world of experiences and, at the same time, find deeper reflections of that world as our ideas and responses become visible. When children are unable to represent themselves, or do so in an impoverished way, they will need help, in the least restrictive way possible, to extend their frame of reference. Our purpose as teachers is to unlock the flow that will allow healthy representation of self to take place. Stereotypical and distorted imagery is an indication of a self unsure of her identity in the world, while flexible imagery indicates a growing sense of self.

Oliver Sacks (1995, 1998) writes that a lack of balance is at the root of illness. When the certainty of the body is taken away, so is its relationship in the world. Reestablishing balance with the environment is, in Sack's view, the process of healing. Making art creates balance, or homeostasis, because it combines play with seriousness, predictability

with unpredictability, the concrete with the abstract, intellect with emotion, and limitation with open-endedness. The balance of play and seriousness in art is especially helpful for children who need to learn in modalities other than verbal communication. Through play children learn the serious lesson that rules benefit the group as well as oneself, and the much needed empathy so lacking in self-absorbed children with ADHD, E/BD, and ASD.

Play is therefore essential in the social and cognitive development of children, as we will see in chapter four. Learning disabilities (LD) reveal how play is essential in the forming of categories and classifications in the concrete operations stage, the foundation on which all new learning, including abstract thought, depends. When children play they form connections, relationships, and groupings by sorting one color, line, or shape from another. Play can be couched within art making and, therefore, reintroduces this important learning missed earlier in life. As children with LD get older, the learning that is normally achieved in preschool must be now framed in a much more sophisticated way so as not to be demeaning. We can do this by embedding classification and categorization in more sophisticated art projects, described more thoroughly in chapter four.

Play is also important in tapping children's imagination. Not surprisingly, children who are unable to play usually have imaginations that are escapist, idiosyncratic, and self-absorbed. For example, many children with ADHD are unable to distinguish reality from fantasy that make their attempts at play prohibitive to their peers. Imagination and aesthetic decision making, on the other hand, lead children out of their isolated play toward the social learning embedded in participatory play. Often with particularly isolated children, such as those with classical autism, teachers might begin by using the less intimidating method of parallel play discussed in chapter two.

Children with disabilities need the arts as an alternative means of reaching independence and autonomy, or as a pretext for multidimensional growth. When used with this purpose in mind, art making helps to expand one's view by stretching out into the world through the conduit of materials.

Body Image

Lowenfeld defines body image as one's sense of self-worth. Without a realistic acceptance of who we are, we are unable to reach out to the

world. The sensitivity to the body and its functions lead to emotional responsiveness and, therefore, involvement and the beginning of a healthy adaptation to one's disability. Without emotional investment, children will make art work that is obligatory, flat, and formulaic, and they will be unaffected by what they do. In whatever diminished condition it might be, the body is, nevertheless, the most accessible point of departure from which children extend further out into the world.

When art is made under compelling conditions, it strengthens the structure of self and creates a world, if only for a moment, outside the reach of external forces that thwart personal development. Self and environment are interdependent and each must be recognized as intrinsic in human development and holistically dealt with in art making. Therefore, educators need to go beyond aesthetic objectives and include, as Lowenfeld so carefully charted out for us, intellectual, emotional, physical, social, and perceptual growth.

In what was originally published as Chapter 12 of *Creative and Mental Growth* (1957) and later republished in the *American Journal of Art Therapy* in 1987, Lowenfeld writes, "It is one of my deepest innermost convictions that wherever there is a spark of human spirit—no matter how dim it may be—it is our sacred responsibility as humans, teachers, and educators to fan it into whatever flame it conceivably may develop" (p. 112). He thought the drive to create not only sacred, but also human. Therefore, no one has the right to deprive a child of his innate ability however diminished it might appear. But how do we make art with a child who cannot hear, speak, or see? Lowenfeld describes the point of departure as the body self.

The body image is the mental picture we have of ourselves—who we subjectively think we are. When the body is drastically affected by an injury, one's identity intrinsically changes. If childhood isolation and stigmatization occur, as it so often does with a visible disability, the child will see herself reflected in the mirror of a rejecting society. The body concept is therefore arrested, and with it, a solid identity. Sensory motivation is not only beneficial for children with special needs. Lowenfeld says emphatically that the kind of motivation that releases inhibition in children with disabilities and leads them to recovering selfhood is different than a typical motivation only in degree and intensity and not in kind.

Thus, to a greater or lesser degree, depending on their severity, children with disabilities experience a limited connection to the environment and to the body self. Stereotypy and repetitive imagery reveal this

lack of connection. The teacher/mentor must begin where the child is and extend his frame of reference incrementally "in order to make him finally 'accept' his individual self, for it is the acceptance of the individual self which ultimately leads to true self expression" (p. 115). The slow process of interrupting perseverative imagery is painstaking, and results are sometimes realized in the distant future. Eventually, however, the right motivation will be found that sparks engagement, and the extent of a child's emotional engagement can be measured by how flexible her imagery becomes.

Lowenfeld tells a poignant story of how he encouraged an eleven-year-old girl who was deaf, mute, and blind to make a representation of herself with clay. The first works showed evidence of a limited awareness of body image. Putting her finger to his mouth, Lowenfeld told her that she was sitting, and while touching her to make her aware of her position in the chair he said, "You are a sitting girl" (p. 128). In the next lesson he brought an apple for her to hold, making her conscious of her hands. He took it away and replaced it several times, each time folding her fingers around the apple. In the clay figure that followed, she represented the fingers on her hand not visible in the first figure. This experience also made her conscious of the starting point of her arms and their relation to her body. "Step by step we made use of modeling as a means of interpreting in plastic representation her own bodily sensations" (p. 128).

The next time Lowenfeld met with his student she was very sleepy. Starting from where a child is, using what is intact and available, he said as he touched her arm, "You are very tired— sleepy—very tired.... You are holding your head in your hands" (p. 128). Unexpectedly she spoke her first words, "'m-y head in m-y hands'.... The emphatic use of the word *my* indicated that she did more than repeat a sentence, for through her sense of touch she had in one brief experience pushed back the limits of her little world of knowledge" (pp. 128, 129). With each visit he found a motivation that came directly from her body gestures, expressions, or on one occasion, with two hairpins that she wore. As she became more aware of her body and environment her representations in clay became more differentiated.

The Sensory System Revisited

[W]ithout any glimmer of sensory experience, there could be nothing to question or to know. The living body is thus the very

possibility of contact, not just with others but with oneself—the
very possibility of reflection, of thought, of knowledge.

—Abram, 1997, p. 45

We have a highly dynamic sensory system that will atrophy without
experiences that nurture it. Our sensory system is at the root of what
we know, harkening back to preverbal infancy. In this early stage of
development, which Jean Piaget calls the sensori-motor stage, we are
not yet able to generalize, categorize, and classify things in the world;
we only experience the thing itself. Only later will our fully formed
brain, with the help of language, recognize things in the world as sub-
headings within larger categories. With the ability to categorize, how-
ever, comes the potential to lose curiosity. No longer experiencing
each encounter as unique, we tend to see less of the world out of bore-
dom with the familiar.

And soon, when it's become commonplace, the brain begins slur-
ring the details, recognizing it too quickly, by just a few of their
features; it doesn't have to bother scrutinizing it. Then it is lost to
astonishment, no longer an extraordinary instance but a general-
ized piece of the landscape. Mastery is what we strive for, but once
we have it we lose the precarious superawareness of the amateur.
(Ackerman, 1991, p. 305)

The sensuality of materials stimulates our senses and evokes per-
sonal histories of the emotions invariably connected with them. These
emotions can go back as far as infancy: the comfort of being held and
the sound of our mother's heartbeat. Sensations and emotions, such
as security and comfort, are stored away inside us and activated only
when our bodies are met with associative sensations. It is no won-
der that we cannot describe many of our present feelings because we
found bodily expressions for them long before we could name them.
For example, our sense of smell is activated in the limbic system, the
most primitive part of our brain. Smell is the first sense to appear in
evolution that kept us alive by recognizing poisonous food. Because
smell first appeared when all life lived in the ocean, an odor must first
be dissolved in our mucous membrane before we can smell it. Once
on land, vision and hearing became more important to our survival.
Smell needs no linguistic interpretation, and it is the only sense that
does not (Ackerman, 1991). We have all had the experience of open-
ing a rarely used dresser drawer and without warning, the odor that

wells up becomes a cloud of memory. We are instantly transported to a previous time and location.

The importance of touch is well known in pediatric medicine. Lack of touch can cause infant brain damage or even death. The key organ for touch is the skin and, therefore, it is a pervasive feeling difficult to isolate because it affects the whole organism; without it there can be no parenting, and no survival.

Our mind completes what we do not see with the sense of touch. Often what we think we see is really known through the visceralness of touch. When we look at an abstract painting, we know that the texture of the paint is bumpy or smooth, but it is only because we have felt a bumpy or smooth surface that seeing evokes the experience of touch. We also paint what we do not see but sense—"to make *visible* how the world *touches* us" (Ackerman, 1991, p. 267). Because of the enrichment touch gives our seeing sense, it is essential to use it when drawing from life. Children especially need to experience the objects they draw with all their senses, which makes their drawings rich, detailed, and *felt*.

Touch is not only essential to development but it is also necessary for survival. Because it is one of our earliest senses, it teaches us to distinguish ourselves from others (Ackerman, 1995). Without touch infant brains will not develop, a perfect example of the human collaboration with the environment. Ackerman calls touch ten times stronger than verbal communication in its affect on the whole organism, and the key to our species. Touch teaches us that we live in a three-dimensional world.

The senses along with their natural counterpart—artists' materials—reawaken lost meaning in children because they arouse the emotion's hunger for meaning through association. For example, Ackerman (1991) describes the hand as an ancient symbol of the body, and a handshake as a watered-down contract whose original purpose was to prove that no one carried a weapon. Because of this and other ancient rituals, the hand became a messenger of emotion. The handshake as messenger of self and emotion is a strong metaphor that invites physical and social contact and leads to larger issues such as trust and friendship.

Mendelsohn said that it is not that music is too vague for language, but that it is too precise. Nor does language have the same emotional potency. Every adolescent knows the power music has in articulating overwhelming feelings. For the adolescent romantic, the newfound internal world of feeling becomes more compelling than the lived world. Music mirrors and symbolizes our emotions and "frees us from the elaborate nuisance and inaccuracy of words" (Ackerman, 1991, p. 207).

Music does not need words to have associative and emotional effect, possibly making it the most direct of all art forms. And unlike color, line, shape of visual space, notes can occupy the same space and remain distinct. Ackerman asks if music might in fact be a language in its own right. If music is a language, it is the only one—because of its precision—that cannot be translated from one culture to another. Viewed from this perspective, music is the language most embedded in the senses. What is music's survival value, asks Ellen Dissanayake (1992)? It must have one because we respond universally to it, and it has led many through the most oppressive of circumstances (slavery and concentration camps are two examples).

Color and music have often been compared for their inherent emotion. Just as colors have waves, a musical note pulsates in the air. For both reasons individuals who are blind are able to enjoy color and those who are deaf are able to hear music. Much of what we see is what our brain tells us we see. Color exists more in the mind, therefore, than in the world, and at the same time it is innate in human beings, making it both idiosyncratic and universal.

For example, we know color through relationship and revise it according to the amount of light reflecting on it. In other words, we see through the filter of experience and memory, and therefore we each see through a different lens. The multilayered nature of the senses makes apparent the variety of ways humans perceive the world. We can honor this knowledge by creating experiences in art making that stimulate the sensory system.

The Integrity of Materials

Ellen Kivnick and Joan Erikson (1983) observed how making art with mentally ill adolescents are beneficial because of the properties and processes of materials that are in and of themselves healing. However, only materials that are able to transform their shape, texture, color, etcetera, are capable of transforming the raw material of the child's psyche. For this reason such materials as cotton balls, Popsicle sticks, glitter, and other predictable and unchangeable packaged products will not produce revelatory experiences in art.

Kivnick and Erikson conducted an experimental study at Austen Riggs Center in Stockbridge, Massachusetts and Mount Zion Hospital in San Francisco in which they queried which characteristics of the arts made this transformation possible. In an article in the *American*

Journal of Orthopsychiatry, they begin by tracing the root of the verb "to heal." The word is rooted in the Anglo Saxon "hal," which means healthy, sound, and whole. The noun "therapy," on the other hand, refers to an activity or behavior in which its sole purpose is to treat disorders. Their point was that we use the verb to emphasize what is intact, while we use the noun to fix what is broken. Because Kivnick and Erikson worked at a hospital at a time when art was used almost exclusively as therapy, their experiment was an attempt to discern the difference between using the arts for their own inherent healing properties as opposed to a vehicle or adjunct of talk therapy. They shifted the emphasis from the child as ill to the child as creator, and analyzed student behavior in terms relevant to artistic learning rather than to the verbalization of unconscious material. Adhering to this philosophy, their dialogue was the kind used between artists rather than patient and therapist. The goal of the two hospital programs were "to encourage participants to learn new skills and strengths, and to build upon those capacities and strengths they already possessed" (p. 603). This point is crucial because it shifts the paradigm of disability from loss to the intactness of artistic talent. Since the projects were considered healthy rather than therapeutic, art making emphasized the building of positive assets rather than the curing of negative ones.

Although Kivnick and Erikson's study focused on adolescents with mental illness, the artistic properties they discovered to be responsible for their recovery can be applied to all disabilities. First, art making is physical and sensory, encouraging young people to engage in an activity that creates and re-creates our relationships with the world. Many children with disabilities are often hyper- or hypoactive, exacerbating the fragmentation of disability. This is particularly true for adolescents who are struggling to build an identity. Art making, however, brings sensory awareness, or a firsthand experience of one's own being in the world. Artist and art educator, Dean Howell (1977) describes the action of shaping and forming materials as a process of bringing conscious attention to our living bodies as we respond to them: "In this way one's sense-ability is the source of one's response-ability which puts him at the control of his own behavior" (p. 22). We become aware of our preferences as we choose and select materials according to our sensual responses to them, and ultimately find contact with our sensuous self, the direct route to self-knowing.

Awareness of our preferences and priorities, so crucial in the development of the self, happens naturally when making art. Yet the young artist might not be conscious of this process. What is happening

consciously, however, is the awareness of materials transforming and decisions being made about shape, line, and color. The unconscious transformation of the body parallels the mind's engagement with art making.

Making decisions is the ongoing process of art making. Out of all the colors on the palette, we choose one. We may not be able to explain why we make that choice, but something pulls us toward one color above another, just as we are pulled toward the people, ideas, and places in our lives. Once the choice has been made, a new response is formed directly from our action on the material. The first mark creates response-ability, as Howell calls it; a chain of choices has begun based on our initial choice. By providing us with a place to act on our preferences, the canvas concretely brings the unconscious to consciousness. We are motivated to make more choices as each choice adds to the complexity of the evolving schema, and the canvas the meeting place of our internal and external reality. This favoring of one object in the world over another defines who we are. The ability to make such choices and then deal with the consequences of further choices is a key reason that making art promotes awareness of our priorities and intentions, important ingredients in self-knowledge.

Kivnick and Erikson find that the lawfulness of materials is crucial for children and adolescents who have problems with boundaries, organization, responsibility, and trust. Again, these issues are characteristic of several disabilities that will be mentioned throughout the book. Materials teach the lesson of cause and effect in concrete and unmistakable ways. To be effective with materials, the authors say, the artist must understand and respect their laws and limits and the consequences of transgressing them. Much can be learned from their predictability, an important lesson that can be transferred to the larger, more unpredictable world. In the more unpredictable world, cause and effect is not as clear, and so it is easier to cast off responsibility and take on the role of the victim. In the more dependable world of art, however, the laws of materials can be learned. It is difficult to play the victim when we know that clay will crack in the kiln if it is not dry. The self can be tested in this predictable environment while taking responsibility for the outcome. With trust in one's own perception through the senses in this made-world of art, children will then be better equipped to test themselves in the less predictable world.

Many disabilities create rigidity, stereotypy, and obsessive compulsiveness in children to the extent that they are unable to form original and spontaneous ideas that can be translated into art. That is why

copying and tracing, antithetical in making art with all children, is especially damaging for children with disabilities. Imagination is necessary for play, which is necessary for development. Without imagination many children miss important learning. A flight of imagination is usually more effective than words—that can sound meaningless or misleading—for finding solutions when no precedents are available. "Our culture places great emphasis on the development of verbal skills—in terms of both thinking and communicating—but we pay comparatively little attention to the appropriate integration of the verbal and the nonverbal" (Kivnick & Erikson, 1983, p. 610). The arts might be considered one of society's few sanctioned ways of communicating thought and expression through nonverbal means. Materials speak directly to nonverbal memory, which makes art not a translation of verbal thought but rather its own reality.

> Unlike psychotherapy or traditional art therapy, simply working with materials does not have as a goal the verbalization of hitherto unconscious, nonverbal material. Rather, the goals of working with materials are to master their laws and to learn the necessary techniques, to use them as vehicles for individual expression, in their own terms. In therapy, patients struggle to take symbols apart and to understand them. The arts provide an opportunity to create symbols and to develop them in their own terms, quite apart from verbal understanding. (p. 611)

Concentration and focus are also issues for the neurologically related disabilities, such as ADHD and ASD. The solution is found in helping children create self-organization by finding novel and engaging projects. However, children with ADHD also need well-planned structure so that they do not become overwhelmed with stimuli. Balancing stimulation and structure is important for all children, and particularly for children with ADHD, ASD, and LD who need external structure to learn self-organization skills.

Through controlled expression, as mentioned earlier, children can connect to emotions. The need to communicate and release feelings is profound and affects the viewer just as powerfully. Jackson Pollack shows that brush marks are carriers of the feelings of the artist and become visible to us on the canvas. Because we know Jackson Pollack's story, we are aware that his feelings were often overwhelming. Art making was his way of diffusing and neutralizing potentially destructive feelings in a socially acceptable way. The raw beauty of his paintings

proves that the rules of the medium act as controls with the power to poeticize primitive emotions and instincts (Henley, 1992).

The final result of continued efforts in the arts is a solid sense of mastery. Lowenfeld (1987) also uses the term to describe a realistic perception of oneself. Expectations that are too high are damaging and will leave the fragile ego devalued. A realistic sense of mastery that comes from steady and visible progress does not depend on extrinsic validation. The self can only develop from within with the encouragement and safety of the trusted adult. The feeling of helplessness and hopelessness is a constant specter in the lives of children with disabilities. Adults who underestimate the capacity of children by doing most of the art work for them do them a disservice. Learned helplessness is the result of these so-called good intentions. The goal of the mentor/teacher always needs to be their students' independence.

Self-Motivation

Art making is a therapeutic enterprise only when children connect to their urgent issues. The materials themselves can then become carriers of deeply held feelings. It is not wise for us as mentor/teachers, however, to try to verbally dredge up these feelings for many reasons. First, we are not trained to deal with the trauma that might ensue. On the other hand, the sensual stimulation of art materials evokes these private feelings and, through their transformation, children take charge of when and how much they reveal. The mentor/teacher needs only to create a compelling artistic condition under which these feelings might be channeled (Henley, 1992). The use of metaphorical imagery inherent in art making is most effective in approaching issues in a nonthreatening way. Children may then filter their issues through the formal structure and content of the work, giving their raw emotions aesthetic form. Once they have been given an aesthetic and concrete form, they are fixed in time and space. This externalization of internal feelings helps children take a step back, and with this distance they are equipped with a slightly more philosophical and reflective attitude, removing them from the immediacy of the feeling (Henley, 1992).

Self-motivation is more likely to occur if art making is generated from children rather than their teacher. While not eliminating structure, teachers need to initiate situations that stimulate a process in which children become the agent of their own learning. The philosophy of the Reggio Emilia preschools of Italy is based on—among the

work of many psychologists and educators—the sociocultural perspective of Vygotsky (1986). They suggest that adults need to be present without being intrusive so that children might learn from socialization with their peers. "They must learn to teach nothing to children except what children can learn by themselves" (Malaguzzi, 1996, p. 66). David Henley (1999) simply says let the child teach you.

Reggio Emilia uses flexible objectives to build on ideas that might arise unexpectedly from children. Ideas that diverge from the teacher's objectives might be timely and important for children, and if the endpoint is rigidly conceived, the discoveries they might have made for themselves are diminished. Reggio Emilia educators accomplish a child centered approach by mutually constructing their curriculum with children through long hours of observation and dialogue. Often they begin with town meetings where real conversations, not carefully prepared questions, reveal important interests and become the starting point of extended projects. They often evolve in complexity as more children join in and discuss other possibilities. David Henley (1992) also describes the multifold benefits of the project method. Children can contribute according to their abilities without bringing attention to their limitations. Projects have a variety of parts that can interest a variety of children, and they are inherently social enterprises in which children are invited to conceive the rules and structure. They therefore feel ownership, active agency, and commitment having generated ideas and guided their development. Adults can support with suggestions about which materials would best bring their ideas into reality. Collaborative work has many benefits, but the one that particularly escapes children with disabilities is to balance self-determination with the good of the group.

CHAPTER TWO

Autistic Spectrum Disorders

The Labels

The highly visible autistic spectrum disorders (ASD) have been described in popular media in the past several years as an epidemic. On February 9, 2007, the *New York Times* published the results of the largest national study to date. According to the Centers for Disease Control and Prevention, approximately 560,000 Americans under age 21 have been diagnosed with autism, which means one out of every 150 school-age children.

Until the term "autistic spectrum disorders" was widely used, autism had been neatly divided into two categories: classical autism and Asperger's syndrome (AS). Now it is considered to be a rather large-scoped and complex spectrum. Classical autism was first diagnosed by Leo Kanner in the United States, and his findings were published in 1943. Hans Asperger described a similar disorder in Austria at approximately the same time as Kanner. Both men were unaware, however, of each other's discoveries. Asperger was more optimistic about the disorder, possibly because in the Nazi controlled part of the world children with disabilities were targets along with Jews and Gypsies. Kanner's classical autism has since been considered the lower functioning of the two, characterized by lack of speech, severe isolation, lack of communication, lack of empathy and affect, ritualized behavior, automatic movements (tics, spasms, rocking, spinning, flapping of hands), hyper- or hyposensitivity to stimuli, lack of coordination, mind blindness, inability to play, and in many cases, mental retardation. The percentage of what was believed to be the instances of mental retardation has

also become suspect now that new computerized strategies, such as the often-debated facilitated communication (FC),[1] are enabling nonverbal individuals with ASD to communicate.

The autistic sensory perception of the world is vastly different from "neurologically typicals." From infancy they miss the developmental landmarks that the typical child seamlessly achieves, such as pointing, sitting, walking, and talking. According to Kanner, if a child with autism does not speak by five years of age, it is likely that he has some degree of mental retardation. While most children with autism—who are predominately male—fall into this category, new evidence shows that lack of language does not necessarily predict mental retardation.

Temple Grandin (1995), an unusually high functioning woman with classical autism, taught herself how to live in the alien world of human beings. She has given us much needed inside information about the disorder and describes a particularly baffling characteristic in the following text.

> People with autism sometimes have body boundary problems. They are unable to judge by feel where their body ends and the chair they are sitting on or the object they are holding begins, much like what happens when a person loses a limb but still experiences the feeling of the limb being there. (p. 41)

AS shares many of the same characteristics as classical autism but with less severity. Children with AS can function in society more easily because language is intact, although it is often stilted, formulaic, monotone, and devoid of affect. New labels have been clarified in the *Diagnostic and Statistical Manual of Mental Disorders-Fourth edition* (DSM-IV) as subcategories of the spectrum, such as pervasive developmental disorder not otherwise specified (PDD-NOS), Childhood Disintegrative Disorder (CDD), and Rhett's Disorder. For the sake of clarity and simplicity, I will use the terms ASD, classical autism (interchangeably with autism), AS, and autistic savantism throughout the chapter.

ASD is often described as a triad of disorders: dysfunctions with social interaction, communication, and play (or imagination). Technically, it is a genetically inherited neurological disorder although other possible causes, such as childhood vaccinations and toxic environments, are considered and hotly contested. Notwithstanding the complexity of all the categories within ASD, none is more perplexing than classical autism. The difference between the wiring of the classically autistic and

the so-called normative brain is so vastly different that we behold an "other" form of being. It can bring with it prodigious gifts but equally devastating limitations.

What Do Labels Tell Us?

Judith Bluestone (2005) developed a therapeutic approach called HANDLE that looks beyond the label to the underlying cause of maladaptive behaviors and specific disorders such as autism. As a woman with autism she has overcome numerous neurological disorders, including three serious incidents of encephalitis, grand mal seizures, deafness, and brain injury. Most of us, she says, are looking for a quick fix: make my child like everyone else's. Curious journalists ask her why autism has become an epidemic.

> I can tell you that, sort of, but the other aspect of the why is what I really prefer to answer, which is the purpose—not the cause, but what's the purpose. People of all echelons may worry whether I should trade in my two-year-old BMW for this model or that model, are now worried, "how can I get the help so my child will hold my hand with affection?" What those of us with autism are doing is giving the world a wake-up call.... What is humanity? What is the purpose of our existence? Is it material possessions or is it our connections to one another? We can buy anything except the eye contact and the smile. You can't buy it, you have to earn it. You earn it by being a little afraid, and a little uncertain, and trying and finding out, how do I connect? (May 23, 2008, personal communication)

Grandin (2006a) describes recent brain theories that might explain some of the perplexing questions about autism, particularly why people on the spectrum might be highly skilled in one area and poor in another. Problems begin with the failure of the "computer cables" of the brain to fully connect the many different localized brain systems. Poor communication between "departments" causes the unevenness of skills.

> Instead of growing normally and connecting various parts of the brain together, the autistic frontal cortex has excessive overgrowth much like a thicket of tangled computer cables. In the normal brain, reading a word and speaking a word are processed

in different parts of the brain. Connecting circuits between these two areas makes it possible to simultaneously process information from both of them.... The great variability in autistic/ Asperger symptoms probably depends on which "cables" get connected and which "cables" do not get connected. (2006a update to Chapter 1)

Because autism diverges from what we know about development, it invites us to examine exactly how we as typical members of the species evolved from primates to have all the social and culture-building abilities that so elude autism. Individuals with classical autism are often strangely untouched by their own personal history as well as our shared human culture. According to anthropologists, a mind that can represent itself and externalize memory is the result of an ability to imitate, manipulate, and speak. Only with these distinguished abilities can we inherit the words and ideas from people far away, alive and dead—the prerequisite in establishing culture (Ridley, 2003). Classical autism, however, diverges widely from this culture-acquiring ability.

What the Coevolution of Genes and Culture Tell Us about Classical Autism

A discussion of the human genome and the development of human culture shed light onto how autism has diverged from the cultural history of the human species. No one is more capable of clarifying how the two seemingly opposing forces, nature and nurture, converge than geneticist, Matt Ridley (2003). Within one thousand years of each other, three civilizations appeared independently— Mesopotamia, China, and Mexico—after four billion long years without literate cultures. Ridley asks what happened in the human brain that enabled such a feat, and why so suddenly? What change occurred in the human genome to produce so much social progress? It is not that a few genes coevolved with human culture, Ridley says, but that an adjustment in the human mind was suddenly equipped "with an almost limitless capacity to accumulate and transmit ideas" (p. 208). Although only 2 percent of DNA separates us from a chimpanzee, the human development of culture remains beyond the reach of the highest primate.

Turning an ancestral ape's brain into a human brain plainly took just a handful of minor adjustments to the recipe: all the same ingredients just a little longer in the oven. Yet these minor changes had far-reaching consequences: people have nuclear weapons and money, gods and poetry, philosophy and fire. They got all these things through culture, through their ability to accumulate ideas and inventions generation by generation, transmit them to others, and thereby pool the cognitive resources of many individuals alive and dead. (p. 209)

Chimpanzees have a rudimentary culture equipped with traditions of feeding behaviors—that include the use of fork-like sticks—passed on through social learning, or in other words, imitation. But why, asks Ridley, did they not have a "cultural take-off? Most scientists agree that only human beings understand the *intentions* of others and, therefore, only human beings can engage in cultural learning. Thus, our prodigious ability to empathize and imitate—described as having a theory of mind[2]—makes us distinctly human.

In a landmark discovery by Giacomo Rizzolatti in 1991,the ability to imitate was narrowed down to one part of the brain that represented both action and a vision of action. He believed this "mirror neuron" to be the evolutionary precursor of human evolution because of its ability to mirror neurons during both the observation and imitation of an action (Ridley, 2003). Christian Keysers (as cited in Nash, 2007) suspects that mirror neurons are distributed in the somatosensory cortex that sends messages throughout the skin. The emotional response to these stimulations then sends information to other regions, most notably to the Insula that then integrates sensory and visceral information. Studies are currently underway between scientist, Vittorio Gallese and art historian, David Freedberg that explores the way mirror activity and aesthetic experiences are linked (Nash, 2007). Mirror neurons explain theoretically what we know experientially: that our emotions are embedded in our aesthetic response to materials in an interpenetration of self and world that lays the foundation for aesthetic empathy.

At this juncture genes and culture converge, which Ridley calls, "a neuroscience of culture" (p. 214). A separate set of genes that modify synapses and secrete and absorb neurotransmitters are the devices that transmit the culture from the outside world to the inside of the brain, which is indispensable to culture itself.

Hand, Symbol, and Culture

The dexterity of the hand was not only a factor in development of culture, but might also have been the genesis of language. A new theory suggests that human language began with hand gestures rather than speech. The fact that language, facial expressions, and hand gestures all share the same part of the brain called the Broca's area supports this theory and explains why most of us cannot talk without using our hands. The "hand theory" also explains why a stroke in Broca's area will prohibit speech and arm movement, but not swearing, crying, screaming, cursing, gasping, and other involuntary utterances. The language center in primates, on the other hand, is used for gesture, touch, and facial and tongue movements.

Whether it was by tool making, throwing, or gesture that caused one part of the brain to become adapted for symbolic communication, says Ridley, the hand played the leading role, which suggests that it also played a part in shaping the human brain. Another theory proposes that the distinction between noun and verb that runs deeply in all languages had their roots in the shape and action of hands. "To this day, nouns are found in the temporal lobe, verbs in the frontal lobe across the Sylvian fissure" (p. 220). Their crisscrossing turned symbols and signs into grammatical language.

Although no hard empirical evidence exists for the "hand theory," its beauty is in its poetry by bringing together imitation, hand, and voice, all essential for the transmission of human culture.

> If opera is culture, *La Traviata* is all about the skillful combination of imitation, voice, and dexterity (in the making as well as the playing of musical instruments). What those three brought into being was a system of symbols, so that the mind could represent within itself, and within social discourse and technology, anything from quantum mechanics to the *Mona Lisa* or an automobile. But perhaps more important, they brought the thoughts of other minds together: they externalized memory. They enabled us to acquire far more from our social surroundings than we could ever hope to learn for ourselves. (p. 220)

Ridley's description of a system of symbols that represent self in the world bring to light the foundational difference between the normative and autistic mind. The formula of symbolism is the ability to imitate plus the ability to empathize equals the ability to represent ideas,

people, and events not present (Deacon, as cited in Ridley, 2003). And thus a more complex culture is born. These are the very abilities lacking in classical autism that prohibit the inheritance of culture through social learning, or survival itself. "As soon as human beings had symbolic communication, the cumulative ratchet of culture could begin to turn: more culture demanded bigger brains; bigger brains allowed more culture" (p. 222). The autistic infant cannot speak, cannot point, and cannot understand body language or facial expression. Because we all share the same genes, these abilities are innate. However, genes must be ready to realize their full potential.

Since the discovery of the human genome, we have known that the structure of our brains and genes have not changed substantially from our distant Paleolithic ancestors. Rather, the development of our brain is the result of an accumulation of knowledge made possible by art, literature, and technology (Ridley, 2003). Although Paleolithic humans had the culture gene, only Homo sapiens were able to use it.

> My brain is stuffed with such information (art, literature, and technology), whereas his larger brain is stuffed with much more local and ephemeral knowledge.... It must have been a genetic change, in the banal sense that brains are built by genes and something must have changed the way brains were built. (pp. 228–229)

Ridley brings us closer to understanding where and how the autistic brain is differently wired. Most likely a change in wiring produced symbolic and abstract thinking, the kind of thinking that allows us to disseminate information far and wide, freeing ourselves from context. This ability was to have great beneficial evolutionary effects (Ridley, 2003). We have gained much in the process, but we have also lost much. These dynamic changes in the human brain allowed us to take novelty with stride and, therefore, set the path for the suddenness of social development. However, classical autism remains rooted in the concrete. The inability to effortlessly adapt in the way that was laid out for us 200,000 years ago is what is so bewildering about autism.

The Autistic Brain

Without intensive intervention, the classical autistic brain remains untouched by culture, history, and tradition. The autistic mind does not filter the world through the accumulation of experience, as the

typical mind does every moment of life. Oliver Sacks (1995) says, we *are* our memory; without memory we are lost, as evident in the disorientation of brain injury survivors who have lost long-term memory.

Individuals with classical autism are generally described as tied to concrete interpretations of life. This fact makes them disarmingly pure morally and intellectually; they are free from "the dirty devices of the world" (Sacks, 1995, p. 260). Abstraction separates us from the here and now and, as it is derived from the symbolism of language, allows us to represent among other things, what is not true. Duplicity is unthinkable for the autistic mind. Because individuals with autism live in the concreteness of the present, they are also unable to generalize information and cannot predict how people might behave in a variety of circumstances. Grandin tells us that she studied the human species and then consciously learned to do what we do unconsciously: store our experience in memory, which prepares and teaches us what to expect as we navigate our way through the world. Rather, she experiences the world with unprocessed, uninterpreted, and unrevised images. The autistic affect is not categorically missing, but only in relation to human culture, which includes aesthetic, poetic, and symbolic experience. The refined feelings that come from cognitive reflection and the evaluation of experience is often beyond the scope of individuals with autism. Thus, their greatest limitation is in capturing meaning. Remembering is easy, meaning is not; children with autism do not understand the social conventions we take for granted. Simple hellos and good-byes must be rehearsed, but even after years of rehearsals social conventions usually appear studied and awkward.

According to Dr. Nancy Minshew of Carnegie Mellon, who has worked extensively with Temple Grandin, the autistic's paucity of concrete categorization normally appearing in the first year of life (e.g., distinctions between male and female faces) might significantly contribute to their severe social issues. Lakoff and Johnson (1999) theorize that we have evolved because of our ability to categorize as a result of interacting with the world. "What we call *concepts* are neural structures that allow us to mentally characterize our categories and reason about them" (p. 19). The authors describe the mostly unconscious neural process of categorization.

Our brains each have 100 billion neurons and 100 trillion synaptic connections. It is common in the brain for information to be passed from one dense ensemble of neurons to another via a

relatively sparse set of connections. Whenever this happens, the pattern of activation distributed over the first set of neurons is too great to be represented in a one-to-one manner in the sparse set of connections. Therefore, the sparse set of connections necessarily groups together certain input patterns in mapping them across to the output ensemble. Whenever a neural ensemble provides the same output with different inputs, there is neural categorization. (p. 18)

To be a neural being is to categorize; without this ability we cannot survive. Categories help us to make social judgments about people, often instantaneously based on prior experience in other contexts. Thus, social conventions arise from our biological ability to categorize and generalize experience. How do we account for individuals whose neural wiring diverges in such a way that prohibits categorization?

I find to be true Sacks's belief that the uniqueness of the human spirit deserves biographies rather than case studies. Jessy Clark, Temple Grandin, Stephen Wiltshire, and Nadia are adults with classical autism whose lives have been studied since childhood. They give us insight into the reality of living with autism in a way that theory cannot.

What becomes most apparent about autism is its contradictions. As we will see, the talents of autistic savants can be as prodigious as they are disconnected from their lives. Savants will exhibit the most exaggerated form of pliability and strength in one overdeveloped area, and inflexibility and impoverishment in almost every other. But after approximately thirty years of artistic and social engagement, this prognosis is not true for Stephen Wiltshire. His dynamic life is replete with close relationships with family and patrons. Now in his thirties, he shows us that we cannot predict how savants will or will not be changed over time. Labels, therefore, will not allow us to enter into the dynamic of life nor predict how intervention might transform what appears to be immutable, and we must proceed with this caveat in mind.

Because of the unreliability of labels, Clara Park (1982) did not construct theories about her autistic daughter. Jessy's symptoms were so intricately connected that no single cause was distinguishable. She approached autism through trial and error, which meant living with error, and valuing "pragmatic flexibility" over dogmatism. Eventually, one experiment might unravel the whole ball. Most importantly, she says, therapy begins with acceptance and knowing the child deeply in her own context.[3]

Jessy Park

An infant pointing is commonplace. It is the first sign of her intention-
ality, desire, and relationship between self and world. Jessy's inability
to point was a significant indication for Clara Park (1982) that all was
not right.

> To point is so simple, so spontaneous, so primary an action that
> it seems ridiculous to analyze it. All babies point, do they not?
> To stretch out the arm and the finger is, symbolically and liter-
> ally, to stretch out the self into the world—in order to remark on
> an object, to call it to another's attention, perhaps to want it for
> oneself. From pointing comes the question "What's that?" that
> unlocks the varied world. To point, to reach, to stretch, to grab,
> is to make a relation between oneself and the outside. To need is
> to relate. (p. 6)

Like Grandin, Jessy was blessed with a loving family and particu-
larly a mother who was unwilling to leave her in self-absorbed indif-
ference, tirelessly looking for the spark that would ignite her interest.
She experimented with a myriad of inventive and spontaneous games
that Jessy did not respond to until—as if out of nowhere—six weeks
or six months later. Park describes the patience she needed to parallel
play with Jessy as she endlessly repeated the same games, gestures, or
shapes. Parallel play is a way of interacting with a shy and introverted
child while not intruding on her world. It means to do the same thing
together but apart, giving all the space and latitude she needs. If or
when she does respond, the adult is ready to engage her. Ritualized
repetition is the hallmark of classical autism, also called perseveration
or stereotypy. Repetition prohibits children from meaningful play—
with a purpose or goal in mind—and also functions to satisfy their
hunger for external order. "Blocks were to tower, then to line up
parallel, but never to build a house. Indeed at that time I had no rea-
son to think that Elly [Jessy] knew what a house was, that she knew
what anything was except perhaps the food she ate, and the clothes she
wore" (p. 50).

Park documented in her journal each intervention as it occurred.
Some were successful, but just as importantly, some were not. If the
child will not come to you, then you must go to him. If the child will
not do what you do, then you must do what he does. In a stroke of

genius, Park tells the reader that if Jessy would not learn from imitation, she would imitate Jessy.

> I had been doing this about four months when one day Elly happened to make five little sounds, ending with a rising intonation—ah-ah-ah-ah-AH! That was easy to imitate, and I did so. But this time, unlike all the others, Elly imitated me again. I imitated her back. She laughed. I tried two more sounds, choosing the explosive ba-ba and la-la she had learned from Joann and never forgotten. She imitated them at once. I then risked all and said "eye," the word she'd learned so well and then abandoned. She repeated that too, full of gaiety and amusement. (p. 101)

In *The Siege*, Park begins with the sense of touch to describe Jessy's development because of its immediacy and primacy to life. Compared with touch, she writes, hearing and seeing are less central to survival. If Jessy could not or would not see or hear her mother, she did, nevertheless, respond to her touch. "She could inhibit her senses, but she could not entirely deny she had a body. . . . It was in her motion, in fact, that the discrepancy between what she did and what she gave flashes of being able to do first showed" (p. 43). Each new discovery went nowhere, however, ending in sterile perseveration and then eventually disappearing out of boredom. She could not build on what she learned by generalizing knowledge in new contexts. Nor did she have the motivation, reason, or desire to do so—the prerequisite for growth and learning. "What did Elly want enough to meet any conditions for getting it? Not a cookie, not a toy, not a ride in the car . . . When a creature is without desires the outside world has no lever by which to tempt it into motion" (p. 45).

Researchers describe autistic mind blindness as seeing with the retina without registering meaning. Under normal circumstances, our brain works in cooperation with our eyes to give shape to the world. We know that most of what we see is processed through the visual cortex, which means that what we see is a memory of what we have seen before, or our brain's interpretation. We make meaning from these interpretations of what we see by forming visual concepts and categories, all of which are not possible in autism. According to Grandin, the autistic brain sees unfiltered details rather than the concept of wholes, which is why categories of things cannot be formed. When Grandin hears the word "steeple," she conjures in her mind a specific steeple

from a file of visual memories. She has no generic mind symbol for a steeple, and each memory she retrieves from her mental file is unique. No *kinds* of things exist, only the thing itself. When Grandin famously says that she thinks in pictures she means that for her, mental categories do not exist.

But what exactly do individuals with autism see? A visual order exists but quite differently from neurologically typical order. Most likely because they see details rather than coherence, they see *more* of the world.[4] Jessy ignored many things, especially people, but colors and abstract shapes intrigued her. She lived in an impressionistic world without the continuity and solidity of form.

Words, Pictures, and Music

Park had a revelation while Jessy looked at a picture of an ice cream cone in her brother's Kindergarten workbooks. She took Jessy's hand and patted it. The next time she encountered the picture rather than mechanically flipping the page, she showed a sign of recognition. Park then used Jessy's fingers to walk up and down a picture of a slide along with the appropriate sounds. She had her fingers ride the seesaws and swings. "She was asking me to do for her what she could not yet do for herself. She wanted me to make her see" (p. 62). Within a year they were communicating through pictures, and soon Jessy was asking her mother to pat the picture for her. Park had discovered a system now used in autistic classrooms called Picture Exchange Communication System (PECS) that enables children to communicate their needs.

Park used magazine images to "talk" to Jessy but later realized that the process of drawing images with her required time to develop and therefore was more powerful than the ready-made product. "A picture that someone is drawing focuses the attention by the very gradualness with which it takes form. The process is dramatic, it involves suspense. The head first, then arms, body, eyes, nose, mouth" (p. 65). She discovered that chalk and blackboard had their own advantages. Jessy liked the immediacy and erasure of her drawings because it satisfied her need for transience. The small acetate boards that can be pressed on and then erased have been used successfully with children with autism for these reasons. Carol Gray authored several short books about writing and drawing with children with autism in which she discusses the advantages, and also disadvantages of using this tool. The inability to erase

is the single disadvantage of an otherwise smooth visual conversation. But erasable material cannot be stored for future reference. Children need to erase and also have lasting images.

Jessy had speech, but she had not yet fully acquired language. In Jessy's case speech meant the uttering of sounds, often meaningless to others except her mother. Like all her landmark accomplishments, the acquisition of words also came and went. When recognition of words did last, it was often because the word was combined with body language and understood through bodily association.

Then Jessy discovered music. Children with autism respond to the repetitive notes in music and a few sing long before they speak. According to Grandin (2005) who could hum Bach at two years old, the only meaning that spoken language has for people with autism is in tone. Music is also the only nonvisual language that she did not need to translate into pictures, possibly because it is a rudimentary language predating human beings and understood by us at a nonverbal level. Perhaps more intensely than the other arts, music's rhythm and order is soothing and satisfying. Many autistic classrooms use music as background or for specific situations, such as making smoother transitions from one activity to the next.

Jessy learned how to use a 45-r.p.m record player by herself because it was "important." The Parks invented songs for every situation: riding in a car, going for a walk, and by four years old, she was connecting songs with images. For the song "Ring around a Rosy" Jessy found a picture of children in a ring, a garland of flowers, and an unadorned circle. The song became a *symbol* for "circle" and all the ideas associated with it. Soon the song, "Happy Birthday" equaled cake, and "Rockaby Baby" translated into rocking motion. She sang not for pleasure or musicality, but for the function it served.

Play, Symbols, and Representation

Because Park was so in tune with Jessy, she found the one thing that felt to her like her own body; her crib was her safety zone. "The crib was no toy to Elly. It was not a representation of the business of life, but part of it. She played a little more with the doll clothes, then once more put her foot into the little crib" (p. 98). At the root of her confusion between the toy representation of reality and reality itself lay her craving for enclosure. For the first time she put her doll to bed and, later to her mother's astonishment, tucked her brother in. Because of this

rudimentary play, several weeks later when turning four, Jessy drew her first representation of a human being.

> I made a circle and gave the crayon to Elly. With faint yet certain strokes she put four marks inside it: eyes, nose, mouth. Casually yet unmistakably she made a body and scratched in arms and legs. Elly, whose eyes six months before could not see pictures, whose hands had been too weak to press down a crayon, had drawn, not a triangle or an E, but a human being. (p. 104)

For the following four years Jessy was initiated into verbal language. However, learning sound formation, meaning, and the social relevancy of words eluded her until she was eight-years-old. The words she favored were abstract rather than relational, and absolute rather than relative. The rigidity, isolation, and lack of affect of autism were the causes of her preference, as was her inability to learn proper names for several more years. Park realized that it was up to her to reach Jessy, which meant speaking in a language without syntax and sequence. In short, it was the language of a child of two, a phase that transforms into intelligible language through continuous integration with the world. Speaking in Jessy's language did not accelerate speech, but it did accelerate her comprehension. Still, each new word she learned was embedded in context, and it was not until adolescence that she began to generalize language.

By her early twenties, Jessy still spoke English as if a stranger in a foreign country, lying somewhere in the middle of the spectrum of autistic talkers and nontalkers. 50 percent of children with autism never develop speech. Many high functioning children like Jessy eventually develop greater complexity of language, although possibly without increasing comprehension of social meaning. Information that most of us process out as irrelevant while selecting what is meaningful is exactly what Jessy takes in, and finds the rest irrelevant.[5]

High School

In high school Park found that a form of behavior modification, now known as Applied Behavioral Analysis (ABA), augmented Jessy's socialization skills. The strategy breaks down a task so that success is

attainable and reinforced with rewards. This method appears to work to some degree with autism, although suspect with other disabilities. Experts like Judith Bluestone (2008), however, oppose ABA as a trade off that downsizes the psyche in exchange for results. The conflict stems from the behaviorist view of *doing* as the measure of success, and rewards as the acknowledgment of success. Although posing an ethical dilemma for all children, many educators will nevertheless point to the efficacy of the strategy to justify its use for the most vulnerable or unmanageable children. For Jessy, behavior modification became a substitute for a sense of purpose. But it is not the only way to break through autism's wall of isolation. Park herself says that some behaviors need coaxing rather than programming. Simplified theories and strategies cannot resolve the unexplainable when a child's very experience is unknown.

Although nine years of high school art had been written into Jessy's Individualized Education Plan (IEP),[6] it was only after leaving high school that she found her voice, giving her a visual language for her obsession of mechanical objects and architecture. Her perseverations were transformed into a series of repetitive paintings of themes with variation. Park calls Jessy's work typically autistic for many reasons. She uses the word "camera" to describe how her eyes work, a metaphor also used to describe Stephen Wiltshire and Nadia's ability to scan three dimensional reality and translate it into two dimensional drawings. Like Stephen and Nadia, Jessy drew in perspective before she was eight. Since nursery school she has rarely used shading, blending, or overlapping of color. "Autistic literalism has its visual equivalent. . . . No shading. No nuance. Like her speech. Like her simplified comprehension of what people say, of their expressions, their emotions and needs" (p. 130). This is not to say that all autistic art looks like Jessy's, but whatever the nature of one's obsessions, it will appear in the artwork. Nevertheless, strong commonalities exist among artists with autism, such as drawing from their prodigious memory rather than drawing from life. Architecture and objects are preferred along with unusual viewpoints that the artist could not have occupied (see figure 2.1). Subject matter is usually drawn from obsessions with arcane objects, such as Jessy's electric blanket dials. Nevertheless, making art is only one of the many things Jessy does, and Park wonders if she would continue making art if it were not for the checks that keep coming in. She is content to be an artist, but it does not have special meaning.

Figure 2.1 Jessica Park. 1997. Title: St. Paul's and St. Andrew's Methodist Church and the Migraine Type Lightening and the Elves. Acrylic on paper. 22.75 × 28.5 in.*

* Jessy's description from http://www.jessicapark.com/church.html

"This is St. Paul's and St. Andrew's Methodist Church on 86th Street and West End Avenue of Manhattan. The sky has five layers of blue. The glowing doughnuts all over the sky are elves. Elves are leftover from the night before. I painted the night before, in a painting of the Con Ed building. In that painting the sky had the jellyfish-shaped blob, sprites and jets. In this painting it is the morning after and there are only elves. You

Temple Grandin

In 1986, a quite extraordinary, unprecedented and, in a way, unthinkable book was published, Temple Grandin's Emergence: Labeled Autistic. Unprecedented because there had never before been an "inside narrative" of autism; unthinkable because it had been medical dogma for forty years or more that there was no "inside," no inner life, in the autistic...extraordinary because of its extreme (and strange) directness and clarity. Temple Grandin's voice came from a place which had never had a voice...and she spoke not only for herself, but for thousands of other, often highly gifted, autistic adults in our midst. (Sacks, in Grandin, 1995, p. 11)

Grandin's onset of autism in early childhood reads typically: the subtle rejection of her mother beginning at six months followed at ten months by fight-flight behavior. Grandin remembers the excruciating pain of her heightened senses, "she speaks of her ears, at the age of two or three, as helpless microphones, transmitting everything, irrespective of relevance, at full, overwhelming volume" (Sacks, 1995, p. 254). Her other senses were just as sensitive, and the frustrations of unexplainable impulses and her inability to adjust to her environment left her in helpless, violent, rages. As a speechless child, she was sent to a nursery school for disturbed children where she received speech therapy. The speech therapist rescued her from chaos and the abyss by giving her the anchor of language through which she might stabilize her hyper- and hyposensory sensitivity. Nevertheless, language did not provide entry into what she thought was a magical transmission of understanding between friends. "Something was going on between the other kids, something swift, subtle, constantly changing—an exchange of meanings, a negotiation, a swiftness of understanding so remarkable that

Figure 2.1 *Continued*

can read about sprites, jets and elves in the article from Science News on the back of this description. The three very pale lavender mint and yellow zigzagging objects are lightning. They look white but they are three different pastels. I made up this kind of lightning because I see them when I have migreine [*sic*]. The third and forth [*sic*] layers of the sky, counting up from the bottom, are wider than the night before, in the other painting. That night there was a band of cloud, but it disappeared in this painting.

This church is old. There are many broken pieces, dented metal and broken window panes. If you look at the outer border of round windows, you can see the broken area in two places. There are also some broken pieces in the scallop section below the windows in the tower. There is a missing face above the center window. If you look further up, you can see five red faces. This is the second version of the Church of St. Paul and St. Andrew. The first version has a cloudy sky and different colors."

sometimes she wondered if they were all telepathic" (p. 272). Social language still remains mysterious to her. She has found her calling in the language of science: clear, concrete, direct, explicit.

All the more miraculous, then, is Grandin's remaking of herself through sheer will-power. Oliver Sacks visited Grandin at Colorado State University where she was an assistant professor in the Animal Sciences Department and about who he wrote so sensitively in *An Anthropologist on Mars*. She struck him from the start as "someone who had learned, roughly, 'how to behave' in such situations without having much personal perception of how other people felt—the nuances, the social subtleties, involved" (p. 257).

By trade Grandin is North America's foremost cattle handler. One third of the cattle and hogs in the United States are handled with equipment she has designed. She is also an ever-present advocate for autism. Grandin has been asked on many occasions if she would choose not to be autistic or support a cure for autism. She says unequivocally she would not because autism makes the world richer. Because of her intelligence, will, and supportive family, she has done what is considered impossible: not only to integrate herself into the nonautistic world, but also to make enduring contributions.

The question always arises why she was not labeled with AS. The reason is that language did not develop naturally for her.

> Words are like a second language to me.... When I read, I translate written words into color movies or I simply store a photo of the written page to be read later. When I retrieve the material, I see a photocopy of the page in my imagination. I can then read it like a Teleprompter. (Grandin, 1995, p. 1)

She was well into childhood when she learned speech, and to understand others she must mechanically translate the pictures in her mind into words. She explained how she accomplishes this unimaginable task.

> I don't have the ability to process abstract thought the way that you do. Here's how my brain works: It's like the search engine Google for images. If you say the word "love" to me, I'll surf the Internet inside my brain. Then, a series of images pops into my head. What I'll see, for example, is a picture of a mother horse with a foal, or I think of "Herbie the Lovebug," scenes from the movie *Love Story* or the Beatles song, "Love, love, love..." (Grandin, 2006b)

To this day Grandin finds certain verb conjugations, such as "to be," meaningless (Sacks, 1995). Nouns are easier to learn because they directly relate to pictures. She and other high functioning people with autism were able to learn how to read with phonics, but lower-functioning children learn language better through association with concrete aides. This is particularly true for abstract verbs that are visually untranslatable. Teachers have more success when words are aided by labels attached to objects or spelled out with tactile plastic letters.

The inability to deviate from routine is a characteristic of low functioning autism that leads to extremely limited lives. Grandin, on the other hand, can vary her routine by modifying her stored visual images with the aid of new experiences, helping her to construct broader visual memories. She has built a library of experiences that she pulls as reference in new situations. Rather than moving from the generic to the specific, as most brains typically do, she records the specific "video-like" thoughts and then generalizes them into concepts in a nonlinear, nonsequential, associative way. All this she does consciously and deliberately while the rest of us who are neurologically typical are primed to do the job mechanically and unconsciously.

> For example, my concept of dogs is inextricably linked to every dog I've ever known. It's as if I have a card catalog of dogs I have seen, complete with pictures, which continually grows as I add more examples to my video library. If I think about Great Danes, the first memory that pops into my head is Dansk, the Great Dane owned by the headmaster at my high school. The next Great Dane I visualize is Helga, who was Dansk's replacement. The next is my aunt's dog in Arizona, and my final image comes from an advertisement for Fitwell seat covers that featured that kind of dog. My memories usually appear in my imagination in strict chronological order, and the images I visualize are always specific. There is no generic, generalized Great Dane. (Grandin, 1995, p. 28)

According to Grandin, people with autism are difficult to understand because they make meaning via obscure visual associations. "For example, an autistic child might say the word 'dog' when he wants to go outside. The word 'dog' is associated with going outside" (p. 32). For Jessy Park, "partly heard song" meant "I don't know." Bluestone uses the following example to describe how she experiences reality.

Somebody just washed a sweater and it's hanging somewhere out-side. A dog may be barking, and that sweater suddenly becomes the dog, because you're picking that sound up peripherally and the sense of smell is overriding it. You hear the dog barking and then that thing that smells like wet fur becomes the dog. (personal communication, May 23, 2008)

Quantum physics helps Bluestone explain this phenomenon. For neurological typicals, objects and particles come together and take on a unity. The senses also work in unity, and at times some will be overpowering and shut down, while others are compelling and turned up. But the mind's job is to integrate information coming in (other than smell which is processed separately) and send it to the various parts of the brain.

The Cattle Handler

According to Grandin, her ability to think in precision-like pictures enabled her to become an invaluable consultant in the cattle industry. She knows cattle from their point of view because she understands how they think more accurately than she does the human species. Like Grandin, animals think in pictures and are sensitive to stimuli that go unnoticed by the rest of us. A clanging chain, a flickering light, or a shadow unsettles cattle the same way it might unsettle her. The ranchers find her simple solutions to what they think intractable problems mind boggling.

Before the vat was built, I tested the entrance design many times in my imagination. Many of the cowboys at the feedlot were skeptical and did not believe my design would work. After it was constructed, they modified it behind my back, because they were sure it was wrong. A metal sheet was installed over the non slip ramp, converting it back to an old-fashioned slide entrance. The first day they used it, two cattle drowned because they panicked and flipped over backward. When I saw the metal sheet, I made the cowboys take it out. They were flabbergasted when they saw that the ramp now worked perfectly. Each calf stepped out over the steep drop-off and quietly plopped into the water. I fondly refer to this design as "cattle walking on water." (1995, p. 23)

Grandin's ability to record camera-like reality enabled her to draw blueprints for her groundbreaking livestock handling systems simply by observing a draftsman at work.

She describes the images she sees in her mind as far beyond the most sophisticated computerized special effects programs, with each component, view and perspective of the three dimensional model visible. Once complete, she can mentally run a video of the plant in operation.

More profound than these skills, however, is Grandin's capacity to appreciate the significance of her contribution to life and her responsibility in it. At the end of his visit, Sacks shares an intimate moment with her. Defying what we believe as the aloofness of autism, she shared with Sacks the core of her existence—her thoughts about immortality and death and the need to leave her mark on the world.

Stephen Wiltshire

Oliver Sacks (1995) writes about the autistic savant Stephen Wiltshire in his typically compassionate style, but as usual he leaves us with more questions than answers, particularly about the much debated merits of the art of autistic savants and under which category it should be filed. Occasionally people with autism and their families share misgivings about Sack's analysis. Given the nature of classical autism, the traditional forms of communication that "normals" use as the means of their observations and to which individuals with autism do not conform, ultimately mislead us into making unfounded judgments. However formidable Sack's skills, his knowledge of Wiltshire remains limited in making a definitive assessment of his gifts or his limitations.

Autistic savantism is described as a hypertrophy of a single mental faculty. Unlike "normal" talent, the talent of a savant has an autonomous quality appearing to be fully formed rather than developing gradually with experience. These talents often do not occupy the whole of the savant's attention, nor seem to have a personal or cultural connection within the individual. According to Sacks (1995) the artistic, calendrical, and calculating savants all have genuine intelligence but are confined to a specific cognitive domain. They provide us with the strongest evidence for a modular theory of the mind. Howard Gardner's theory of multiple intelligences suggests that intelligence can come from modular or discrete areas of the brain, each autonomous and possibly in exclusion of others. This theory has helped, somewhat, to normalize such talents as Wiltshire's, making

its isolation and prodigiousness a matter of degree rather than of kind. As a reminder that theory does not accurately predict human potential, Wiltshire's sister Annette suggests that like everyone else, Stephen inherited his gifts from his parents. "We come from a creative family—it's in our genes" (A. Wiltshire, personal communication, September 26, 2008).

> As a small family our time was used constructively: play time, homework time, shopping time, church and our own responsibilities such as cleaning our room, and preparing the dinner table. As a family we did not have much so being creative was almost a must without realizing it. On my father's side of the family, engineering and math were and still are very strong. Mother was a seamstress and at a young age I learned to patch, crochet, knit, mend clothes, make clothes and rag dolls, and so on. (A. Wiltshire, personal communication, October 2, 2008)

Annette observes that theories about autism are riddled with contradiction, its dynamism often overlooked by "experts." One must live day to day, says Annette, to see "the subtle or vast changes in behavior. You need to eat, breathe, laugh, cry, sleep and experience life with these unique individuals" (A. Wiltshire, personal communication, October 2, 2008).

Wiltshire exhibited all the delayed developmental landmarks by two years of age: sitting, standing, hand control, pointing, walking, resistance to being held, and bonding with caregivers. His father was the first to notice. But when the family sought help from doctors they were assured that he was just slow in reaching the milestones, an unfortunate misdiagnosis told to parents thirty years ago.

> In spite of all this we learned to be grateful for whatever little we had, and especially after the death of our father in 1976 we became closer as we only had each other. Learning to understand Stephen's behavior was certainly a challenge and by no means easy. But in time we had a code that only the family understood, and this made communication and understanding each other's emotions a lot easier to deal with. Both my mother and I can translate Stephen's behavioral patterns straight away which enable us to distinguish his anxiety and agitations without the sound of verbal words. Sometimes silence can say so much. (A. Wiltshire, personal communication, October 2, 2008)

The death of Wiltshire's father affected him profoundly, just as a death in the family affected Nadia and artist, Jonathan Lerman. Usually talent subsides or emerges as a result, evidence that children with autism have deep emotion. In Lerman's case evidence of his grief emerged with his drawings. He defies the expectations we have for autism with his uncharacteristic passion for showing the human form, almost exclusively the face, in all its emotional states. His drawings are replete with charcoal smudges, the polar opposite of what is generalized as autistic savant art.

Stephen Wiltshire also defies the prognosis usually appointed to autistic savantism. While he lives with his mother he remains independent, attending college at City and Guilds in London, traveling and socializing. Although he is tentative socially, he will initiate interaction when his interest is aroused. Not surprisingly, as we hear more vivid descriptions from family members who know autism intimately, the more we recognize ourselves. Annette often thinks that all of us have some form of autism, however negligible it might be. For example, we might prefer our own company "because socializing can be difficult, so we find other comforts, such as art and reading." Small talk is of no interest to her and she would "much prefer to use that time being constructive in some other way" (A. Wiltshire, personal communication, October 2, 2008).

True to savantism, Wiltshire's gifts are like no other's, having shown spectacular accomplishments by five years old when an insightful teacher at Queensmill School taught him to read and write by using architectural landmarks as an alphabet game on field trips through London (e.g., A for Albert Hall, etc.). Wiltshire simultaneously found his passion as well as companionship. His well-known gift for internalizing architecture and translating it into drawings with almost blueprint-like accuracy began with those games. Later on his literary agent, Margaret Hewson, helped him to grasp the context of the landmarks he loved by reviewing such styles as Gothic and Classical architecture.

By eight years old Stephen was able to grasp, retain, and reproduce complex visual, auditory, motor, and verbal patterns. He had an innate understanding of perspective and other drawing techniques, none of which he had been taught. He was able, like Grandin, to hold visual detail in his mind and reproduce it later in photographically accurate drawings of buildings. A scholarship took him to Venice to study architecture, changing his work dramatically with his new use of paint and charcoal. His interests were not limited to architecture because by then he was absorbing everything.

There have been many discussions as to why Stephen likes build-ings so much and the best description is Stephen's: "It's because it always stays the same." So to elaborate, buildings are reliable. Ten, twenty, thirty years from now he knows that he can look back and there have been no changes. This comforts Stephen but he is also excited about the challenge of something new and modern being built, or if there is a demolition of old office blocks, he has already done his research of new developments and what will take its place. (A. Wiltshire, personal communication, October 2, 2008)

Wiltshire's visual acuity was noticed at the age of three with his sud-den interest in visual shapes and images, particularly animals and air-planes. Unlike Jessy Park and Nadia, people held an interest for him. By thirteen he became a well-known artist in London, and now, twenty years later, he has had a profound influence on his family and friends.

The Troublesome Categories of Art

> Art and world arise together in the energy of a moving, prescient line.
>
> —Rexer, 2002, p. 12

Art, as we know it, is made by intentional individuals whose experi-ences are the material and source of their art making. It is believed that savants do not think in symbols nor have they made constructs of the world that are then deconstructed by them. A global sense of self that "shines through whatever particular talents there are" is missing from the savant (Sacks, 1995, p. 226). This impairment is sometimes called an impairment of the abstract attitude, which is the inability to fil-ter from the world the symbolic, conceptual meaning of things. This impairment also causes a lack of meaning in social and cultural life because what is found cannot be used in any way other than in its own context, forever freezing possible meaning in time and space.

What does Wiltshire bring other than his impressive skill? Sacks asks this question based on Wiltshire's work as a thirteen-year-old. He sug-gests that the skill of faithful, unmitigated, reproduction is itself valu-able as art. Perhaps the art that the autistic savant produces is as close as we have to an objective representation of the external world. Sacks calls Wiltshire a genius of concrete representation. This does not mean, as Annette attests, that his work is devoid of meaning. "I agree his con-crete representation is remarkable. However, it does not stop there and

seems unfair to limit his skills as there is much more to Stephen that I am continuously learning about to this present day" (A. Wiltshire, personal communication, October 2, 2008).

The literalness of the work of autistic savants might cause the viewer to ask whether it is art as we know it or autistic mechanical perseveration. Lyle Rexer (2002) asks, "'Can there be art without an artist?' The answer is no. Where there is art, there must be an artist. But what makes an artist?" (pp. 10–11). If art requires an "I," then does the psychologist or art historian decide where the limits lie? Lerman's drawings remind Rexer that the self that communicates through art can exist in degrees of cohesion. Should art require the affirmation of a self or need "only to exist as the ordered product of an intention?" (p. 13). Sacks (1995) noted Wiltshire's intentionality in his deliberate choices to select, remove, and revise what he saw. Rather than the automatic quality of savantism described earlier, his work shows evidence that he brings humor and intelligence to his work.

All these questions, however, are raised and can never entirely be answered. Sacks suggests that the faithful representation of the world without human affect is a valuable art form. Even so, Wiltshire's drawings while accurate, are not photocopies. There is now a private body of his work, neither published nor on his Web site, that diverges from what we know. They are of people and daily events, and occasionally imaginary girlfriends.

In the end, a discussion of his work might not be possible if we adhere to traditional definitions of art. Wiltshire considers himself an artist in his own right, as do others. He is also a high functioning autistic. Annette asks, who has the right to judge if our way of living with all our worries and problems is better? The arguments become moot as the viewer is overcome with awe while looking at his drawings. The artwork of savants asks us to see with different eyes and speak with a different vocabulary—to meet them at least half way.

Nadia

Nadia is the subject of one of the first case studies about an autistic savant and recorded in *Nadia; A Case of Extraordinary Drawing Ability in an Autistic Child,* by Lorna Selfe (1977). Like Jessy, and so many other children on the autistic spectrum, the disorder was recognized when she was approximately two years old. By her sixth year, she was able to speak only a few words and unable to communicate with gesture or pretend play. But she was able to draw with astonishing ability.

Unlike music, the only prodigies that exist in the visual arts are autistic savants. Mozart composed the music of a highly sophisticated and talented adult at three years old while Picasso's drawings at the same age were typical of a talented child but, nevertheless, a child's drawings. Nadia, on the other hand, rendered foreshortened figures and objects and used perspective with an un-childlike sensitivity and skill, skipping over the developmental artistic stages of childhood. One theory that explains this phenomenon is that Nadia, like other autistic children, did not see visual concepts. Rather, she saw detail with exquisite precision but without its surrounding context. Her ability to see parts rather than wholes enabled her to draw what she *saw* rather than what she *knew*. "Normal" children of her age have learned to categorize and classify. Their first drawings are *concrete* categories of things: generic people, animals, and objects that later lead to *abstract* categories; for example, the concept of *bigness* within which concrete categories of people, animals, and objects can be filed.[7] The people and things of children's early representations are at first rather general categories. As we saw, categorization and classification is the necessary learning of children so that they may make distinctions between male and female, big and small, and so on. Almost universally, children begin with an enclosure to describe the body of a person, animal, or object and radiating lines to suggest limbs or parts.

First attempts at representation are not what typical children *see*, but rather symbols of what they *experience,* having been trained by experience to see in visual concepts. Nadia, on the other hand, has never gone through this development, and she sees only what the retina itself sees without the influence of the categorical and rational mind. She sees with her sense of sight alone, unfiltered and unchanged by the brain. Nicholas Humphrey (2002) cites Selfe's explanation of this phenomenon: "Thus it was discovered that although Nadia could match items with the same perceptual quality, she failed to match items in the same conceptual class" (p. 144). Selfe (1977), who studied other autistic savants with similar graphic ability as Nadia, explains that visual imagery is more accessible for them because they lack the "naming" properties generally used in children's drawings.

Again, it is difficult for us who see with different eyes to understand how a three-year-old savant perceives the world. Grandin (2005) describes the way "normal people see" as "*abstractified*" (p. 26), which she learns to accept as she deals with her co-workers in the meatpacking industry. The problem lies not only in abstract thinking, but also in abstract seeing and hearing. With autism, the devil is in the details.

The job of the human neocortex is to tie things together that remain separate in the animal brain. The categories that animals make cannot merge and overlap the way they do in the human brain; thus, they do not experience mixed emotions. Another example of our difference is in our ability to generalize, which is dependant on the associative power of the neocortex. " I think many or even most autistic people experience the world a lot the way animals experience the world: as a swirling mass of tiny details. We're seeing, hearing, and feeling all the things no one else can" (Grandin, 2005, p. 67).

The ability to see the way that Selfe and Grandin describe does not automatically make one a savant. However, a lack of speech, Selfe originally theorized, is necessary for savantism to take place for the same reasons mentioned earlier. The phenomenon of verbal overshadowing[8] reveals that language dilutes visual memory. In fact, as Nadia began to learn language later in childhood, her drawings interested her less, and with it her breathtaking ability. The death of her mother certainly played a role in the shifting of her communicative abilities and the loss of interest in drawing.

In a later essay Selfe (1995) reconsiders Nadia, at that time in her twenties and living in a residential home for adults with severe learning disabilities. With this longitudinal study she has come to the conclusion that a lack of language and the inability to symbolize and conceptualize alone cannot be the cause for artistic savantism, as Stephen Wiltshire also proves. While Nadia's skills waned as she used language, Wiltshire's skills developed. Selfe theorizes that Savantism is a subgroup with its own constellation of gifts and deficits that might set it apart from autism. Furthermore, no other savant, including Wiltshire, produced the adult-like work of Nadia's at three years old that Selfe believes makes Nadia a case apart from the subgroup. The reasons for the skills that united savants in this subgroup remained a mystery for her. One quality of this subgroup that is striking for its metaphorical and poetic connotations is the ability to represent the world from one viewpoint, the "lone viewer surveying a scene from one fixed spot" (p. 223), an ability that children do not usually acquire until adolescence.

Savantism and the Lascaux Caves

Nicholas Humphrey (2002) offers an intriguing hypothesis that the mind that created the naturalistic cave drawings of Chauvet and Lascaux was similar to Nadia's. Humphrey plays devil's advocate to the popular

theory that ice age art is an example of human conceptual and symbolic thought that is evidence of language. He suggests that the drawings do not prove that they were made by people with either symbolic thought or language. If Humphrey's theory is correct, then ice age art would shed light on the artwork of an untrained prodigy. Possibly like Nadia, ice age artists were not drawing images to represent a concept of "lion," but rather "living animals faithfully reproduced" (Clottes, as cited in Humphrey, 2002, p.134). Grandin (1995), who unlocked the mystery of visual thinking, explains that language is not necessary to accomplish highly sophisticated representational images:

> Some renowned scientist calculated that humans had to develop language before they could develop tools. I thought this was ridiculous.... When I invent things, I do not use language. Some other people think in vividly detailed pictures, but most think in a combination of words and vague, generalized pictures. (p. 27)

Humphrey puts the work of Nadia and the Lascaux artists side by side, and they are indeed strikingly similar. Like Nadia, the drawings on the cave walls are often superimposed upon each other and give them a haphazard appearance. Humphrey suggests that in premodern nonsymbolic minds, the details trumped the wholes, and the whole of the animal was lost in the rendering of its parts, which Uta Frith (1995) calls weak central coherence. With Nadia, we know that the superimposition was not an intentional stylistic technique. Selfe (1977) observed how she began from an arbitrary place on the page and, just as arbitrarily, began another drawing on top of it. Humphrey suggests that this lack of intentionality might be the case of the cave art as well. Selfe also describes Nadia as sometimes using the line of the original drawing as the starting point for the next. This kind of drawing would often produce her composite animals, for example, the body of a giraffe and the head of a donkey.

Scientist Steven Mithen (1998) suggests that after Homo sapiens separated from primates, communication was used for social purposes alone. Although the brain of early human was equipped with both social and technical intelligence, the linguistic module of the brain was only available to the module of social intelligence. Thus, language was used only to "talk" about interpersonal concerns. Mithen's timing, however, does not support Humphrey's theory, for he believed that the integration of brain modules occurred 50,000 years ago, long before the drawings of the Lascaux caves that date approximately 30,000 years ago. Humphrey

hypothesizes that if this integration occurred only 20,000 years ago it becomes a compelling reason why the animals on the cave walls—for which there were no names—were naturalistic while human figures were symbolic, child-like stick figures. Nadia had no names for anything with a particular disinterest in people. Following this logic, her figures would be, like everything else, skillfully drawn.

Selfe (1995) writes about an experiment by Bremer and Moore in 1984 who asked young children to draw a coffee mug with its handle out of sight. The first group of children were asked to name the object before they drew it and the second group after they had drawn it. Almost all the children in the first group drew mugs with handles, while most of the children in the second group did not. Naming appears to inspire canonical drawings, and its absence inspires more view-specific drawings. In another experiment, the researchers produced from young children between four and seven, line drawings in accurate perspective when presented only as lines out of context. When they were asked to draw the same lines, but this time told that the lines represented part of a table, they drew representations that were dramatically different from the first drawings and were typical of children their age.

With another compelling argument, Humphrey asks what happened to the tradition of cave paintings at the end of the ice age. The art that followed was the highly stylistic and symbolic art of Egypt and Mesopotamia (except, Humphrey says, the Greek vase paintings that, while realistic, do not have the fresh, unstudied naturalism of cave art). "Indeed nothing to equal the naturalism of cave art was seen again in Europe until the Italian Renaissance, when life-like perspective drawing was reinvented, but now as literally an "art" that had to be learned through long professional apprenticeship" (pp. 150–151). Perhaps this theory is too neat to be true. We might never know. However, it gives us a context within which to understand the savant mind.

Asperger's Syndrome

Two Brilliant Men

The contribution of the Austrian Pediatrician Hans Asperger was lost for some time after World War II. German psychology was not as welcome in North America as it had been before the war. In the 1970s his research was rediscovered by Lorna Wing who suspected that the disorder that Asperger had identified in 1944 was in fact on the

same spectrum as Kanner's autism. AS was finally recognized by the American Psychiatric Association (APA) in 1994.

AS lies on the higher end of the autistic spectrum, and children often learn later as adults to integrate themselves into society. In fact, many of our computer technicians, musicians, mathematicians, and scientists have the syndrome, with Albert Einstein among them. The primarily male (approximately 90 percent) child with AS is known for his incessant talk about arcane subjects. Their knowledge of these subjects is prodigious, but until adulthood individuals with AS often have little effect on the world. It is the self-absorbed knowledge of classical autism but with meaning attached. In childhood their attachment to the experiences of the human world is tenuous, but in adulthood they understand who they are, form intimate relationships, and find a way to contribute their talents to the world.

These circumstances are certainly true for the young savant Daniel Tammet (2006) who wrote the memoir, *Born on a Blue Day,* as well as the musician and critic Tim Page (2007). Both men describe perplexing childhoods, particularly with their introduction to school and the ways of other children. They describe the happiness of playing alone or absorbed in their momentary obsessions. When interrupted by teachers and children with their confusing demands, they become keenly aware of their difference and aloneness. What were once blissful solitary experiences are now observed by curious and often hostile peers and adults. Life demands that their aloneness be postponed.

Most agonizing for both Tammet and Page were the endless unstructured activities, particularly during lunch and on the playground, both fertile ground for bullying. Socializing in small groups agonized Page who would rather "improvise an epic poem at a sold-out Yankee Stadium than to approach an attractive stranger across the room and strike up a conversation" (p. 41). Accidentally, "in a moment of early-teen hippie scorn," Page picked up Emily Post and was instantly introduced into the world of gentility, courtesy, conversation and, above all, manners which "properly understood, existed to make other people feel comfortable rather than (as I had suspected) to demonstrate the practitioner's social superiority" (p. 40). But in his predictably autistic way, Page's interpretations of Post's suggestions were slightly off kilter.

As Tammet and Page describe, children with AS are attracted to activities and subjects with fixed and constant rules and patterns. Tammet's first language is math through which he thinks, feels, and understands the visual world, while Page loves music for "its resistance to change, its protracted unfolding, its mantric sense of perpetual return" (p. 40).

He is particularly attracted to rigidly patterned music, and wonders were it not for the syndrome if that would still be the case.

Like classical autistics, individuals with AS live in a world of perseverative and obsessive rituals. With language in their arsenal, however, they are more equipped to tackle the triad of dysfunctions: social interaction, communication, and play. Although language is at the Asperger's child's disposal, it is not a language used for social purposes but rather for the self-absorbed communication of one's own interests and needs. Much of their classtime is devoted to decoding facial and bodily expressions and learning the social ways of the world. Children with AS will make social overtures to their peers, but with hopelessly immature and inappropriate behavior. Tammet's large family eased him into socialization by helping him cope with noise and unpredictability, both major obstacles to listening and focusing. However, the typical issues of eye contact, waiting one's turn to speak, understanding the rules of games, what to say and when to say it, plagued him throughout high school. The onset of puberty was particularly a time of loneliness and longing. "There was certainly no shortage of times when I felt like I wanted to vanish. I just did not seem to fit in anywhere, as though I had been born into the wrong world" (2006, p. 74).

Like autistic savants, the special talents of children with AS are rooted in their disability. Knowledge is isolated, fact-oriented, and independent of experience. Like classically autistic children with language, they are at sea in mutual conversation; small talk and social conventions particularly baffle them. They are unable to understand the purpose of *mutual* play, and their fantasy world does not invite the participation of other children. At times their fantastic obsessions can become very dark leaving them unable to distinguish what is and is not reality. In desperation for companionship at school, Tammet invented an imaginary friend who accompanied him on walks around the perimeter of the playground. They engaged in deep conversations that calmed him while other children played.

A Curious Character

In Mark Haddon's (2003a) novel, *The Curious Incident of the Dog in the Night-Time,* Christopher is a young male with AS. In an interview Haddon (2003b) explains that although Christopher clearly has AS, he is careful not to diagnose him in the novel because he would then be reduced to a child with a label. Rather, he prefers to think of Christopher as a gifted young mathematician with quirks. Haddon is

also adamant that there is not one way to depict a fifteen-year-old with AS because of the varied and diverse nature of the syndrome. Rather, he says ironically, all of Christopher's traits are taken individually from people in his life.

Haddon did, in fact, have extensive experiences with people with disabilities when autism was still an unknown quantity. And while he will not succumb to generalizations, he speaks of the almost universal problems of parents of children with autism, many of whom are similar to Christopher's parents who divorce as a result of their differences in confronting their emotional challenges. More recently another phenomenon has taken place. As more children are diagnosed with AS, more interest has been shown in the diagnosis of their parents. And indeed, at least one parent is usually diagnosed with AS. With this information, parents can offer the support and knowledge to their children that they never had. This was the case with Michael John Carley, director of the Global and Regional Asperger's Syndrome Partnership (GRASP), who finds a kindred spirit in his son.

Haddon's fanciful book is a murder mystery of a dead dog, but actually the mystery lies in the way Christopher weaves the event in his mind. From the start Christopher lets the reader in on his unusual thoughts. We find out on page two that he sees details rather than the big picture, as Grandin described. His thoughts move rapidly and nonsequentially from the murder of a dog to the look and feel of its fur: "It had curly black fur, but when you got close you could see that the skin underneath the fur was a very pale yellow, like a chicken" (p. 2). On page three, the reader finds that Christopher cannot read emotions on the faces of friends, family, or strangers, and so in this sense everyone is a stranger. By page four the reader finds that the narrator of the story does not distinguish between the affective meanings of the details he is so fond. "I pulled the fork out of the dog and lifted him into my arms and hugged him. He was leaking blood from the fork holes. I like dogs. You always know what a dog is thinking." Also on page four Haddon reveals that Christopher cannot engage in the emotions of others, and that intense emotions such as his neighbor's at the sight of her dead dog will make him fight or flee. "I put my hands over my ears and closed my eyes and rolled forward till I was hunched up with my forehead pressed onto the grass." Critic Michiko Kakutani (2003) describes many children with AS while commenting on Christopher:

He has trouble figuring out other people's feelings, and he doesn't understand why they use metaphors or why they tell lies.

Strangers, noise and unfamiliar situations terrify him, but he is curiously detached about things like illness and death. Two years earlier, when he was told that his mother had had a heart attack, he wanted to visit her in the hospital because he liked hospitals; he liked "the uniforms and the machines." He thinks of his memory as a movie; he thinks of the human brain as a computer. (p. 1)

The murder mystery lures Christopher from his predictable and safe environments of home and school, and we are reminded of the circumscribed world in which he lives as he challenges his fears of change and chaos. We witness his "odyssey" from a suburb to London as he desperately tries to make meaning of everything he experiences and fails miserably, but nevertheless gets to his destination. We empathize with a character who cannot empathize with us because of the author's skillful laying bear of our own fears of the unpredictability of life and our inability to control the future.

Haddon's choice of Christopher as his narrator served many purposes: one lies in Christopher's simple telling of the tale, revealing his paradoxical perception of reality, while Haddon points to deep schisms in our ability to understand him, and he us. Christopher did not understand the meaning of lying and thus he was compelled to tell the unvarnished truth as so many children on the spectrum do. The paradox, says Haddon (2003b), is that "he always gets things wrong" (WNYC, Fresh Air). With truth in the physical details unadorned by affect, children on the spectrum do not perceive how events impact a greater social network. As a narrator, Christopher is not, in fact, conscious of his readers, as Haddon points out. Therefore, Haddon gives us a transparent narrator who reveals our own adult betrayals, contradictions, and fears.

Special Educational Settings

When Special Schools Work

Because of the complexity of their special gifts and deficits, educators and parents often agree that small self-contained classes are best for children with AS. They do not flourish in a class in which they are expected to behave like other children; their emotional lives are too dense for this approach. Children with AS have much to offer if they are encouraged to develop their interests in ways that benefit others.

We, as empathetic adults, need to invent strategies that entice them into collaborative projects so they might see the advantages rather than the drawbacks of allowing others into their lives.

Valerie Paradiz (2002), author of *Elijah's Cup*, a memoir about her son, realized that she was not the only parent of a child with AS who was unhappy in the regular classroom. She reminisces on the classroom battleground that led her to establish the Autistic Strength Purpose and Independence in Education (ASPIE) School.[9] By fourth grade Elijah was known as the oddball among his peers, the first of many indignities that he, like other children with AS, must suffer. She observed the complex social hierarchy that left Elijah and other Special Education children out of the groups of friends so critical for children at this age who are awakening to the joys and intrigues of peer relationships. Like many children at the outskirts of the social order, Elijah lapsed into what Paradiz thought was outworn perseverative behavior when coping techniques failed to ingratiate him with his classmates.

Although children with AS have the intelligence, and often greater intelligence, to do the academic work required of their age level, they are ostracized because of behavior that their peers find inappropriate, illogical, and unusual. Ostracization and marginalization induces stress that shuts down the rational thinking mind, and therefore prevents children with AS from fulfilling their academic potential. Paradiz experienced how children with AS thrive in environments that honor their giftedness. In 2003, she founded the ASPIE School in the Onteora Central School District in New York State. One of the greatest benefits of such an environment is the building of a solid identity as an individual on the autistic spectrum. When autism is discussed openly in positive, self-affirming ways, self-respect and the long elusive friendships are forthcoming.

Rather than the formidable time out room, ASPIE had a crash room that Paradiz (2005) says is never used in a punitive way but instead its purpose is to promote self-monitoring skills. The room then becomes an alternative to acting out as a result of overstimulation. Choosing to make a change of environment on one's own volition is crucial because its purpose is not to further isolate children but rather provide an alternative to coping in a noisy classroom. Children with AS just need extra help to make beneficial choices.

The ASPIE School also recognized the need for children to practice what they learned about dealing with distractions and overstimulation in a larger context. The carefully honed environment of the school encouraged students to analyze their own responses and therefore gave

them the time and space to prepare for challenges. Students also analyzed how information about AS is transmitted to the public, and the inevitable stereotyping that comes with it. This knowledge invites them to exercise their own voice by speaking out against false views. Children on the spectrum are also accustomed to hearing the interpretations of their disorder from experts. Discussion prepares them to represent themselves.

Most importantly children need to understand the purpose and benefit of learning social skills. "If you spend all your time trying to make neurotypicals [non-autistics] satisfied, that causes depression. It's almost like working against yourself, your own core" (Paradiz, 2005, p. 8). In a self-affirming environment children with AS learn to respect themselves while at the same time adjust to the expectations of the larger social group. "So it's more like going through the really complex process of sticking to your own core and at the same time choosing what you do and don't do in terms of your own feeling of success as a minority in a larger culture" (pp. 8–9). The following paragraphs describe an equally beneficial environment, albeit outside the classroom.

A Therapeutic Environment

Therapeutic art specialists David and Dawn Henley were for many years directors of a summer camp in New Jersey for children with AS and ADHD. David Henley's artistic projects gently reach children who see little advantage in listening to and learning from others. Summer, as Henley says, is a time for relaxation and fun for most children, but not for children with AS. Rather, in some instances, it is a time of stress, depression, and isolation for a child who lacks peer relationships and summer friends. In this camp every activity from the banal to the artistically creative became a source of social learning for the children. Almost everything the child does in a social setting poses the problematic behaviors of AS, such as perseveration, ritualistic and self-stimulating behavior, and hyper- and hyporeactions to stimuli. In Henley's hands these behaviors become the ground on which socialization begins, each activity becoming its pretext.

The behavior that is usually addressed in the beginning of camp is the stress of separation from parents and familiar environments. For many disabilities, separation anxiety is an issue that needs the gentle understanding of teachers and staff to make smooth transitions. For children with AS, separation anxiety can take the extreme form of fantasies of annihilation. Henley (2001) offers the concept of object relations—one's

relationship with the things and people in one's life—as the theoretical foundation for this phenomenon. Children with AS have frail relationships with their environment that is both cause and consequence of a frail identity. Most of these children have fight–flight responses and self–stimulatory behaviors in response to social contact in which they feel out of control. "In other words," says Henley, "these children are chronically terrified" (p. 114).

Henley finds that their art work mirrors their need for safety in nonhuman mechanical objects that are more *object constant*[10] than unpredictable human beings. Henley's mission becomes one of humanizing these drawings that slowly strengthens the children's connection to the human world, as well as bringing into realistic balance their outlandish fears, which also appear in their subject matter. Henley transforms unhealthy ritualistic behavior into healthy ritualized art making, the first step toward establishing a healthy ego and realistic perception of the world. Through dialogue he transforms the children's frightening imagery into more manageable subject matter. For example, a child who drew planets colliding in a catastrophic end–of–the–world narrative was led through a discussion of the Star Wars Trilogy bringing his work one step closer to science fiction rather than impending doom. "This is accomplished by staying within the metaphors brought forth through the narrative content of the child's art and helping write 'scripts' that are rooted in reality" (p. 117).

Imagery that serves as a substitute for human spontaneity, such as machines with human characteristics, also absorbs the threatening unpredictability of life. These objects need to be slowly coaxed into more human form. Henley uses an example of a child who drew a crash test dummy in the seat of a car that could literally *absorb* the inevitable catastrophe. The transition from inanimate to sentient being in the driver's seat was made gradually as human feeling entered the picture. After four years of therapeutic summer camp, this child began to show developing ego strength through his transforming imagery. As it often happens, the new imagery corresponded to his ability to live with less stress and anxiety. This child is an example of the slow progress that can be expected from children with AS and co–morbid disorders, such as obsessive compulsions and annihilation anxiety.

In the following paragraphs I discuss how the art teacher might begin this possibly long process, disarm the child, and make inroads with subtle but seductive art making.

Making Art with Children with AS

In the course, *Art for the Exceptional Child* at the State University of New York at New Paltz, students find ways to approach children who are unwilling or tentative about using the human body in their art work. As mentioned earlier, children on the autistic spectrum make a much more comfortable connection with mechanical objects, often substituting them for human beings. Inspired by an approach used by Reggio Emilia educators, the students went outside to draw their shadows on the pavement. They took turns drawing their partner's shadow while inventing narratives about the figures. Working together, while maintaining autonomy, is one of the important benefits of shadow drawing. Another is the indirect and nonthreatening way children can work with the human figure without needing to touch or make eye contact.[11] The mentor/teacher might ask, "What can you do with a partner that you can't on your own?" Or she might ask, "Can you show me how you look when you play ball together? What was the most exciting moment in the game? What position were you in?" These questions address several issues. First, the children are asked to think about their body in space—particularly problematic for children who have difficulties socializing—by revisiting a memory with the body feeling intact. These questions also invite children to think about another person as a team mate—someone on their side. Thus, children with AS and high functioning classical autism can take the first step toward observing, accepting, and documenting the human body as well as learning the art of collaboration.

Artist Dennis Oppenheim describes a work in collaboration with his young son Erik called *Two-Stage Transfer Drawing: Returning to a Past State,* and later, *Two-Stage Transfer Drawing: Advancing to a Future State.* In the first drawing Oppenheim, the father, runs a marker along Erik's back while he tries to duplicate what he feels onto a wall. Oppenheim says, "My activity stimulates a kinetic response from his memory system. I am...drawing through him. In this sense, he is making contact with a past state" (as cited in Heiss, 1992, p. 72). When the roles are reversed (Erik is now drawing on his father's back), he makes contact with a future state. This cleverly simple and intimate drawing exercise suggests a variety of possibilities for children on the autistic spectrum. The pair are neither facing each other nor making eye contact. They are instead in nonverbal and physical communication. Symbolically, the drawings suggest that a more intimate contact was found between them

than might have been possible in verbal dialogue. If taken further, this strategy might lead to an empathetic connection between peers.

Ironically, Alanna Heiss (1992) describes Oppenheim in a way that is reminiscent of Asperger qualities.

> I've concluded that if there are people from other planets, it's probable that Dennis is one of them, an alien. Look at the facts: to begin with his work, the changes in his work, his mind, his attitude, and even his appearance would be a lot easier to explain if he were an alien, working from an experience that's different from ours. The information he takes in is different, and what he puts out seems to come from another data base, one that has been gracefully adjusted to ours. (p. 5)

The experience of gifted and unearthly artists such as Oppenheim can help us as teachers in imagining new and unconventional ways of communicating with our students through the medium of art. We must be on the lookout for the uncommon and the idiosyncratic, and embrace these alternative ways of perceiving the world. Conventional art projects will probably not capture the imaginations of children with AS. They, as others on the spectrum, are in touch with a layer of reality that most of us cannot see. As Paradiz (2002) writes when describing her son, "He was focused on the fine layer of what lies between, on the seemingly invisible places that neurotypicals overlook. It's another order of vision" (p. 169).

Now that we have a visual culture brought on by an onslaught of media and technology, we might tap into this onslaught as a rehearsal site toward the self-realization of children on the spectrum who struggle to secure their identities. Shirley Temple was Andy Warhol's role model well into adulthood, says Paradiz (2002). Behind his tape recorder and film camera, he was able to safely bridge the aching distance between himself and the world. Cameras and tape recorders made life possible. We can also learn from Warhol how to use the fascination of repetition, cataloguing and classifying, so much the occupation of children with AS. Warhol not only made this occupation an art form, but also began a new era of postmodernism in the visual arts. With a little awe and less judgment, teachers might follow their students down paths that we cannot dream of.

Attention Deficit Hyperactivity Disorder

Characteristics of the Disability

Before the 1960s, when attention deficit hyperactivity disorder (ADHD) was called hyperkinetic syndrome, "bad behavior" was thought to be a result of environmental influences (particularly parents) and the moral weakness of the child. By the 1970s, the successful results of Ritalin pointed toward genetic and biological causes. Without factual information, however, most clinicians believed the evidence to be dubious, and they continued to blame parenting skills and the moral nature of the child (Hallowell & Ratey, 1994). In 1980 the syndrome was renamed attention deficit disorder (ADD). Now ADHD is used as an umbrella term to encompass attention deficit *without* hyperactivity. But even this most recent label is less than adequate given the complexity of the disorder whose causes are generally understood to be genetic and neurobiological. In 1998 the National Institutes of Health conference on ADHD arrived at a consensus statement that "it was unable to discern what ADHD was, how to diagnose it, and how to treat it" (Bluestone, 1998, para. 4). With new awareness about differences in brain wiring, many clinicians feel that it is more humane to refer to the symptoms of ADHD and other disabilities as traits rather than disorders, and differences rather than syndromes. Judith Bluestone (2008) believes ADHD to be an inaccurate label because it does not account for the fact that everyone is attending to something at any given moment, and thus prefers the term *attentional priorities disorder*. If we were to look at children with ADHD in this way, then we might find out what makes their priorities such that they selectively block out stimulation making attention so inflexible, particularly at school.

In a 1990 experiment of adults with parents with ADHD, Alan Zametkin found that his subjects metabolized glucose at an 8 percent rate lower than the control group. He found lower metabolism to be widespread in the brain, but the greatest area affected was in the frontal region, the site of working and long-term memory and the principle regulator of behavior that allows us to plan and initiate action, and screen out irrelevant stimuli. Edward Hallowell and John Ratey (1994), authors of the popular book *Driven to Distraction*, use an interesting metaphor to describe the altered neurochemical system of people with ADHD.

> Most likely, it is a dysregulation along the catecholamine-serotonin axis, a dance where one misstep by one partner creates a misstep by the other, which creates another misstep by the first. Before they know it, these dance partners are out of step not just with each other but with the music—and who is to say how it happened? (p. 274)

The frontal lobes receive information from the limbic system (the emotional brain) synthesizing sensory and cognitive information and preparing the mind for attention and action. Hyperactivity and impulsivity are equated with disturbed inhibition in the cortex, and without cortical inhibition the brain can neither block inappropriate responses nor send out appropriate messages. As inhibition breaks down, impulsivity and hyperactivity escalate (Hallowell & Ratey, 1994). We will see later in the chapter that the affected working memory causes the most problematic symptoms of the syndrome: the inability to review and evaluate experience and plan for the future. As we have seen, these symptoms are experienced even more intensely within the autistic spectrum whereby life is experienced in disconnected frames of time.

A few researchers theorize that ADHD is a right hemisphere dysfunction, the seat of the executive function of the brain that organizes decision making and the processing of stimuli (Hallowell & Ratey, 1994). Others call it an inhibition and disinhibition problem: the inability to stop receiving a constant flow of messages. "Everything runs together, unbraked, uninhibited...the inability to stop the words...to stop the thoughts...to stop at the other's boundaries" (p. 283). Hence, the inability to listen above the din of one's rapid thoughts.

The National Institute of Child health and Human development (NICHD) identifies at least 4 to 8 percent of America's children with this complex spectrum disorder of the central nervous system, which

also shares features with learning disabilities (LD). According to Hallowell and Ratey (1994), more than 15 million adults and children have the syndrome, although many go undiagnosed. Once believed to be a childhood disorder, it is now known to carry into adulthood with only one-third of adults outgrowing ADHD. The preponderance of males to females with the syndrome is approximately three to one.

Although the *Diagnostic and Statistical Manual of Mental Disorders-Fourth Edition* (DSM-IV) delineates three subtypes, the inattentive, hyperactive-impulsive, and a combination of both, inattention is presently understood not to be at the root of the problem. Children with ADHD need to find a compelling reason to pay attention. Theirs is a motivational problem, setting them apart from children with LD who want to pay attention but have little success. In other words, children with ADHD are selective about what they want to learn. The impressive intelligence of children with ADHD often accompanies equally impressive skills and abilities, and they will pay attention for long periods of time if they are in control of what, when, and how they learn. With both beneficial and detrimental results, children with ADHD often prefer to learn alone with the companionship of digital technology. Because of its spectacular special effects and thrilling possibilities, technology too often becomes a substitute for friendship. In effect, they have in electronics the rapid feed back, instant gratification, visual complexity, and constant reward they desire, along with ultimate control.

Children with ADHD and LD do have in common their rigidity, although children with LD are rigid for fear of making mistakes while children with ADHD have little patience for reciprocity. Their impatience with their peers leads to noncompliance, oppositionality, and other manipulative behaviors, all effects of their inability to self-regulate. What ensues is a cycle of conflict and negativity prohibiting satisfactory relationships with others.

The complexity of the ADHD personality, with its sometimes formidable intelligence and equally formidable frustrations, invite us to look at how well public education not only accommodates but also encourages such challenging children to fulfill their academic potential. When the style of teaching they need is not forthcoming, children with ADHD will resort to more satisfying but destructive alternatives. On the other hand, if educators find a way to enable them to learn through one of their sometimes compulsive and usually arcane interests, their chaotic attention transforms into steadfast absorption. These interests usually accompany their obsession with digital technology that

not only characterizes the ADHD child's insatiable hunger for thrilling and dazzling entertainment and intense sensory stimulation, but it also temporarily resolves the problem of aloneness. Computers function as feedback without the judgment, competition, and general intrusion of peers. When they venture out into the world we witness the inevitable conflicts that arise with children whose bodies are always moving and minds always racing. Usually frustrated with their peers, children with ADHD are overbearing, insisting on taking charge; if their peers do not comply, they are left in the dust.

ADHD is often called a self-absorbed disability in which children are absorbed in their interests while finding little reason to participate in the interests of others. Bombarded by the high speed of their oncoming ideas, they rarely have the patience to wait for the speaker's final words. David Henley (1998) worked with children for several summers in a multimodal, integrated arts program with extremely gifted children with ADHD. He describes a child with classic ADHD characteristics as "unquestionably bright and gifted, impulsive in his actions toward others and oblivious to their feelings, energetic to the point of exhaustion, yet hopelessly uncoordinated on the playing field, friendly—even charming—to adults, yet regarded as a 'loser' by his peers" (p. 2). Communication and socialization are the great obstacles, disavowing children of the critical social learning that shapes a strong identity.

Children with ADHD can easily interpret, analyze, and understand information. They do not as easily interpret and follow social rules of behavior, particularly from authority. The inability to deal with "rule governed behavior" often ends in rebelliousness, impulsiveness, and oppositionality. This inability prevents children with ADHD from participating in play, a vital locus of growth and development. Children with ADHD sometimes resemble children with Asperger's syndrome (AS) with their prodigious gifts and woeful social deficits. They also display, among other unsocial behaviors, the dyssemia[1] of AS. Dyssemic behavior prevents children with both AS and ADHD to experience the needs and desires of others, the foundation of empathy. It follows that children with ADHD are clueless in predicting the outcomes and consequences of what they say and its affect on others. With the breakdown of inhibition and the rise of impulsiveness discussed earlier, their affected working memory makes them poor planners, incapable of envisioning the future with its multiple possibilities. Later in the chapter we will revisit this important learning skill when discussing how art processes enhance planning.

Poor planning, impulsivity, and lack of empathy, all add up to poor judgment and an inability to ponder one's options and reflect on one's actions. Without the support of an empathetic adult, most children will choose the less than best way to resolve problems by giving in to the first impulse rather than considering the many alternatives. The ability to make good choices is usually considered a test of wisdom, but children with ADHD do not allow their experiences to teach them about life (Levine, 2002). In order to be reflective, children must slow down, which is at the heart of their problems. Rather than reviewing their options, they will impulsively follow the most compelling idea. Levine calls output control that which helps children "to slow down, to stop, listen, think, and look before they leap" (p. 80). Larry Silver uses the metaphor of a "faulty filter system in the lower parts of the brain known as the reticular activating system" (as cited in Hallowell & Ratey, 1994) whereby the injured system cannot screen out irrelevant information,

> letting everything that registers at the desk of the reticular activating system arrive in the rooms of the frontal regions of the brain. The individual is bombarded, taking care of ten thousand guests in a hotel built for one thousand, on overload all the time, receiving messages about every minute aspect of his or her experience. (p. 281)

Self-evaluation is the best antidote to this problem, requiring children to monitor their behavior (Levine, 2002). The lesson plans in chapter nine suggest how self-evaluation can serve to exercise their metacognitive skills. Checklists, reviews, and other writing assignments might be built into the lesson that can be camouflaged as artistic reflection. Discussion within and at the end of the lesson is also crucial for children to hone their awareness. Student to student and student to teacher dialogue encourage children to consider the choices they made and changes they will need to make in the future to improve performance.

All these issues are exacerbated as children grow into adolescence, their behavior becoming more observably behind their peers. By second grade most children learn to delay gratification and, by the end of elementary school, to sift out visual and auditory distractions. Even though their intelligence might surpass their schoolmates, adolescents with ADHD are woefully ill-equipped in the early foundational learning that their peers have long since mastered.

Mel Levine (2002) redefines inattention as chaotic attention that requires control. He suggests that the way to resolve chaotic attention in all activities can be reduced to three forms of control: mental energy, intake of information and other stimuli, and output of work and behavior. Energy is required in thinking and controlling behavior just as it is for a physical task. This so-called mental fuel if functioning correctly is regulated so that just the right amount is received by the parts of the brain needed to do the mental work. "That fuel supply not only must be delivered to the right parts of the brain at any moment, but also the flow has to continue long enough to get the job done" (p. 58). The loss of energy is experienced as boredom and the child with ADHD goes on to the next stimulating experience, abruptly leaving the previous one.

Thus the attention dysfunction of the child with ADHD is one of neurologically misplaced and deregulated mental energy. Similar to LD, ADHD is the result of an immature central nervous system that does not permit children to delay gratification in service of receiving challenging but less entertaining information. Most of us have learned the patience needed to control our impulses when we are bored and wishing to be elsewhere. This is not so for the child with ADHD who will act out physically, perseverating in response to his distress. His neurological functions (or "intake control" as Levine calls it) are unable to "prepare the mind for thinking, making the best use of available newly arrived or remembered facts, ideas and experiences" (p. 64). Children with ADHD and LD are unable to filter out what is not relevant—the white noise and visual detritus—in order to focus on the task. Probably the defining difference between them lies in the fact that children with LD cannot decide what to concentrate on first, while children with ADHD, in their astonishing ability to multitask, try to take in everything at once. The ADHD child's prodigious ability to concentrate once her interest is held will also be the cause of a new array of problems. Hyperfocus easily turns into perseveration in which the child neglects other tasks in favor of his obsession. The overarching issue for ADHD, then, is balance. A mind with regulated and balanced control will be able to pace itself, focus, and effortlessly shift from one event to another.

Managing Behavior

The characteristics usually associated with ADHD are made complicated by the additional disorders that so often accompany it. The

addition of emotional and behavioral disorders, oppositional defiance disorders, anxiety disorders, and obsessive compulsion, present educators with the daunting challenge of finding the most effective way to regulate behavior. Classic behavior modification with its rewards and punishments, although ubiquitous, is considered by many therapists and educators to be an inferior strategy, particularly when used alone. Henley (1998) describes behavior modification as "a form of low-level bribery" (p. 4), and anathema for the highly verbal and intelligent child with ADHD who needs to learn to reason and reflect on negative behavior. Reward and punishment encourages dependence on an external authority figure with short-term effects: once removed, old behavior returns. Learning achieved with behavior modification is superficial at best; it does not encourage children to understand their behavior, nor does it address the deeper issues of the disorder. Rather, children need to label and identify emotions and anticipate anxiety-producing situations. Henley advocates for the indirectness and subtlety of the arts that require internalization and generalization of positive behavior. Once self-motivated, art activities become their own reward. But they need to be compelling for this thrill-seeking population.

Because of the complexity of the disorder a multifaceted form of therapy, such that the arts innately possess, is far more effective than an isolated behavioral or psychological therapy (Henley, 1998). In a therapeutic summer camp for children up to latency age with ADHD, Henley (1998) uses a multimodal program that integrates art projects with behavioral, cognitive, psychodynamic, and medical approaches. Flexibility is the rule of thumb. With their low threshold for frustration, it is wise to negotiate individual agreements or behavior contracts rather than demand that children with ADHD follow universal rules. The teacher/mentor will need to attend to the idiosyncratic needs of each child while respecting general guidelines so that order prevails.

Henley (1999) describes a time when a child's obsession might have either been frustrated with foreseeable negative effects in the future, or accommodated by channeling it into an artistic endeavor. Often one compromise will help to neutralize future aggression if an agreement is made. After a dialogue on the camp grounds, campers were ushered back to the studio to draw from memory. One camper, however, wanted to remain outside in order to "capture the spirit of the environment" (p. 46). Though reasonable, a perplexing problem arose. How might a teacher accommodate one child without showing him preferential treatment? Henley's responsiveness to his "divergent expressive and learning styles" (p. 46) was tempered by compromise. Henley did

not give carte blanche to this camper's hyperactivity, but rather channeled his energy through the physicality of the artistic project. The project became the opportunity for a reasonable contract to be made between the child and adult.

The teacher's flexibility "paid behavioral dividends" (p. 46). Henley's flexibility gave him the leverage he needed to negotiate a compromise—compliance with the rules for the rest of the day in exchange for this reasonable exception. Such divergent learning, Henley points out, is typical for artistically gifted children. Drawing from life is always preferable to drawing from secondary resources, and this child instinctively knew it. In cases such as this one, the expressive styles of both giftedness and ADHD converge. The need for intense sensory experience typical for children with ADHD is also typical for artists. The benefits outweighed the risks of appearing inconsistent in the eyes of the other children by channeling potential agitation into constructive art making. Unfortunately teachers are more apt to suppress this nature in children labeled with ADHD and encourage gifted children, a paradox discussed later in the chapter.

Self-regulation and organization are the important issues for children with ADHD requiring consistent thought and planning from the teacher. Children will benefit exponentially if this learning is embedded within the lesson or activity. Henley seeks to balance "discharge and control" by maintaining stimulation and excitement with "finesse and control" (p. 46). The trick is to allow for enough energy to be released while setting limits within the structure of the lesson so that energy is controlled and recklessness and chaos do not ensue. Children also need to understand how control benefits them personally, for the good of the group is not usually what motivates them. The subject of many of Henley's lessons is indirectly about rulemaking. He directs dialogue so that children may analyze the reasons for rules by asking provocative questions such as, "'What if there were no rules in football?' Primary process material began to surface; one ten-year-old responded with, 'They'd put spikes and horns tipped with poison on their helmets'" (p. 46).

Any strategy to regulate behavior might be couched within the theme of a project. Behavior modification, on the other hand, cannot create the kind of situation in which children are able to experience the internal rewards and reasons for social boundaries and rules of behavior. They must see for themselves that the benefit of following rules is greater than its drawbacks. Henley accomplished this learning by leading children toward a capstone experience that they shared together.

He took the children to the shore and asked them to imagine how it might feel if they were the first people to discover land. This ingenious subject was couched in the most important learning for the children: that cooperation has personal rewards and "aggression and selfishness work against their best interests" (p. 49). His campers gave up their antagonism and opposition when given the opportunity to create their own reality.The children rose to the occasion, overcoming their inevitable conflicts with a great sense of agency. They witnessed and experienced how conflicts are created and how, with reason and measured action, they are surmounted.

Art, Play, and Socialization

The Lessons of Art

By creating the right circumstances in which to work out important relationships, art and play provide much of the crucial learning and socialization that young children require to make sense of the environment. In play children learn to be fair, the purpose of rules, empathy for other's needs and desires, as well as spatial and temporal organization.

Most problematic is the aggression and self-absorption of children with ADHD that prevent them from enjoying the natural play of their peers. Henley (1998) suggests that the loss of play diminishes imagination, necessary for empathy—to imagine the feelings and needs of the other. Children with ADHD have difficulty waiting their turn and complying with the pace of others and, rather, impulsively intrude on their private and quiet activities. Their emotional skills are fixed at an earlier self-centered stage of development while their formidable intelligence is consumed by self-interest. Their need for companionship once aroused is then forgone as the children's fear of peer rejection causes them to withdraw, and the vicious cycle continues. Henley proceeds cautiously, often retreating a few steps before advancing again.

Once children are guided into play, nothing more than coaching, cueing, and redirecting is needed. Organized play easily gives way to the more ambitious projects of art making. Because of the group nature of art projects, the subject turns to individual as well as group dynamics. Among the typical behaviors that arise when this population engages in organized projects are difficulties transitioning from one activity to another and approach–avoidant behavior; both signaling self-protective and defensive instincts. Henley's lessons become proving grounds where the benefits of successful group relationships outweigh

the fears of fragile egos. Eventually the children's visual images serve as a bridge to appropriate interaction, replacing the adult's interventions.

Because of their need for dazzling sensory stimulation, the arts can, in their socially sanctioned way, provide the right balance of dazzle and order, or as Henley (1999) says, "a highly desired integration of sensory, cognitive, and affective faculties" (p. 5). The need for immediate and constant gratification is satisfied, but it comes with the important learning of social rules and physical laws that cannot be transgressed if the outcome is to be successful. Once a child with ADHD is emotionally invested, she will be motivated to accept rules and laws. In so doing, children learn to monitor their behavior, reflect on the concrete destructiveness that impulsiveness renders, and recognize through the metaphor of materials their own internal states.

As in play, however, children with ADHD do not easily participate in activities that require the sharing of ideas, materials, and space. Like play, art requires that children follow rules of behavior, such as listening to and understanding the words, facial expression, and body language of others, forgoing one's own needs, frustration, or anger in service of empathy, problem solving, and generally appropriate peer behavior (Henley, 1998). Children with ADHD have the resources to meet these expectations if they are given the kind of novel and stimulating circumstances they crave. Denying their needs will have little effect and will instead arouse their anger and frustration. In other words, teachers/mentors must work around the land mines that are set to go off with only a hint of provocation. Henley cleverly disguises aspects of activities that might provoke anxiety, and couches important learning in highly sensory and stimulating projects. The dynamics of drawing and other media allow carefully guarded issues to rise to the surface before they can be censored. Children who are resistant or oppositional to talking about sensitive subjects, unknowingly confront these issues through the images and symbols of art. By fixing them "in time and space, and by making it concrete, the problem can be objectively examined" (Naumberg, as cited in Henley, 1998, p. 5).

Like it or not, art making becomes a lesson in dealing with reality, but a reality that is governed by the conventions of the medium that act as internal controls. Rules are not imposed from the outside, which children with ADHD will resist, but rather become integrated as their relationship with materials develops. Art making requires that children with the disorder surrender to what they perceive as the slowness of time and maturation of materials undergoing transformation. The arts have their own predictable laws, organization, and structure. Children

who work within their laws will see concrete cause and effect relationships, and that responsibility lies squarely within their own action on the materials. Children must respect limits, laws, cause and consequence, all the learning necessary to participate and be effective in the world. At the same time, they can exercise their hyperactivity in ways that artistically channel their energy.

Children with ADHD need a compelling reason to self-regulate. Among other reasons, art is compelling for a population that thinks divergently and excels when projects can be started, continued, and completed on one's own. Once the process of making art becomes self-motivated, children move toward greater homeostasis, bringing together internal and external reality, self and world. Because the arts are socially acceptable, the more adventurous, risk taking, thrill-seeking members of our society pursue professions in this field. Educators are aware of connections between the highly gifted and ADHD, and this notion will be given consideration later in the chapter. Thinking along these lines makes more apparent the internal cultural clashing of a society that favors patient and cautious planning, attention to details, and predictable routines as opposed to impulsive risk taking, broad-based interests, and unpredictable and seemingly disorganized bursts of energy.

Thom Hartmann (1997) makes these comparisons in his well-known description of the misappropriated hunter in a farmer's world. If children with ADHD were understood as inheriting a metabolism that is not suited for Western culture but nevertheless has its own value, we might find more equitable and supportive solutions. Rather than a disorder, Hartmann calls ADHD "an inherited set of skills, abilities, and personality tendencies" (p. 41) that, unfortunately, are not favored in our society. In societies more suited to their skills and abilities, the same children might flourish. This clashing is more apparent when we witness confrontations of ethnic groups, such as the Indigenous peoples of North America and Australia with their colonizers. The older civilizations having survived by adapting to their land and developing skills and abilities that are appropriate, are now faced with a dominant culture with opposing demands and expectations. Aboriginal Australians, a 40,000-year-old culture, were hunter and gatherers until their contact with Europeans. The outlawed practice of the *Law* in Western Australia in which teenage males are sent to the bush alone for weeks or months still has its effects on adolescent males. They report oppressive restlessness that often turns them to drugs, alcohol, suicide, and violence. Several of their mothers attribute their behavior to the deep

loss of cultural traditions that they are still consciously or unconsciously prepared to follow. Many of these young men have found the visual arts, music, and dance as symbolic ways to use their inherited skills and abilities. The physical, symbolic, nonverbal arts, while not the answer to all the problems in the world, appear to strengthen and solidify identity in the most adverse circumstances.

Metaphor in Action

The visual and tactile language of the arts inherently communicates, as Maurice Merleau-Ponty (1962, 1964) says, in the flesh of the world. Symbolism is a natural outcome of the arts; children and adults choose materials by the physical and tactile attributes that best represent their ideas. From their first representations, children make the mental leap that paint and clay have attributes of the seen and felt world. With more experience their ability to make symbolic associations between idea and material evolves in complexity. The concrete materials and the sensorimotor activity of the body continually inform the mind flooded with associations made by the crisscrossing of sensory and cognitive domains. Children consciously or unconsciously draw and paint symbolic images of their psychic issues. Through the artistic need to plan, experiment and communicate, these issues can be brought into consciousness with appropriate metaphors. Making art then parallels the social and psychological issues that need to be processed and later applied to living experience.

When teachers construct lessons so that the subject matter serves as a metaphor for the children's issues, the emerging images help to neutralize those issues by crystallizing them in time and space. Metaphor might arise from the child, or be insightfully suggested by the adult, paving the way toward a discussion that will have deep relevance. Henley (1999) used the theme of relationships and social interactions in a project with children with ADHD helping them to come to grips with their biggest obstacle. Working along a lakeshore in ankle-high water, the children paired up and began stacking stones using mud as mortar to create "dolman" sculptures in the manner of Andy Goldsworthy. Afterward, he posed the reflective question, "How did this project help to build cooperation and friendship?" With great finesse, Henley seized on the moment when he knew that the children would be artistically and emotionally ready to respond to this question. Henley used the stones and mortar to approximate as closely as possible with materials the metaphor of building a friendship. As the children worked in pairs

building their sculpture, Henley cleverly reinforced the idea by using the materials again as metaphor, such as suggesting how they might "cement" their ties. Henley flips back and forth between the formal structure and the experience of creating a friendship in—literally—a concrete way. Thus, emotion is given form through the interaction with materials, turning raw emotion into symbol and poetry. Once the process of making art and the back and forth discussion between art and life was secure, Henley asked, "How do we deal with separation or with loss?" From experience he knows that if he had introduced this question too early it would be frightening and threatening for the children. But they are prepared to open up to these difficult issues once the ground is laid for trust through physical work. At the same time, the deep relationship between inner feelings and the materials make for the best kind of art. There is nothing touchy-feeling about it, Henley reassures us. The child's emotional make-up is filtered straight from the form and content of the work.[2]

At the therapeutic summer camp, Henley (1999) capitalized on the unlikely activity of fishing to bring about self-reflection, self-awareness, and eventually self-representation for a group of seven- and eight-year-old campers. A child who catches a fish learns that if she does not contain her excitement it will escape and never reach the shore. Then comes the dilemma of releasing the fish or contributing it to the camp aquarium for the benefit of the other children. These spontaneous and inner directed decisions were actually studies in empathy, responsibility, and reasoning.

Henley deftly took the raw material of fishing and turned it into a metaphor for art making. Gathering around the aquarium, Henley initiated a dialogue about the children's experience by asking, "How do our fish feel in their temporary new home?" (p. 44). The responses were just as Henley had hoped. The children saw in the fish their own loneliness and anxieties by empathizing with their abrupt transition into the aquarium. Henley then asked "Has anyone been a 'fish out of water?'" (p. 44). In an effort to address and process the campers' separation anxiety, he offered examples of how new surroundings might cause someone to feel uneasy and anxious. With a little prompting, he was able to pull from the children specific experiences in which they felt like a fish out of water. Now that the children clearly grasped the metaphor, they were introduced to drawing materials. Many of the poignant images continued to surface in future art projects.

Henley's projects make visible an art that serves not only aesthetic, but also social, cognitive, and perceptual growth. Making transitions

from the known to the unknown, or simply from one task to another, challenges children with ADHD. Since flexibility is necessary when confronting any life situation, this issue was of particular interest to Henley. Transitions exacerbates such qualities as impulsiveness, frustration toleration, impulse control, and decision making. If confronted directly, however, the children would most likely feel threatened. Art instead allows us to embed these issues in the gentle process of making metaphors.

ADHD versus the Gifted

The elements of idiosyncrasy, pathology, and special gift contribute to the paradox of giftedness.

—Henley, 1999, p. 45

Talent, brilliance, and antisocial behavior can make children with ADHD exasperating. They are in a sense incorruptibly honest about where their interests lie, which is often not within the content of the curriculum. They are not Alfie Kohn's (1999) other-directed learners or Jerome Bruner's (1961) unimaginative achievers, who study for tests, do their homework, please the teacher, and hate every minute of it. Their interests are not a means to achievement, for they are unstoppable intrinsic learners. However, their frustration with, and rejection by their peers contribute to their oppositional behavior, which can have such adverse effects that teachers and other adults are unable to make use of their giftedness. On the other hand, both exceptional and negative characteristics of children with ADHD are also evident in children who are considered gifted. For example, both children are divergent thinkers who do not easily adapt to the conventions of the dominant culture. Both have little patience for the apparent slowness of others. Both are metaphorical, symbolic, and intuitive thinkers. Both are excitable and sensitive. A positive spin is often all that is needed to describe children with ADHD by using the terminology of the gifted. For example, children with ADHD are oppositional, while the gifted are independent and original. Children with ADHD are squirmy and hyperkinetic, while gifted children are energetic. Children with ADHD are immature, while gifted children are passionate. Children with ADHD are hypersensitive, while the gifted are sensitive. Children with ADHD are "hands-in," as hands in everything, while the gifted are "hands-on," as in hands on learners.

This list of contrasting terms might tell us that ADHD children are not provided with the environmental support needed for their gifts to be utilized. Because both children are tactile-kinesthetic learners (nonauditory learners), they do not thrive in the classic auditorially driven classroom of lecture/reading/testing (Weiss, 1997). Lynn Weiss describes children with ADHD as analog thinkers as opposed to digital thinkers. Analog thinkers process information in a visual, symbolic, and metaphorical way, while digital thinkers favor speech, reason, and logic, which schools also favor. Weiss clarifies that children are not entirely digital or analog, but rather have a tendency toward one. However, the dominant environment of school that favors digital thinking actually shapes children in its own image.

According to Weiss, creative or gifted individuals commonly favor analog thinking, but without support children with ADHD, who are not acknowledged for their gifts, will succumb to what for them is the mind-numbing repressive structure of the classroom. The vicious cycle begins when children misbehave from frustration with the school's nonaccommodation to their thinking and learning that might take the form of criticism from peers, teachers, or administrators. Nonconforming behavior escalates when teachers and administrators punish children by removing experiential art activities that they need. "An injustice and paradox occurs" (Solomon, 2003, p. 19).

Art teacher Pat Solomon has found that only in a few schools do pediatricians or psychologists test for creativity when problems arise. According to Cramond (1995), 50 percent of the ADHD population score above the 70th percentile on creativity tests, yet only 21 percent are tested for gifted programs. Weiss (1997) suggests that ADHD and highly creative individuals share similarities in their neurochemistry. In Solomon's classroom, "squirmy" children often turn out to be talented dancers and athletes because they are spatially and kinesthetically gifted. She describes several highly talented, often ingenious individuals who also share many of the qualities of our ADHD children.

> Actress Sarah Bernhardt was expelled from school three times. Comedian/actor Will Rogers was incorrigible at school and ran away from home. Inventor Orville Wright was suspended from school because of mischievous behavior. Musician Louis Armstrong spent time in an institution for delinquent boys, as did Satchel Page. Painter Paul Cezanne having a very bad temper would frequently stamp his feet in hysterical rage under undue criticism. (p. 20)

Children with ADHD need to learn from role playing, life expe-
rience, trial and error, games, and drama. ADHD actually disappears
when these multimodal approaches are used, and their innate talents
emerge. Weiss (1997) theorizes that before classrooms were the norm,
children learned from mentors. Learning through apprenticeships
would be more appropriate for children with ADHD who learn by
doing.

A Teacher with Heart

Pat Solomon teaches a self-contained art class of kindergarten and first
grade children with ADHD and autism. By the third week of school
at the end of September, much progress had already been made. "The
first week they were like little atoms spinning around" (P. Solomon,
personal communication, September 25, 2008). Her accomplishments
can be attributed to the way she absorbs the children's behavior without
judgment. She coaxes them into attention by singing, rhyming, joking,
or, in other words, playing rather than teaching. Young children, par-
ticularly those with weak auditory learning skills she says, have diffi-
culty hearing the adult voice. "Some kids don't know I'm even talking
to them. They don't even hear me" (P. Solomon, personal communi-
cation, September 25, 2008). To accommodate them she turns clean-
up into a game, which is more often a painful experience for both the
children and teacher. "You are frozen. You can't talk, you can't walk,
you can't wiggle, you can't giggle."

Solomon teaches at the Morse Magnet School of the Young Child
in the Poughkeepsie City School District in New York. Three schools
within the district are magnet schools embracing learning themes in the
areas of the humanities, science, and technology. A New York magnet
school receives money from the state and is opened to the city by lot-
tery. Beginning in the 1980s, Poughkeepsie has used magnet schools to
enrich curriculum and create diversity, trying to balance ethnic demo-
graphics within the district.

Morse used to include Kindergarten through second grade, with eight
preschool classes. It now houses kindergarten through fourth grade.
Over the past few years, the make up of the building has changed due to
the loss of grant funding and district reconfiguration. Morse once had
an early morning and after school enriched learning programs for kin-
dergarten through second grade. Beginning at 7:00 a.m., the morning

program provided breakfast and the after-school program included a dinner-like snack and homework help. The programs assisted parents balancing multiple jobs and child care by closing at 4:30 p.m.

The day I visited the school Solomon was preparing for the children's first painting class of the year, or possibly the first in their lives since several children were just beginning public school. Late September is still early enough in the year for changes of placement to be made, which are sometimes necessary because testing will not always predict how children perform in a group. Solomon had not yet looked at their Individualized Education Plans (IEPs) because the information might affect her expectations. She hopes to avoid unconsciously treating children unequally, for which children have a sixth sense. Each class is forty minutes long which means that she will spend three minutes per child per week. So far she has known each child for nine minutes.

Less than the twelve children assigned to the class walked in with their classroom teaching assistant, Ms. Barnes. For Solomon, teaching is "a bag of tricks," and she often uses one of her favorite attention-getting strategies, talking to the chalk. "Chalk you're not dusty! Did you take a shower? What did you sing in the shower? You Gotta Have Heart?" You Gotta Have Heart and its variations then became the leitmotif for the next forty minutes. Many children in the class are not yet auditory learners and 20 to 30 percent of the children will never be. Therefore, her hands-on multisensory approach helps to bridge the communication gap.

A few children come in late, which makes them squirmy, so she asks them to touch their nose. "We've been learning how to do cartooning" she tells the class. In their previous classes they have drawn simple cartoons, circle dudes, triangle girls, and rectangle dads, and now they will build on that experience by using paint. Solomon explains that she chooses to begin the year by drawing from cartoons rather than drawing from observation because children have spent countless hours in front of the television. As a result, their imaginations are locked inside that box. On the other hand, she thinks that television and video games have strengthened their visual networks and increased the number of visually dominant learners.

After Solomon draws circles on the board and the children draw circles in the air, they begin on the next task of putting on smocks. "To paint in Ms. Solomon's class you have to put a paint shirt on backwards and pretend to be an emergency room doctor....Dr. John,[3]

report to the emergency room." The children are now playing inside their oversized shirts and Ms. Solomon turns down the lights. "You tickle the water with the brush," she demonstrates, "but not me or Ms. Barnes."

Each child, who has one color, interprets the lesson differently, but mostly the children explore circles. They are still at the early stages of representation and the circle dude is not far from how children begin their own symbols of figures as enclosures with radiating lines.[4] Only Dan, who appears to be bordering autism with ADHD and attention seeking behavior, is unable to make the shape and instead paints overlapping lines. In response to a child who says "I can't do it," Solomon says, "You can't say you can't, but you can say 'Ms. Solomon will you help me?'" Even her admonishments, while stern, are in rhyme. "No play or I'll take the paint away."

She uses ritual to encourage children to feel safe in the classroom. Once safe they are able to develop artistic and emotional intelligence. Her young students have unstable lives that Solomon discovers from their drawings. For example, one student chose the theme of decorating a room in her house which revealed that she was sleeping on a couch.

Admonishments, however, are rarely heard. Rather, her patience and tolerance open pathways to communication and learning. "I've had to close the door because Dan wants a chase game. Today the door was open—that was progress." Throughout the first two weeks of school he was in his teacher's lap or having tantrums. This day was also the first time that the children worked rather than danced through the lesson, and Dan showed a glimmer of attention. After fifteen minutes, however, with his focus lost, he was finding the tables and chairs more interesting. Five minutes later the majority of children lost theirs. Only John completed all three figures. Although holding a structured classroom, Solomon is not afraid of losing control and will tolerate guided chaos, a courageous way to teach that might appear counterintuitive to the followers of authoritarian teaching methods. Solomon gave free reign, for example, to Dan, neither encouraging nor admonishing his behavior. I suspected, however, that she would intervene the moment his behavior compromised the safety of the classroom. Rather, she learns the students' rituals, such as with one potentially reactive student who was set off by transitions. Before the end of class she looked into his face and stated clearly that "class is over in 5–4–3–2–1–minutes. Did you hear me?" (P. Solomon, personal communication, September 25, 2008).

Clean up comes with a bowl of wash cloths and children dance gracefully with them. "Touch your nose, touch your toes, sit in your seat," Solomon sings. Sometimes she will sing, "Put your name on your paper when you get it" to the tune of "She'll Be Coming around the Mountain." The scraggly group attempts to line up at the door while one child lies across a table, and each has a rhythm of his own. Solomon has not once raised her voice.

C H A P T E R F O U R

Learning Disabilities

All knowledge emerges in the process of self and social
construction.

—Rinaldi, 2003

Overview

Many social contexts exist in which learning problems are—if not
caused—certainly exacerbated. According to Lev Vygotsky (1986),
identity is formed in social construction and, therefore, the quality of
a child's social world is vitally important to learning, since all learning
generates from a sense of self in the world. The ever-present but nonin-
trusive teacher becomes critical, not as teaching machinery, but rather
as an active agent within the important relationship between cognitive
and social development and the *construction* of knowledge.

Labeling is particularly problematic for children with learning dis-
abilities (LD) who have what has been called a "hidden disability," and
are both over- and underdiagnosed, or have simply fallen through the
cracks. Rather than labels, Mel Levine (2002) uses the terms neurode-
velopmental profiles, functions, and systems. He honors the individ-
uality of children by understanding disability not through so-called
objective characteristics, but rather by learning and listening to them.

A combination of new research and data from schools that failed
children with LD has led to a paradigm shift in understanding and
working with them. One of the greatest failings, Levine says, is that
our labels mislead us into believing that children under the label do not
require us to think about their differences. They also etch the so-called

disorder in stone, rather than conceiving how it changes within each child over her life span.

> Labels deny the resiliency we know drives the human central nervous system. And, as we have noted, there always lurks the substantial risk of self-fulfilling prophecy. If we imply to our kids that they are always going to be pathological, in all likelihood they will be. (p. 328)

In the 1997/1998 report by the Individuals with Disabilities Act, children with disabilities totaled more than 2.7 million. More than half of these children are diagnosed with LD. Of the learning disability population, 80 percent have dyslexia (Lyon et al., 2001). Like children with autism and attention deficit hyperactivity disorder (ADHD), boys outnumber girls. Although many children with LD have been tested with above average intelligence and are placed in inclusive classrooms, for 85 percent, reading ability remains the greatest obstacle. Children with LD share much of the same attention problems as children with ADHD, but it is their inability to discriminate between what is useful and not useful in the constant stream of audio and visual information that distinguishes them.

Early detection is ideal, but unfortunately neurodevelopmental dysfunction is not detected until specific skills are developed in the first years of school, and learning to read is at the forefront of these important early skills. But tragically the disability is not often diagnosed even in these early school years. Parents, doctors, and teachers hope that children will "out grow" their slowness and, thus, precious time is wasted.

The comparing of children's skills is first experienced in school and makes for the awareness of their inability to meet the standards and expectations of what adults consider "normal." For them, children appear to hold secret knowledge from which they are excluded. Without important early skills, children fall increasingly behind. Former director of the U.S. Department of Education's Office of Special Education Programs, Thomas Hehir (2002) indicates that K-1 intervention has proven to be helpful in identifying early reading problems, although poor teaching skills in special classrooms might be the cause of many of them. He recommends that educators do not, however, conclude that full-inclusion in general education is the answer, for children do not necessarily get the support that they need. As a result of this conundrum and the resulting low performance on statewide assessment tests, the National Longitudinal Transition Study (NLTS) in the 1980s found

that students with disabilities drop out of high school at twice the rate of nondisabled students (Wagner et al., 1993).

Hehir suggests that the federal definition of learning disability as a discrepancy between intelligence and performance implies heavily that children with the disability must first fail before they are eligible for special education services. After a short time, children with LD learn "to equate education with humiliation" (Levine, p. 14). By preschool, at approximately four-years-old, children are expected to achieve the important "pre-skills" for academic learning. The inability to follow directions is one of the first signs of learning problems as is matching sounds and symbols, the precursor to reading.

Abstracting the Senses

Reading is a fairly new skill developed late in the long evolution of our species, and it is a complex one that uses parts of the brain originally organized for other purposes. But for some ethnologists and ecologists, reading has its origins in the following of animal signs and tracks, harkening back to our hunter ancestors who survived in the snow by *tracking* animal footprints. For David Abram, reading and writing are derived from these same set of skills, a recent transfer from the tracking of animals. "As one picks up a book or newspaper and follows the tracks across the page, the hunter follows the tracks across the land" (D. Abram, personal communication, November 13, 2008). According to Abram, scanning foot prints has the same feel as tracking words on a page and inhabits the mysterious quality of chasing the other; in this case it is the meaning of the author that holds us to the page. Whether animal or author, Abram says it is the mysterious "otherness" that we are in relation with and try to get closer to. His naturalistic perspective allows us a window to see how the cognitive evolution of our species has influenced our sensorial interaction with the earth in such a way that it morphed our original sense of primary space and circular time into homogenous space and linear time.

Literacy taught us to abstract the world of the senses, " freezing the dynamic experience of place into static, homogeneous space" (Abram, 1996, p. 193). Although our capacity for abstraction and reflective thought is practical and necessary, Abram argues that when not used in a full bodied relationship with the wider world, abstraction assumes an autonomy that overtakes the sense of self in relationship. Early in school Abram realized that his way of thinking and learning was not

the norm; reading was slow and math was painfully abstract. The only way he could solve a math problem was on his fingers.

> Children who are unable to abstract from their senses have a somatic empathy with the world, not with human-made signs and signals, but rather with the unmediated world of other bodies that have co-evolved with humans. From the perspective of ecology, there are probably tremendous gifts that are waiting in children who are classified as learning disabled. (D. Abram, personal communication, November 14, 2008)

The Mechanics of Reading

Approximately seventeen regions of the brain are involved in the process of reading, leaving wide open the possibility of failure. Reading begins by the child perceiving the visual representation of the letter in the brain's visual cortex that then sends it to the auditory cortex so that it may be articulated in sound. Dyslexia is caused by the inability to translate the graphic representation into sound and meaning despite adequate intelligence and perception. Children with dyslexia cannot break down words into sounds, nor put the sounds back together, which is what we do when we read. These children often never recover from this early failure while we, as so-called normals, who have a full compliment of skills and abilities only suffer temporary set backs. Children with LD (and ADHD) who chronically fail, have little or no support system from their peers. Because they fall behind and thus become marginalized, peer relationships suffer.

We now know that the brain is more resilient than we believed only a short while ago, and children with LD can recircuit their wiring as a result of environmental stimulation. Children with dyslexia in particular will need to activate more areas of their brain than typical readers. Sensory stimulation helps the child—who remains a concrete thinker longer than other children—to remember prior information, build on new information, and make connections between literal and symbolic meaning. They need to make learning visible through the sensuous and concrete qualities of the arts. School should be fostering these idiosyncratic, highly individualized minds so that they might find the right combination of stimulation to channel their specific skills with specific tasks. Regrettably, children with LD are held to the same standards of testing as other children.

How Our Schools Fail Us

Students with LD drop out at twice the rate as their nondisabled peers, few attend college, and many fail statewide assessment. Poor reading skill is the underlying cause, particularly for children with dyslexia. Hehir (2002) suggests that reading failure has led to the heavily researched reading skills in early childhood education, and there is much evidence that the majority of children are not prepared to receive the level of education they need. Thus, children with LD who are slow to read need to be considered in the larger context of the structure of teaching in schools.

Even with intense intervention, children with dyslexia remain slow readers for the rest of their lives. Hehir suggests that one aspect of this failure, which disability advocates call *ableism*,[1] is to myopically require remediation of reading and denying full access to the curriculum. Given the nature of the disability, educators might instead make the learning of all subjects as accessible as possible with necessary accommodations. Hehir places responsibility on the Individualized Education Plans (IEPs) that instead focus on discrete skills rather than planning a full spectrum of subjects. Ableism is at least partly responsible for children with LD not getting the appropriate education. As is the case with other disabilities, the programs for these students often focus on the characteristics of their disability—their reading deficiencies—to the exclusion of their total educational needs. Like the deaf who must learn to lip-read and speak before they can access the curriculum, many believe that children with LD must learn to read at grade level before they can access other subjects. This approach clearly magnifies the negative educational impact of the disability.

High Stakes Testing

The 1997 amendment of IDEA[2] required that students with disabilities be included in statewide assessment. For many educators, exclusion before 1997 implied that children with disabilities are neither capable of achievement nor important enough to track, reinforcing the status quo of low expectation (ableism). The New York State Regents exam, which began in 1998, also documented its beneficial results for children with disabilities, such as scholarships, college admission, and higher level high school courses (Hehir, 2002). Hehir warns that the statistics might be misleading; sufficient research remains to be

done before proving that the benefits outweigh the drawbacks. The drawbacks are many, particularly with high stakes testing that determines promotion and ultimately, graduation. Much of the problem lies in the inappropriateness of the tests. Standardized tests are not satisfactory measures of what children know, particularly children with LD. Thus, testing becomes a double edged sword, and Hehir highlights this conundrum with a provocative question, "what is reading?" (p. 15). Does it mean to read print, Braille, or listening to recorded text? Most states fail to recognize these modalities in standardized testing, and " such a decision is likely to discourage the use of taped tests in schools, even though they may represent the most efficient means by which some students with disabilities gain access to the curriculum" (p. 15).

The Numbing Nature of School

Far too many schools ask children to memorize facts rather than develop sophisticated, insightful and critical knowledge. "Some kinds of minds prefer to dream up their own original thoughts rather than drawing upon the ideas of others, and vice versa" (Levine, 2002, p. 23).

Typical schools expect children to be skilled in a wide range of subjects from math to gymnastics—the death knell for children with LD. When they fail they are usually given remedial classes in the same subjects causing further and deeper frustration. They are not given the opportunity to succeed in what they are good at, which is usually one of the arts, and the ability to use it as a bridge to difficult academic subjects. We expect children to be masters of all trades of which we as adults are not capable. Rather, we teach process and retrieve information in a variety of ways: from fast to slow and with more or less precision. Some of us have minds that can receive a lot of information in a condensed amount of time while others can handle only a small amount at a given time (Levine, 2002).

The primary tool for learning and applying learning, writes Levine, is in neurodevelopmental functions that he describes as delicate instruments in a tool chest. Specific clusters of neurodevelopmental functions and their combinations are harnessed for learning and applying specific skills. Within neurodevelopmental functions are specific applications for categories of memory, such as visual and spatial memory and their specific tasks. With thirty trillion synapses in the human brain, the number of combinations and tasks are infinite. How easy it is for these complex combinations to go awry.

Among the neurodevelopmental *dysfunctions* possible are textual and auditory deficits. For example, the brain must make distinctions of more than forty English language sounds essential for reading. Motor skills may also be affected that require the brain to send correct messages to specific muscles that perform tasks in writing and reading, from holding a pencil to scanning text. Neurodevelopmental dysfunctions interrupt the mental flow of energy necessary for concentration, and the poor performance that results produces emotional and motivational problems. Levine organizes each neurological function into eight neurodevelopmental systems or constructs: attention control, memory, language, spatial ordering, sequential ordering, motor control, higher thinking, and social thinking. Each must partner with the other to ensure the accomplishment of a task. These systems are the foundation from which comes either humiliation or gratification in student life.

Children bring the strengths and weaknesses of their wiring with them to school. But from the start, schools encourage children to develop learning behaviors that conform to their expectations, and then perpetuate these behaviors by rewarding—through acceptance—children who effortlessly learn them. Children who do not meet the demands of the style of learning prescribed in school fall behind. The mind that perseveres in the linear and sequential world of beginning, middle, and end, desks and chalk boards, forty-five minute intervals, and the endless transmission of prepackaged information, stands in good stead. Levine proposes that the ever greater demand that school imposes on the young has burdened "the neuro-developmental functions that together make up memory capacity" (p. 91). The mind that prefers to dream, imagine, search, and originate does not do well either in school or later in cube-like work places.

The same arbitrariness with which children are labeled ADHD as opposed to the gifted, often occur with the labeling of LD. Children with both disabilities often learn to use what has been perceived as limitations in more gratifying and constructive ways later in life. Children who are considered stubborn and rigid, who need to use the same methods once they are finally learned, might eventually be considered single-minded and focused when they are successful in the fields of their interests. Because they need to invent their own ways of achieving the same outcome that comes effortlessly to other children, they are not inhibited by methodical routine, and therefore imagine refreshing approaches to tasks. Their art work is often an example of their inventive approach to preapproved methods. Overly concrete

and visual thinkers see details of the world that escape the conceptual minds of others. Because of the difficulty children with LD have holding multiple ideas, thoughts, and directions in their mind at once, computers have helped by creating an external memory, and many children later become accomplished graphic designers and computer programmers.

Levine (2002) is optimistic that disabilities change over the course of a lifetime, depending on how supportive the environment. On the other hand, children who excel might find later in life that the memorization of facts does not serve them well in situations that require social intelligence that they might not have fine tuned. In other words, there is no guarantee that academically successful children become successful adults. Kohn (1999) argues that schools fail by encouraging extrinsic rewards rather than seeking the intrinsic gratification of learning itself. The endless search for the reward "out there" begins in elementary school and continues throughout life for those who are willing to base their lives on extrinsic standards of success. However, the straight "A" student who emerges from high school and who has succeeded by living up to the expectations of others might not be listening to her own voice. Our assessments tell us, writes Kohn, how a student is performing, but not his desire and interest to learn, a quality that will insure inner satisfaction throughout life. A sentence from Paul Dressel (1957) puts this notion into perspective: "a grade can be regarded only as an inadequate report of an inaccurate judgment by a biased and variable judge of the extent to which a student has attained an undefined level of mastery of an unknown proportion of an indefinite amount of material" (as cited in Kohn, 1999, pp. 202–203).

Report cards are not accurate predictors of children's futures as their lives are limited by the parameters of the school itself. School is purposely designed by limitations, and the packaged and content-driven curricula perpetuates mediocrity. As children grow up and choose their fields of study and work, they inspire new strengths to develop. The hidden strengths that exist in each child with LD become realized later in life if she has not given into peer-pressure, societal expectations, or is fortunate enough to be guided by an insightful adult.

LD is not a problem of motivation, as it is with children with ADHD. Children with LD will try to go it alone until downtrodden or luckily find a helping adult. Children and adults with ADHD are selectively motivated by their own interests, but people with both disabilities endure unbearable frustration, LD for trying, and ADHD for having little reason to do so.

Spatial and Sequential Ordering:
Managing Space and Time

Fairness becomes an issue when assessing regular and special needs children in the inclusive classroom. Is it fair to slow down information into simplified parts? Is it fair for the greater part of the class to accommodate a few? Flexibility is always the rule of thumb, and adjusting to individual needs a balancing act of a carefully crafted curriculum that ensures internal support and structure while allowing for maximum expression.

The world has been designed, or rather we have been conditioned to see the world as designed in logical patterns. We are trained to do so by the wiring of the typical brain and the increased complexity of the environment that shapes the typical brain. We then capitalize on this way of perceiving the world and continue to design it in the same and ever more sophisticated fashion. Hence, the desks lined up in the classroom, modulated offices, the grid system of many of our cities with its hard vertical and horizontal buildings, and the list goes on.

Unfortunately, children who are not typically wired to perceive the world in this orderly way remain forever in disarray, hopelessly looking for clues to the secret of the world's order. Once in school, this inability to self-organize one's space and mind becomes a hazardous situation. The left side of the brain houses the sequential organizing system along with linguistic intelligence, while the right houses the spatial organizing system along with visual intelligence. Because information at school is usually presented in a sequential and logical spatial pattern, children with LD have difficulty in interpreting, analyzing, and understanding (Levine, 2002). Spatial disorganization can be revealed in spilled lunches, dropped and misplaced possessions, or the transgression of another's territory. Both mind and body are seeking to learn internal organization.

Children with LD often have difficulty making sense of the whole visual picture via the inner relationships amid the parts and the relative distance between each part: that is, each part's location and the pattern and/or design it creates. When these "pictures" are stored in memory they become our visual memory. Other senses beyond sight, such as touch, contribute to our recognition. Language itself is steeped in touch, particularly through metaphor discussed in the previous chapter. Also discussed earlier is the theory about the emergence of language that purports that it can be traced back to hand gesture and facial expression rather than verbal utterance that has been thought to be its

source. In the same tradition as Lakoff, Johnson, and Merleau-Ponty, Abram (1996) also locates perception in the flesh, ours being a reciprocal and unconscious relationship with the animate world leading to the conscious relationship with language. Merleau-Ponty's philosophy of perception is the precursor of the hand/gesture genesis of language theory in which the bodily gesture is the spontaneous communication with the external world; "the gesture is the bodying-forth of that emotion into the world" (Abram, 1996, p. 74).

We first communicate bodily to emote a need in a direct and felt experience, rather than to practice syntax and grammar. Children with LD are wired to receive more accurately these conscious and unconscious messages rooted in this base layer of language developed at the gestural and bodily level. Therefore, they are less apt to decode the symbolic and abstract human-made signs of written language. Sally Smith (2001) cites research conducted by Frank Wilson who found that the use of the hand influences cognitive development. Like Ridley (2003), Wilson theorizes that as the use of the hand evolved with Homo sapiens, it was not only shaped by the development of the brain and human culture, but also contributed to the shaping of them. In other words, it is the human hand itself that is one of the prime causes of growth of the brain and, therefore, our culture.

> Wilson claims that the movements of the hand lead to the redesign of the brain's circuitry. He states that it has been proven that the influence of manual play and object manipulation facilitate the acquisition of language and cognitive skills in young children.... Wilson sees the hand as the launch pad of learning— the primary mover in the organization of human cognitive architecture and operations. (Smith, 2001, p. 6)

Wilson deduces that the missing piece of circuitry in the LD child's brain lies in a diminished "hand-thought-language nexus" (pp. 6–7). This theory brings new light on the arts as influencing underdeveloped connections, suggesting that they are capable of creating new neurological pathways and connections in the brain.

Art's Organizing Principles

Each art is a discipline. To master each step takes practice—doing the same thing over and over again, perhaps in different ways. It

means relating one thing to another and integrating them to have meaning. Most of the arts demand a certain rhythm, specific timing, which helps the child whose sense of time and timing is off. Placement in space is important in all of the arts. The arts can serve to develop basic elements of reading decoding and reading comprehension. (Smith, 2001, p. 29)

Levine (2002) calls the creative arts "worthy conquests over space," and the art room an "untapped resource of many underachieving students" (p. 163). He calls "spatial output impairments" the inability to connect spatial intentions with motor output. Computer graphics, he suggests, is a good alternative to the more motor-driven visual arts and may become the testing ground for conquering the mechanics of visual design and organizing the physical world that so eludes children with LD. "Good use of mental imagery relieves the need to put every single idea or skill you learn in school into words and sentences" (p. 166).

Establishing a discrete place in which to work is essential to accomplish artistic projects, particularly with this population. The printing processes are especially helpful in challenging children with both LD and ADHD. Printing requires that children understand the purpose and meaning of each part of the process, and the necessity of having discrete locations for each to have a successful outcome. Children see concretely the cause and effect relationship of transgressed boundaries: printing ink where it is not wanted, wasted materials, and aborted or ruined results. Time is an abstract concept that can be made concrete by the strict and unyielding laws of time inherent in artistic processes. Art teachers know that children easily learn the spatial principles of foreground and background and parts and wholes through the cutting and pasting of collage. Paint and clay dry at their internal rate and artists must submit to them. Because the arts are so engaging, they readily become the genesis of organization so elusive to children with LD and ADHD.

The same is true for songs and stories. Our love of song, says Ackerman (1995) harkens back to the womb. Our brain and nervous system incline toward specific intervals between sounds, particularly the iambic pentameter of the heart beat so soothing to children. This primal beat is the genesis of our spatial ordering; how we regulate and order the world creates predictability and, therefore, comfort. The geometry of math, art, and architecture do not exist in nature, but rather serve as the "super order" of culture. Geometry controls space in the same way that rhythm and repetition control time.

Our response to the "spatio/temporal structures" of the arts, says Dissanayake (1992), dates back to the preverbal and presymbolic evolution of our species. Perhaps that is why Deborah Koppman (2002) says an overly analytical use of the arts diminishes imagination. The emotional response to art is what matters most and not easily put under analytical scrutiny. Making art gets under our skin and changes us at the core, which is why verbal communication as intermediary is not necessary for understanding or translating feelings. Making art challenges our whole body in a process that matches internal thinking and feeling with their external manifestation (Howell, 1977). The value that art has for LD is that it helps to make the link between body, thought, and language. Similarly, meaning is inseparable from the sound, shape, and rhythm of words.

> Linguistic meaning is not some ideal and bodiless essence that we arbitrarily assign to a physical sound or word and then toss out into the "external" world. Rather, meaning sprouts in the very depths of the sensory world, in the heat of meeting, encounter, participation. (Abrams, 1996, p. 75)

Bodily sensation is the bridge from which our ego propels into the world. If those sensations are disturbed or disordered, then our contact with our surroundings is diminished or destroyed altogether, which is what happens with the disordering effect of disabilities. Artistic materials that remind us of the inseparable link between body, language, and other human-made signs promote the smooth transition from self to world, the body's drive for homeostasis discussed later in the chapter.

Learning from a Preschool

The Reggio Emilia early childhood schools in Italy are well known for their work with the visual concept of shadows and the abstract idea of time, both important early spatial and sequential learning, respectively. Children in preschool are just beginning to learn the words that describe spatial and temporal concepts. Older children with LD need to return to this earlier stage of making links between life and abstraction, but in more sophisticated ways.

Reggio Emilia educators use the arts to reinforce primary abstractions with concrete examples from life. Thus, they set the stage for life-long inquiry through observation of the physical world. Young children are

guided to look at the world with sustained curiosity and then manipulate artistic materials to test their hypotheses. To assist young children in their "research," the teacher must be committed to a culture of investigation in the classroom and allow children to lead the way, as authors and inventors who bring with them their own interests and knowledge base. The educators make the distinction between teaching and learning which means that children learn more often not what the teacher intends to teach, but what they need to know. If teachers support self-motivated learning, it will come from children's first-hand explorations, rather than second-hand from teachers. Learning takes priority over teaching when we prepare the conditions for teaching what children want to know rather than what we want to teach. This paradigmatic shift is even more critical for the child with LD.

Smith (2001) emphasizes the learning possibilities of the arts beyond their traditional use as tools for expression and therapy. In both Smith and Reggio Emilia's philosophy, materials assist children in learning how to learn. Artistic materials are not only important for their aesthetic or therapeutic value, but also as tools of communication in a variety of contexts. Creativity is not sacred, says Malaguzzi (1996) founder of Reggio Emilia, "we do consider it as extraordinary, but rather as likely to emerge from daily experience" (p. 70).

Time management becomes the crucible that children with LD must overcome to succeed at the many tasks at school, and certainly later in life. Pacing oneself becomes the obstacle that prevents both teacher and student to successfully bring a lesson to completion while achieving its intended goals. For Malaguzzi time needs to be understood for the task master it is. To master time one must first thoroughly observe and understand it.

The generous giving of time to children's interests is essential for the slow maturation of children's ideas. The complexity of thought involved in art making is possible only when time becomes a useful tool rather than an obstacle or limitation to be negotiated, manipulated and, finally, conquered. The depth of the children's investigation into an idea and its communication and concretization into materials would not be possible if it were not for the luxury of time. Such Reggio Emilia philosophy often exasperates North American teachers because it asks them to challenge the system despite the paltry resources and limitations of schools, not least of which is time. However, Malaguzzi asks us to make a leap of faith: to move what seems to be the immovable status quo. He invites teachers to enter the time frame of the child, " the full, slow, extravagant, lucid, and ever-changing emergence of

children's capacities" (p. 74) whose interests emerge from within the activity itself.

The educators view time with children as sacred and, therefore, interruptions do not take place. Bells do not stop the learning process, nor do telephone calls or the occasional teacher who drops by. Children understand interruptions for their tacit message. School time is regrettably more often controlled by the clock, evident in the forty-five minute bell, falsifying the subjective time of children. John Gatto (1992) argues that bells send children the message that what they are doing is not sufficiently important that it could not be interrupted. "Bells are the secret logic of school time....Bells destroy the past and future, rendering every interval the same as any other" (p. 6).

The Arts and the Memory System

Short Term, Active Working, and Long-Term Memory

"Memory is a multidepartmental operation that does its work at many diverse brain sites" (Levine, 2002, p. 91). But no one, says Levine, can excel in all departments. Memory is the seat of learning that allows information to be retrieved and applied. A flawed information filing system renders children unable to transfer and globalize information. It must be learned each time and in each context.

"Short-term memory is learning's front entrance" (p. 94). Short-term memory holds thoughts just long enough to either act on them or send them to long-term memory. Teacher directions fall within this category and, therefore, the more diverse the modalities are that teachers use, the more children with LD are able to process, retain, and retrieve information. Because children with LD are often visual thinkers, they will retain information that they see. Traditional auditory transmission of information alone is not sufficient.

Levine suggests that teaching and practicing recoding (or paraphrasing) does wonders for the memory. In the lesson plan suggestions in chapter nine, emphasis is placed on recapping dialogue among children, and children and teachers, which serves the purpose of synthesizing information to make sense of it and commit it to memory. The more teachers ask questions and then restate the children's responses in lieu of directions, the more internalized information becomes.

Thus, unlike children with ADHD who lose attention when information is too slow in its transmission and uninteresting in its content,

children with LD benefit from a slower delivery and highly organized and thoughtfully delivered content. Children with LD are attentive but their short-term memory is unable to make use of the information. While children with classical autism usually have prodigious memories without perceiving their experiential meaning, children with LD cannot remember and, therefore, cannot make meaning. A dysfunction in the active working memory makes reading for meaning problematic. This memory system normally holds many ideas in time so that the intention to do a task remains throughout its doing and completion. Children with LD, however, cannot retain the meaning of what they read from the start long enough to make sense of it by the end. Reading is a complex set of processes that must integrate sound and sight in order to have meaning. Children must learn to visually track and scan words, sort, classify, categorize and label information, recognize parts that make up a whole, break down the whole into parts, understand concepts expressed in words, understand that marks, sounds, and patterns represent an object or idea, and so on. Children with LD are unable to integrate all these processes at once. Unable to prioritize the overwhelming mass of sensations, they attend to everything at once. However, the job of the arts to sort color, shape, size, and position through one's senses and muscles is exactly the training that they need in order to learn. The organization of action and progress in the spatially linear way necessary in an artistic project is what is needed in order to read.

One of the jobs of the working memory is to hold multiple intentions of a task at once. If a child with LD gets stuck in one of the many elements of the task, then the whole process unravels. The problem for the child with LD is her inability to act on more than one part of the task at once. This attention to what is known as *detail* is the bane of the LD child's existence. What might appear to be willfully careless is in fact a limitation of the working memory. It is this working memory that must be intact in order to read and relate verbal sounds with visual symbols. The gestalt of the arts provides a good arena for children unable to synthesize details into a cohesive whole. They are intrinsically organized so that children can lay the foundation of learning upon sensory information, muscular movement, and rhythm from which abstract and conceptual thought is derived. Through the formal elements of art, such as color, form, and line, children are encouraged to discriminate by using their hands, bodies, and eyes. The art product serves as the physical reminder of perceptual learning that lays the foundation for further learning.

It is in the long-term memory that information is stored and filed so that it may be retrieved as needed. Children with LD are lacking the ability to store information systematically, an ability that is developed seamlessly in early childhood and continues to grow throughout life as we deal with greater and more complex knowledge. In addition, the kind of retrieval of information required in school is mostly convergent: the right answer to the question (Levine, 2002). Many children with LD can retrieve information divergently, which means less precisely, or with several possible answers. This way of thinking is more creative, but unfortunately, as discussed earlier, schools do not value divergent thinking as often as they do convergent thinking. In any case, children with LD are able to learn to think convergently, but they need more time.

By the time typical children are ready for school their brains have mastered the ability to generalize and globalize information. In other words, they are able to recognize the bigger picture and transfer information to another context. Children with LD, however, cannot separate superficial differences and see similarities of information. Each event or learning experience appears to them as a new entity. They are unable to build knowledge, and so it is bereft of both continuity and meaning. What most children do effortlessly and unconsciously, children with LD do laboriously. And without automatic recognition of information, children cannot progress onto more challenging work. It is far better that teachers show students *how* to accomplish a task rather than teaching the task itself (Smith, 1988).

The teacher must find the right fit so that learning can be transferred beyond the context of the subject matter. Usually the right fit means finding a student's special interest or ability. Distinguishing which came first, the specialized ability or the interest is difficult to assess in a child with LD, and probably it is a combination of both. Do children have a special interest because they have a specialized ability, or do they have a specialized ability because of their special interest? As Smith has found repeatedly, the several arts appeal to both ability and interest, and they can be generalized into other subjects.

The Arts as Knowing and Learning

The Search for Equilibrium

We are born responsive to external stimuli, our behavior the result of a balance between our genetic make up and the environment. Even the structure of our bodies is the result of seeking equilibrium. The

fact that we stand upright and move horizontally is our species way of accommodating ourselves to the environment. With our eyes, mouth, and nose leading the way, we have been designed to move in a horizontal direction in search of food (Lebost, 2008).

Like our body, our brain is also shaped and built upon the transaction between self and its environment. "The body edits and prunes experience before sending it to the brain for contemplation or action" (Ackerman, 1991, p. 304). The basis of storing our perceptions of things in the world begins with categorization and classification so that we survive amid a cacophony of stimuli and learn in greater complexity over the life span. This is the important learning of the preconcrete, or early symbolic young thinker.[3] By the time children are five-years-old, they have begun to understand the primary concepts of abstraction by making relationships between one concrete category and another until the common qualities of each emerge. Part of our biological adaptation to the environment is to make what we experience fit into a schema; we need to see *relationships* in order to learn.

Play, discussed in previous chapters, is essential not only for human learning, but also for the broad spectrum of species on earth. But only human beings use the learning in play to develop an information base. Play invites children to categorize and classify by using their bodies as their reference point. In this regard, children with LD will need more time to play in order to catch up to their peers. However, play does not come easily for them because of their disorganization and problems with sequencing, language, and motor skills.

The created worlds of art and play reinforce classification and categorization. During play children make concepts that lead to generalizations and comparisons of experience, and learn to separate differences and similarities such as tall/short, big/small, round/square. Art and play are inextricably linked as children learn to distinguish one color or shape from the other. One only needs to look at a cross section of children's early symbolic art work to affirm that they are making sense of what they know from direct experience. The generic early symbolic enclosure meant to represent "person" is soon classified by gender and function, such as mother, father, and siblings. Once this learning is sorted, it is filed into categories for later retrieval and use. This process is vital to success in school and later in life, and it must be in place before school begins so that children might later access needed information on command (Smith, 2001). These schemas are organized systems of knowledge that assist us in remembering and, therefore, understanding our stored information. Each child experiences his own environment

through individualized schemas—the cognitive structures that come from experience. Therefore, with the building of experience we constantly reconstruct this knowledge base. If their filing system does not work by the first grade, children will continue to fall behind. "When there is no schema, there is no 'hook' on which to hang new information" (p. 38). Previously learned information will not be remembered and therefore cannot serve as a foundation for new learning. A structure needs to be created that activates previous experiences for children who are neurologically immature. Since children with LD are not able to establish these relationships on their own in their early years of life, they will need the support of a helping adult. Teachers can be facilitators of knowledge, guiding and stimulating students through trial and error, emphasizing interaction with the environment and experiential learning.

New pathways of learning are made through the body-self when children submit themselves to a consuming experience. Art making requires both sensory and conceptual participation, so it provides us with a vehicle through which to form new ways of storing and organizing information. It can be used as the hook on which to hang new information for children who need help remembering through their muscles and the physicality and concreteness of materials. The canvas or sculpture becomes the external memory creating continuity from yesterday to today—the visceral and visual symbol of abstract and concrete, internal and external experiences.

Children with LD need help making sense of the information coming in through their senses and understanding their own physical boundaries (Smith, 2001). They need an inscribed space to work, a judicious amount of materials, directions given one at a time, and a limited number of choices. The physicality of the arts and its direct connection with one's body might provide the parameters within which they can organize their bodies in space. Sculpture and other three dimensional media are particularly helpful to children with LD because they can work in the same dimensions of their bodies.

Because children with LD are not only unsure of space but also of time, they will need help beginning, sustaining, and completing projects. They understand the length of time required in each phase of a process if it is compared to such concrete experiences as, for example, traveling on the bus to school. Breaking directions down into parts—known as *task analysis*—helps children make sense of verbal directions critical in the physical completion of a project. But they will also need help in understanding the larger goals of the project.

Art projects might begin with foundational sensory knowing, but the process quickly engages children in idea making. The manipulation of materials suggests the relationship between physicality and abstract symbolic ideas that evolve as they provoke memory and experience. For this reason materials that are transformable rather than prescriptive are critical in making the connections between concrete and abstract knowing. These materials also have the internal laws of order that can be analyzed and internalized. Prescriptive materials do not have a logic, sequence, or discipline that children can master and apply to their challenging subjects in school. Within its reliable structure and the closeness of the arts to our sensory understanding of the world, children might more easily learn to self-organize. The following paragraphs describe an example of how the body serves as the starting point for observation, categorization, and memory.

A Self-Contained Bilingual Art Classroom

Student teacher Samantha Quinn was at the end of a self-portrait and mural project with a small first and second grade class of bilingual children with LD. They were working on the same project as the regular classes in the New York City elementary school, and so it was interesting to see how she adapted the lesson. Like the regular classes, the children in the self-contained class began by studying their faces in the mirror while exploring their eyes, eye brows, and eye lashes. Samantha gave the children problems to solve and choices to make, such as choosing the right size brush and the right skin color which they brushed on their hand to insure its accuracy. They then learned that they might need more white, yellow, blue, or red to make a lighter or darker shade of brown. Once the portraits were completed the class discussed the concept of background. The backgrounds of portraits have a richer meaning for children if they see how other artists have used them to enhance the psychological mood or personality of the subject. Samantha showed how Freida Khalo, Vincent Van Gogh, and students in the school enhanced their self-portraits by choosing to put significant places and objects in their backgrounds. But rather than individually painting backgrounds, they decided to make a group portrait in a playground, their favorite place.

On the last day of the project the children put on the finishing touches of their self-portraits preparing them to be collaged onto the background. Samantha and the supervising teacher were building on the previous learning of the lesson in which the children studied their

faces. Reina, David, and Andrew worked with their paraprofessionals to find the right materials to accessorize their figures. They used yarn for hair and buttons and zippers on their jackets, and made decisions about gluing and cutting with a minimum of direction. Unlike the young children with ADHD and autism at Morse Magnet School in the previous chapter, the children were quietly, almost solemnly concentrating. Samantha prepared them for the end of class and the adults helped them place their figures in the playground.

While David puts his figure next to the slide and Reina puts hers next to the monkey bars, Andrew is getting a lesson in how to tie his shoe laces. His paraprofessional patiently breaks down the task and repeats the demonstration several times, each time Andrew does his best to focus. "One bunny ear and another bunny ear, wrap it around and push it through. Try it now." Andrew tries but falters. They begin again slowly and together. "Cross over and pull through, one bunny ear and another bunny ear." She holds the laces upright.

A few minutes are left and Samantha and the teachers use them to check for learning. Samantha has forgotten her glasses and a teacher asks the children, "Is there something different about Sam? What is missing? Samantha asks,

> "What did I forget today, Reina? Do you know? Look at me."
>
> "Your hair?"
>
> "I don't have any hair today? I feel like I have hair." Samantha pats her head. "Can you see it?
>
> On my face. What do I usually have on?" She points to her eyes.
>
> "Brows?"
>
> "Eyes?"
>
> "What do I usually have on?"
>
> "Eye brows?"
>
> "No, what do I use to see better that I usually have on?" Samantha cups her hand around one eye, but still the children are unsure.

A teacher lends Samantha her glasses that she puts on.

> "What did I forget?"
>
> "Your glasses," they all scream together.

The two dialogues above are examples of the patience and tenacity needed to encourage the learning of children with LD. Both teachers patiently searched for concrete ways to activate children's memory, make connections, and build on knowledge. They analyzed the tasks and then broke them down into manageable parts. Andrew's paraprofessional helped him learn the sequence of shoe tying by connecting each phase to a visual image. The children studied eyes, eyebrows, and eyelashes with Samantha and her cooperating teacher, and they attempted to build on that learning by asking the children to see what was not there. The spontaneity of dialogue throughout the lesson and particularly the time made available at the end is essential in not only diagnosing what children learned, but also whether or not the lesson was helpful and appropriate.[4] The concreteness of LD is evident in the children's inability to imagine what they could not see, Samantha's forgotten glasses.

CHAPTER FIVE

Emotional Disturbance and Behavioral Disorders

Overview

Nobody likes emotionally disturbed children. They are costly and unsightly warts on the clean skin of society. Nevertheless they exist in significant numbers and are tragic reminders to the rest of us that they cannot read and will not be ignored.

—Bower, 1996, p. 31

No other disability opens up a can of worms more effectively than emotional disturbance and behavioral disorders (E/BD). John Johnson (1996) writes that the field is itself disturbed, one that patches together moral, ethical, psychological, legal, sociological beliefs, and theories from conflicting professionals. E/BD might be viewed as a mirror of society on a collision course with urban and community disintegration replete with child abuse, violence, injustice, and racism.

Nor is there a disability that more thoroughly underscores the self-referential nature of labeling: how tied it is to local knowledge and sociocultural interpretations (Rhodes, 1996). Because the causes begin primarily in the environment rather than in the body, the E/BD label represents the inextricability of self and context, subject and observer. Given this fact, the perception of the disorder is culturally embedded in Western codes and standards. Because there is a predominance of nonwhite children in special education, the label's five subjective criteria[1] as well as ambiguous identification procedures invite us to engage in a self-reflective discussion of how the label is constructed,

who is doing the constructing, and if it is effective for children from all backgrounds.

I often think of a concept that Australian scholar Michele Grossman uses to define success in cultural exchanges. She says the loss of boundaries renders the "benign gesture" suspect, because it ultimately speaks to a lack of respect for difference and distinctiveness. The other is emptied out of otherness and becomes merely a part of the self, which means that effectively, the other is diminished or even destroyed as a consequence. In other words, we need to be transformed by our relationships with children in the same way we expect them to be transformed by us. "But if the expectation is only that the other will change, and not the self, then I don't think this can be considered benign in any sense" (Grossman, personal communication, March, 2007). Nicholas Long (1996), founder of the Institute of Psychoeducational Training underlines the need for this reciprocity between teacher and student, self and other. He remained in this challenging field only because of the lessons he learned, which were the inconceivability of the human mind and his own vulnerability in the process of reaching out to children who reject and abuse these overtures.

Finally, the label itself is inextricably intertwined with maintaining the system that causes the disability, and comes with a host of racist, sexist, and classist constructions (Paul, 1996). Many would agree that the density and variability of children's experiences that lead to the label demand a more affective and biographical approach in documentation. E/BD highlights the systemic effect of overlabeling, mislabeling, Euro-centric prescriptions, and conformities that have in the past demanded compliance rather than promoted resiliency and self-understanding (Johnson, 1996). "How does one liberate an entire race from its disadvantaged condition?" asks Johnson (1996, pp. 157–158). Behavior management and control, favored by the special education system, cannot empower a diverse group of children not only to overcome their past but to thrive as well.

A disproportionate number of African American males are labeled E/BD while ironically their teachers are disproportionately white females. Although many students warrant intervention that the self-contained classroom provides, cultural differences nevertheless pose ethical questions. Children not privy to white standards must navigate between the conflicting expectations of peers, community, family, and school. Johnson argues that the symptoms usually identified as E/BD, such as inattention, failure to learn, disruptive behavior, disrespect, and truancy are often acts of African American resistance

toward a system in which they are disenfranchised and see no benefit in joining.

Brenda Townsend (1996) described how she, as an African American, knew and wanted the rewards that came with compliance in school. But for the males in her family and community the stakes were higher for peer acceptance. For example, her younger brother was more interested in perfecting his swagger even if it meant punishment for inappropriate behavior by his white teacher. Her example is a text book case of the clashing of white cultural expectations with children who either consciously or unconsciously reject them. In hindsight Townsend wonders whether minor infractions such as her brother's were the genesis for the crisis facing African American males and the special education system. How many children now given the label E/BD failed in the regular classroom? Townsend argues that an increase in the quality of teacher-student relationships and a decrease of irrelevant school norms would bring back the children at the fringes in the likely position to drop out. The mounting dropout rates among this and similar populations have staggering social consequences. More than a decade ago Eli Bower (1996) wrote

> Set aside for a moment the loss of human capacity, dropouts from one single graduating class in a large urban school district will earn 200 billion dollars less than graduates during a lifetime. Each additional year of secondary school reduces the chance of being on welfare by 35 percent. More than 60 percent of jail inmates are dropouts. (p. 34)

Thomas McIntyre (1994) developed an instrument that helps determine whether or not cultural behavior is factored as negative. To avoid such misjudgment, he suggests that cultural coaching might help nonwhite students make more productive choices. Behaviors that clash with school decorum are "a more flexible view of promptness, adolescent male rejection of female authority figures, reacting aggressively to commentary on one's female family members, ritual testing of an adult's authority, etc." (McIntyre, 1996, p. 238). At the same time it is not McIntyre's intention to promote white middle-class values and behaviors. Value of one's own cultural behaviors need to be maintained while learning new (read dominant) behaviors. The even more challenging question is how to address the sub/street culture. Unfortunately, the mismatching of educators with students causes more emotional stress that creates more of the same unwanted behavior. The

often-abusive placement process alienates children from the start. "No one has researched how much of the aggressive behavior put out by children with E/BD is reasonable reaction to provocation of bureaucratic systems and arbitrary adults" (Morse, 1996, p. 254).

Struggling with Definitions

> Emotional disturbance is a drama of individuals (children, families, teachers) and systems (schools, home, community, and churches, synagogues, and temples).
>
> —Paul, 1996, p. 297)

Many educators object to the term *serious emotional disturbance* (SED) used by *the Diagnostic and Statistical Manual of Mental Disorders-Fourth Edition* (DSM-IV) because of its marginalizing effect. The favored term by educators, E/BD, continues to transform as the field debates and disagrees on its meaning. However, the official federal definition has not changed since 1977. The issue, as alluded to above, is the subjective perception of what the disability is and who it should include. The ongoing friction (and fiction) of labeling has produced the term E/BD for now, although the federal law as enacted by the 1997 Individuals with Disabilities Education Act (IDEA) continues to use the term "emotional disturbance." However, E/BD has become the choice of many professionals and parents as well as the National Special Education and Mental Health Coalition who believe that when the term is used alone, emotional disturbance is stigmatizing and does not describe the complex issues. For others the term *behavior disorder* lacks the meaning and depth of the internal causes that produce the behavioral manifestations of the disability. There are still others who say that the very debate about the definition is representative of the problem: the polarized way that we perceive situations as either/or. Finally, there are educators who are not only skeptical of categories, but also question their efficacy and relevancy. Do categories tell us which interventions will work and what can be expected in the future? Can a generic description explain the within-category variance or describe a living child? The label debate invites us to ponder the political and moral responsibility we have in its making.

There are, however, several behaviors that educators agree characterize this label. A few are: unmotivated, withdrawn or overwrought, disruptive, disrespectful, aggressive, and violent. Notwithstanding the

inseparability of nature and nurture, these behaviors are socially learned by children in response to isolation, abuse, and neglect. Given the size of regular classrooms, the lack of experience of regular teachers, and the children's inability "to manage their own inner curricula sufficiently to attend to material presented to them from the outer world," children with E/BD are generally found in self-contained classrooms (Bower, 1996, p. 32).

Children medically defined as emotionally disturbed before 1975 were considered uneducable until Eli Bower's (1960) seminal social reinterpretation of the disability influenced federal legislation. Against the prognosis of the medical field, experimentation began in the early 1960s that tested whether teachers could adequately be prepared to work with this population in the classroom. Children with behavior problems had been expelled from school and were creating a critical mass in the communities. Not enough or adequate public services existed, particularly for the poor, that could hold down the large numbers of young adults heading for correctional facilities and psychiatric hospitals. The teachers were reeducated in a program conceived by Nicholas Hobbs and funded by the National Institute of Mental Health. Since coming under the domain of education, teachers and administrators have been searching for the best way to serve children with E/BD. At the same time children are experiencing an escalation of violence in their communities as never before, such as shootings, substance abuse, domestic violence, poverty, and loss of parents to murder or imprisonment.

William Morse (1996) warns that no one is responding to the entirety of the child. Many educators have now found that the classroom is too limited an environment to offer the social skills, security, bonding, and culturally sensitive support and teaching that they badly need. Services in the community have been called upon to help create a larger environment in which healthy and "normalized" experiences can occur. The isolation of the classroom does not allow for a comprehensive approach to the multifaceted needs of children and their families, in whatever reconstructed form they may be. Morse advocates for the Full Service School in which parents and children can receive economic, housing, social, and therapeutic support, and where each agency is aware of what the other is doing.

If the Full Service School is out of reach for now, then community organizations might serve the same purpose. Shirley Brice Heath's[2] (2000, 1999) extensive research found that community organizations, and particularly arts organizations, fill the institutional gap left between families and schools in economically disadvantaged neighborhoods. She

found that aimless activity during the critical hours after school in both urban and rural settings indicated that adolescents did not have sustained quality interactions with adults. Heath (2000) asks how learning might be made to work in a globalized world. Individualized learning is losing traction in a global society that needs cooperation to survive. "Learning is not an individual gain but a continuing communal commitment, going even beyond life work, that self-chosen work we do to sustain our spirit" (pp. 42–43).The intergenerational nature of community projects resolved this problem. "They (arts organizations) encourage young people to develop multiple talents that place 'intelligence' not just in the individual, but also in group collaborative effort and resourcefulness for community benefit" (Heath & Smyth, 1999, p. 8). Arts and community organizations have multiple results not only in engaging youth in productive activity and learning critical career skills, but also in exercising their social responsibility through civic engagement. Of three types of organizations, the arts-based organizations were the most successful. More than athletic-academic and community service organizations, arts-based organizations have the potential to partner with other organizations.

Most crucial was that the youth based organizations' planning, organization and management would be run by adolescents so that they might have a direct impact on their neighborhoods and, at the same time, apprentice adult roles. Their own roles in the organizations were fluid, rotating among hosting, directing, fundraising, accounting, as well as artmaking. Role playing is invaluable in learning social and civic responsibility and, as artists, adolescents learn why representing more than one's self and self-interest matters. Youth get the chance to extend their frame of reference into society, taking on a fuller identity beyond the limitations of school, family, and poverty. They become the authority that they once defied in school, turning their at risk status on its head (Heath, 2000).

Possible Causes and Cures

> I believe we are not born civilized beings but come to be human through the investment of the societal caretakers, which I admit leads to linear reasoning.
>
> —Morse, 1996, p. 267

The external and internal environments are fundamentally intertwined, and, therefore, E/BD effects not only the social behaviors for which

it is labeled, but cognitive behaviors as well. Children with E/BD are often a good two years behind the academic performance of their peers. They might exhibit autistic-like behaviors such as withdrawal and/or outbursts of mystifying rage. Recent research has offered convincing reasons for the similarities of E/BD and autistic behaviors, which also supports the theory that our external and internal lives coexist in a constant balancing act beginning in infancy. A definitive cause for autism continues to elude us although we know that there are often genetic and biological causes that begin early in life. E/BD also begins early in life, and while it is not generally considered the result of genetic or biological causes but a complex combination of both, including environmental causes such as neglect and/or abuse by caregivers. These early days and months without care determine how we will perform and interact with the environment for the rest of our lives if no effective therapy redirects us toward more balanced relationships.

Stanley Greenspan, Clinical Professor of Psychiatry and Pediatrics at George Washington University Medical School has been working with infants, both typical and autistic, and arriving at compelling theories. He theorizes that the emotional systems give meaning and balance to the language/cognitive/rational systems as early as the first few days of life. Our emotional systems are foundational in our ability to plan, sequence act, interpret, understand, focus, and make meaning from both visual and verbal symbols. In chapter two we saw that some individuals with classical autism mentally archive photographic memories of visual images that can be retrieved at will. But the images are often without affect, disconnected from emotional experience. Conversely, "Meaningful words involve emotionally rich images.... Therefore, to create a meaningful symbol, the image must be invested with emotion" (Greenspan & Shanker, 2004, p. 25).

Greenspan and Shanker's theory explains how the ability to form intimate relationships depends on the ability to form symbols—two important factors in language development. Language, although existing as potential, will not be manifested without the social need and desire to reach out to the world. Therefore, the construction of symbols is ultimately what allows us to unite as social groups. Although it is well known that classical autism is limited in all the above behaviors, it is also true for children with E/BD depending on the severity of their neglect and/or abuse. While children with classical autism come into the world ill equipped to bond with their mother despite her overtures, children with E/BD are often ready and willing but their overtures are rebuffed. When these overtures are mutually responsive and sustained

by infant and mother, they become what Greenspan calls co-regulated, reciprocal emotional interactions that lead directly to symbol formation. These nonverbal, playful interactions are deeply imprinted in our bodies and psyches.

Our caretakers help us make the crucial connection between gesture, sound, and meaning (Greenspan & Shanker, 2004).With the continuation of this relationship throughout the crucial early developmental years, children learn that words and images are carriers (symbols) of the meaning made from their experiences. This theory, as we have seen in chapter two, describes the classical autistic's inability to find relevant emotional meaning in verbal and written texts. Even when speech is available, the social and emotional meanings of words often are not. Rather, they are empty symbols whose connections are unknown, and which make problematic the development of a coherent self who can interact with the world through a symbol system. The ability to symbolize, label, and categorize is the foundation of consciousness, self, and self in world. Without the continuous physical and emotional support of the caretaker, an infant will not grow to learn what is consistently me and not me. To a greater or lesser extent, depending on severity, the inability to distinguish fantasy from reality is a feature that is shared by children with both E/BD and autism.

As suggested earlier, the inability to form a distinctive, emotional sense of self is the root cause of the inability to organize, sequence, rationalize, plan, and interpret our own and other's behaviors. What was traditionally considered independent but accommodating functions in our brains now appears to be interdependent. Along with normative development comes socialization through which we come to know ourselves at more complex levels. For the child with E/BD, the transition into socialization is prohibited by the shifting ground on which he has grown up. Without a self defined by early relationships, a child cannot embark freely on an expanding self defined by the social group, and instead will reduce opportunities of growth by compulsively and rigidly protecting herself from what she perceives as a threatening environment.

Fight or Flight

Children with E/BD are well known to act before they think. Because of the associative power of emotions, the symbols that they have internalized are not only misinformed but rigid as well. All that is needed

for a child with E/BD to be reduced to a fight-flight response is the semblance of the original threat. Considering that the original threat to his existence might have been internalized before verbal symbols were formed, the images that remain are as inexplicable to him as they are powerful. As Greenspan and Shanker (2004) point out, it is the symbol that separates our perception of a threat and our response to it. Without the healthy creation of symbols, children cannot make this separation. As a result, children with E/BD live in a state of emergency. Rarely do they experience a state of relaxation in which they might think, reflect, conceptualize, and learn.

Daniel Goleman (1995) describes the reactive process as the quick and dirty approach to threatening stimuli. These behaviors are the primitive survival strategies we have carried with us from our distant past as we evolved as a species, and which early in our evolution created a direct pathway from the thalamus to the amygdala, the latter being the oldest part of our brain and the seat of emotions. In fact, we are never aware of the full picture of an emergency, nor is it processed by the thinking brain (cortical centers) and, therefore, it is not fully conscious. When these emergency responses go awry, as they do with individuals with E/BD and posttraumatic stress disorder, they create havoc in the environment. As Goleman says, it is the job of emotions to act, an impulse that has been engraved in us. How we as a species have tempered emotion is explained through what Greenspan and Shanker call "emotional signaling."

Helpless, we come into the world with primal reactions to our environment. Only emotional signaling—the sound, sight, and gestures of a reassuring mother or caretaker—can assuage our fears. By the end of the first year emotional signaling modulates the infant's anxiety and she learns to internalize and regulate her emotions. She is, in effect, learning from her caregiver to make connections between the emotional center and the developing thinking center, or neocortex. Without emotional signaling the world is at odds with the infant's desires and intentions, and prevents him from learning that the world is a safe place in which to explore and grow through the motor and sensory systems.

Emotional Responsiveness

To communicate with the environment we must desire to do so, which is particularly evident in people with classical autism. In many cases their sensory system is so hyper- or hyposensitive to stimuli that it

overrides this basic need. As Judith Bluestone (2008) says, given the choice to survive or socialize, the child will choose to survive. A chaotic interaction with the environment produces a lack of stable intentionality from the infant and continues to become even more apparent as the growing child is invited to engage in a more complex social system. Typically, our first experiences are made through our senses that are "coded" by their physical properties from which we construct an emotional world, each perception having a physical and emotional response (Greenspan & Shanker, 2004). Greenspan and Shanker use the example of a hug that feels either tight and secure, or tight and frightening. As we build our cognitive understanding of the world, our primary emotions grow in their complexity, and our transactions with the world shape us into unique responsive beings. When our bodies are not instructed by our caregivers to respond to life with the necessary life affirming emotions, we will not develop a wide range of emotions. This limitation of emotional response is what we will see in children with E/BD.

A broad range of emotional responsiveness is critical in the growing autonomy of children. The early physical and emotional responses generated from our sensory system allow for their natural integration and leads to purposeful communication, and later social problem solving. As we become integrated as emotional, motor, and sensory beings, we are able to engage flexibly and reciprocally with our environment. Children with both autism and E/BD are lacking in the sensory integration of words, images, and motor action and, therefore, are unable to acquire the nuanced and sophisticated emotions that come with development.

Because emotional interaction is at the root of integration, revisiting emotional interactions missed during critical development will help redirect children toward a greater engagement with the world. However, we must devise emotional interactions that are developmentally appropriate for children while making up for the missing pieces of early development. The playful interactions between caregiver and child are crucial in developing motor patterns such as attention, sequencing, and planning. But as Bluestone (2008) explains, a seventeen year old is not going to be willing to play patty-cake with his mom or crawl on his hands and knees in a patterning program that increases organization in the brain, but he will play ball. A repetitive game of tossing the ball and catching it accomplishes the same thing as patterning, and the adolescent is at the age where he needs to do his patterning socially. "So when my buddies come to ask me if I can shoot some hoops, instead of

saying 'nah' I haven't finished my crawling yet, I can say I haven't finished my warm ups yet. But there are some balls over here if you want to join me" (symposium). Using games and, of course art, disguises these much needed interactions. The trick is turning art into a game and a game into art.

Greenspan and Shanker (2004) describe the growing brain as performing a two part process:

> From our clinical observations, it appears that emotional or affective transformations serve as organizers of the central nervous system. They create connections between the lower and higher brain centers and coordinate the parts dealing with the parts that plan and sequence actions and the parts that symbolize and interpret experience. (p. 273)

The rhythmical timing of emotional signaling increases neuron connections in the cerebellum (which integrates sensory perception and motor control), but it also affects the prefrontal cortex because it is where sequencing, problem solving, and emotional regulation are supported. And more importantly for children with E/BD, emotional signaling also helps make connections between the limbic system and prefrontal cortex. If neural connections are not established with the caretaker's support, children will be unable to modulate, discriminate, represent, and reason through negative and positive emotions. Needless to say, dysregulation between emotion and reason have long-term effects on general development. Empathy, which often baffles children with autism and E/BD, begins with early sensations provided in a stimulating and healthy environment. "In other words, the depth, quality, and subtlety of one's inner life depends on the depth, quality, and subtlety of one's relationships and their emotional interactions" (Greenspan & Shanker, 2004, p. 290). The child's ability to experience and share subtle and nuanced emotional states depends on the sensitivity with which the caregiver responds to emotional overtures. Neglect and abuse not only prohibit subtlety, but also disrupt the potential altogether for a functioning emotional life. Without a stable ground on which to experiment, the child never achieves the texture of consciousness that is the backdrop for a healthy range of emotions. The erratic and incomplete partnering between parent and the child limits her to the global emotions of survival, such as fight–flight, a typical reaction to environmental triggers for children with E/BD. Ultimately, they do not have the reflective ability to not only experience but also label

and discriminate among a range of emotions. Without intervention the child with E/BD will not grow dynamically toward a strong sense of emotional differentiation of self in the world.

Greenspan and Shanker also point out that there are more pathways from the limbic system to the cortex than the other way around, which indicates that our emotions influence our thinking more than our thinking influences our emotions. In "typical" development, emotions and reason coexist harmoniously, with emotions playing a necessary role in forming reason and logic (Damasio,1994, 1999, 2003; Goleman,1995). Greenspan and Shanker's new twist to this now accepted theory is that through co-regulated interactions with caretakers, emotional signaling guides cognition.

Our Human Roots

Several neurobiologists, microbiologists, behavioral scientists, geneticists, and other medical practitioners have written extensively about the development of our species since its appearance more than 200,000 years ago. Particularly alarming is how our species continues to resolve emotions in ways that are embarrassingly similar to our nonhuman ancestors. Greenspan and Shanker (2004) take a larger leap and trace our cultural learning back to primates. They theorize that while we come with the same equipment as early humans, we developed by dealing with the cultural changes that were specific to geographic locations.

Lev Vygotsky (1986) theorized that thought processes began with verbal and gestural communication between child and caregiver and later internalized by the growing autonomous child. Similarly, Greenspan and Shanker (2004) explain that through the process of emotional signaling each generation learns all over again from its caregivers how to master the global emotions that, without thought, reason, judgment, and reflection, are bound to have catastrophic effects. Emotional signaling allows us to create the symbols by which we will live out our lives in peaceful harmony with each other rather than succumbing to the unregulated beat of our primal instincts. Emotional signaling allows for symbol creation, which creates the "idea," giving us the space and time to evaluate the emotion, and thus separate it from possibly destructive action. We then live by these emotional-laden ideas, building on them with increasingly sophisticated social skills. Greenspan and Shanker (2004) write that "what takes a baby two years to learn took our human ancestor millions of years. Remarkably,

however, we can trace the same steps in both" (p. 2). They argue that emotions not only influence how we think, but are the evolutionary causes for thought, reason, language, and ideas through the intuitive interaction between infant and caregiver.

Microbiologist Rene Dubos (1972) wrote more than forty years ago that consciousness is a representation or symbol of reality, a job we learn as infants and the ticket to the complex culture that we have created today. These representations and symbols begin with the desire to "artistically" depict our thoughts about our relationship to the world. Many theories have been written that seek to offer explanations for the decoration of early tools and ornaments. Dubos suggests that decorative activity indicates that, in the most profound sense, early humans, and possibly our predecessors, felt the need to integrate the external world within the self. This theory, like Greenspan and Shanker's, explains how out of biological necessity and our symbolic responsiveness to life, we have created an array of cultures. Symbols that are meaningful to one culture may have no or negative meaning to another, and our emotions are often stirred more by symbols than the reality that they represent.

> This transposition explains in part why certain human groups seem to accept conditions that others find intolerable . . . in Harlem and Watts the slum is a symbol of segregation, whereas the shanty town [of Hong Kong or Rio de Janeiro] is regarded as a step from agrarian poverty to city life with its potentialities. . . . Objective reality is misleading when it does not take subjective feelings into account. (Dubos, 1972, p. 61)

Just as our ancestor's brain's evolved with the introduction of cultural symbols, so too do our infant brains evolve as we form symbolic knowing. Our subjective selves take on greater importance as life takes on greater complexity. Therefore, even with environmental and cultural influences, we each establish a unique self responsive to life. But a child needs to be prepared to use his *self* as a reliable standard, or he will not shape the environment in a life affirming way. The healthy ego cannot transform the raw emotions of infancy with newly conceived symbols, which is the integration of emotion and reason. Children with E/BD have not been grounded in this process, their emotions remaining disconnected from thought. We have seen how this disconnection plays out on the autistic spectrum. Without the connection between the limbic system and the prefrontal cortex, children are unable to *initiate* seeing, hearing, and action in an organized way.

Children with E/BD are often described as shut down in their left hemisphere where language and logic are located. But if emotion is the foundation for thought, rather than a linear cause and effect situation, what might be at risk in both autistic spectrum disorders (ASD) and E/BD is the feedback loop in the brain in which stimulus from the environment sets off an action that then inspires a further thought and then further action.

Matt Ridley (2003) describes an idea fundamental to theories of consciousness, that the messages from neurons are changed by responses to them, which in turn alters their response. Finding the first cause of action is impossible because the senses, memory, and action influence each other in a feedback loop where the results of one process become the starting point for the rest. Even genes are locked into a circular causality; "They are cogs responding to experience as mediated through the senses.... These genes are not just units of heredity—that description misses the point of them altogether. They are themselves exquisite mechanisms for translating experience into action" (p. 275). What Ridley makes abundantly clear is that biology, experience learning, culture and society are interdependent, influence each other, and in no way at odds with each other—unless one goes awry.

Hijacking Reason

"All emotions are, in essence, impulses to act" says Daniel Goleman (1995, p. 6), each one preparing us for an entirely different response. The physiological states that take place in such pleasurable feelings as love and happiness are the opposite of what takes place in our bodies in fight-flight, anger and fear. With the emotions of love and happiness the body has a chance to rest, cooperate, and is in the optimal condition to pursue further goals. Children with E/BD do not enjoy moments of rest in which the body is able to recover from the shifting ground of environmental and emotional disruption. In the rudimentary way that might have once served us in survival, children with E/BD live their lives in a state of peril. Slower reflective thought that assesses the situation for more accurate information takes too long. The quicker response with less accurate information can make the difference between life and death.

As discussed earlier, emotions normally inform and are necessary for thoughtful decisions. However, all of us experience times when we are thrown off balance by such a powerfully negative feeling that we act

in potentially destructive ways. Later we might be aware that who or what we reacted to so passionately was only a representation of a feeling associated with a past event. A word, gesture, or look might return us to a feeling of fear or anger without our conscious awareness. Most of us have this experience only occasionally, while children with E/BD perpetually perceive danger in situations that others perceive as benign.

In terms of evolution, the limbic system, the seat of emotions, is the older part of the brain, while the neocortex, the seat of logic and reason, came relatively late. Without integration between the two we would not have the added layer of thoughts about emotions that we call feelings. The mother–child bond is a product of such feelings and the root of not only individuation and symbolic thinking, but also family, culture, and society. Although we now know that primates and a few nonprimates have rudimentary language and culture, what makes the possibility for more complexity, subtly, nuance, and variety in our own species is the greater number of interconnections in human brain circuitry. The breakdown of these connections disrupts the child's autonomy and his ability to become a proactive member of family, culture, and society.

Because of a breakdown of connections between the limbic system and neocortex, children with E/BD misinterpret messages from the environment as threatening. Neuroscientist, Joseph LeDoux (1996) describes this breakdown as a shortcut, or hijacking of sensory information from the thalamus, the brain's way station, directly to the amygdala, the part of the limbic system that processes and stores emotional responses. This process enables us to act on information unprocessed by the neocortex and not entirely conscious. Our responses to our emotions are normally mitigated by thoughtful analysis thanks to the neocortex. When an emotion is triggered the prefrontal lobes perform what Goleman calls a "risk/benefit ratio" of possible responses and considers which one would serve as the best choice in the situation; " when to placate, persuade, seek sympathy, stonewall, provoke guilt, whine" (p. 25). In our distant past this slower process, albeit only by milliseconds, might have cost us our lives.

The amygdala can perceive, remember, and direct a response. It can store unconscious memories that have occurred early in life, and these memories are stored with greater vibrancy simply because they have been formed by the brain to respond to life-threatening emergencies.

Under stress…a nerve running from the brain to the adrenal glands atop the kidneys triggers a secretion of the hormones

epinephrine and norepinephrine, which surge through the body priming it for an emergency.... The amygdala is the main site in the brain where these signals go; they activate neurons within the amygdala to signal other brain regions to strengthen memory for what is happening. (Goleman, 1995, p. 21)

The amygdala stores emotional memory as "rough, wordless, blue-prints" (p. 22). This extra-strength memory system makes excellent sense in evolution, but can wreak havoc in our present. This is partic-ularly true for a child who lives in the past and is unable to judge the safety of her present. The associative nature of emotional memory picks up attributes of the present that correspond to the past. The amyg-dala compares the present and past situation and when they are sim-ilar enough (information is incomplete and therefore never accurate), alarms us into action. When the limbic system interferes long enough, severing its connection with the working memory, the working mem-ory cannot do its job. Children with E/BD are in this compromising situation unable to learn at their developmental level.

Managing Behavior versus Behavior Management

Teachers who care about children with E/BD are often the first adults to do so. Unfortunately, most classrooms employ the "punitive no-win atmosphere" (Morse, 1996, p. 253) that create boredom and hope-lessness. Walking the fine line between nurture and discipline is a Herculean task for educators and administrators. In many cases, the project becomes the rehabilitation of the whole family (often a single working mother) in which the family is neither present nor interested, or hostile. Monday mornings, says William Morse (1996) are often the most difficult, as a week of building egos are crushed over the weekend. Nevertheless, children will feel deep ties with their families, parents, and caretakers who need to be consulted as regularly as possible—if possible. Because of the potential and existence of long-term damage in the most abusive families, ideally intensive programs with children need to begin at the earliest age possible.

Children have learned from experience that adult intervention means rejection, and in the cycle of negativity, they learn to imitate their oppressors. Trust is the currency and difficult to acquire. Therefore, one of the greatest challenges, says Nicholas Long (1996), is the neg-ativity aroused in oneself. Arousal and acting out fulfills the child's

. prophecy that adult intentions are meant to harm them which perpetuates a self-destructive world view. Coercive demands for compliance increase alienation and resistance, while hoping to win children over by "speaking their language" gains little respect. How does one maintain a nurturing yet structured classroom? It helps to set sites on the long-term goal: developing strong identities in students based on new choices.

A diminished sense of self is always at the root of violent behavior. Because appropriate emotional responses are integral to a healthy ego, dealing with emotions honestly needs to be central in a behavioral strategy. The social nature of the art room makes it a good testing ground for positive interactions. On the other hand, the often used behavioral approach places a low priority on emotion by suppressing the symptoms that give rise to behavior rather than looking for its root cause.

Punishment and Rewards

Both rewards and punishments induce a behavior pattern whereby we try to impress and curry favor with the person who hands them out. Whether we are looking to secure a reward or avoid a punishment is almost beside the point. Either way, what we don't have is the sort of relationship that is defined by genuine concern and that invites us to take the risk of being open and vulnerable— the sort of relationship that inspires people to do their best and can truly make a difference in their lives.

—Kohn, 1999. p. 58

Since the last century the overwhelming influence of B. F. Skinner has embedded behavior modification in our tacit understanding of how human beings operate. Many educators are reluctant to forgo the cycle of punishment and rewards for fear that the school system will crumble, while others cannot conceive of a viable alternative. And more problematic, many do not question their efficacy even though data has shown that long-term effects are negligible. Even the short term effects, writes Alfie Kohn (1999), do not accomplish their mission if we consider our goals of education. Instead, what we get with our "carrot and stick" is compliance. "Do this and you'll get that" (p. 31) is a phrase that Kohn uses to explain the misguided strategy of extrinsic motivation and how rewards are not far from punishment in their intent. Punitive features are built into rewards: they encourage competition and ultimately the

potential of loss, fear of failure, and diminished motivation. We need to make the distinction between conformity to rules and responsibility, and what we mean by a *good* child.

Any strategy whose purpose is control is not dealing squarely with the underlying problem. The problem of acting out, resistance, and rebellion cannot be solved in a way that encourages children to be more caring, responsible, and compassionate citizens. On the contrary, it has been shown time and again that force, intimidation, and the thinly veiled manipulation of rewards do not achieve this end. This system can only benefit the educator. "Change what they do and you have dealt with the problem" (p. 62). Control is concrete, practical, and autocratic, while negotiation is un-formulaic, time consuming, and demanding because it is democratic. The desire to learn is intrinsic and if respected children will not need extrinsic rewards. Learning as a means to an end resulting from extrinsic rewards will not be as useful and potent as learning that is intrinsically motivated (Bruner, 1961).

As any educator will tell you, once rewards (or even punishment) are used to "encourage" children to continue doing what their teacher wants to see, or not doing what she does not want to see, more and better rewards are needed. Unfortunately, once this cycle is entrenched, once children are not given the opportunity of developing self-determination through dialogue and other respectful means of communication, the need for control escalates as we help to perpetuate a culture of "out of control" children. "Control breeds the need for more control, which then is used to justify the use of control" (Kohn, 1999, p. 33). Finally, punishment and rewards abort creative thinking and imagination, and discourage cooperation and collaboration. Children with E/BD and other disabilities who lack social skills need to see the benefits of working in a group, which encourages them to imagine solutions to their inevitable resistance and hostility.

Behavior Modification and "Bad" Behavior

In the absence of attempts to understand them, even the lowest functioning children feel patronized. The expedient means of maintaining an orderly classroom environment through conformity misses the long-term goal of redirecting the limited emotions of fear and anger and expanding more life-sustaining emotions through self-knowledge. The complex dynamics of behaviors are ignored in favor of the *appearance* of socialization. The appearance of order quickly caves in with a

change of teachers and other unexpected conditions. By its own assessment behaviorism does not produce long-term change. Data shows that behaviors return to previous levels when interventions are removed.

Some educators believe behavior management to be inherently racist because the model for correct behavior is based on Western standards, and the nature of behavior modification itself, based on analytical, sequential, and mechanical procedures, is a mirror of Western thought and in conflict with the world views of other cultures (McIntyre, 1996). One distinctly Western behavior is the demand for eye contact that conflicts with African American, Latino, and Asian cultures that teach that it is respectful to look away from an authority figure when reprimanded. Public admonishments might have more serious implications than intended when perceived as "losing face" by Asian cultures. Even "catching 'em being good" a Euro-American strategy, can be at best irrelevant and at worst patronizing (McIntyre, 1996, p. 241). The problem, says Kohn (1999) is that children are getting *caught* whether doing something good or bad: the feeling of both is lack of control. What is at issue is an imbalance of power, or an asymmetrical relationship. Rather, what needs to be fostered is an internal sense of morality and optimism to break through "the diamond-hard antisocial exterior" (McIntyre, 1996, 243).

The Purpose of Art

Self-knowledge is a greater commitment than changing behavior and involves digging into problematic emotions to transform them. Rewards and particularly the coercive techniques of aversion—the flip side of rewards—create a battle of wills between child and teacher. The child is more experienced in negative attention and its inevitable escalation and, therefore, more expert at it. The momentary subduing of impulses soon gives way to even more problematic behavior. Only in a nonjudgmental environment can we hope that children will drop their defenses long enough to reveal their psyches.

The arts become useful in helping teachers cope with such a daunting responsibility. Direct confrontation of powerful emotions is far too threatening, but the raw material of the psyche can be reconstructed into symbolic representation through the image. If teachers allow students to use their own experience and resist safe and formulaic recipes, unconscious material may be brought to consciousness through the conduit of materials. If children make art on their terms they are more

likely to invest it with emotion and develop symbols that neutralize the emotion's original power.

Making art replaces destructive rituals of self-preservation that serve to ward off anxiety, fear, and anger, all of which can be channeled into symbol and metaphor. Children can also process violent imagery if teachers allow it to arise in a safe and controlled studio. When teachers and students use art authentically for these purposes, the emerging imagery becomes a *symbolic equivalent* of the emotion that eventually achieves its neutralization (Henley, 1992). The teacher will need to intuit, however, whether a student's use of imagery is intended as an honest attempt to work through conscious or unconscious material, or as an aggressive act of intimidation. As Henley (1992) says, teachers know instinctively whether or not—in the term used by art therapist Edith Kramer—the student is waving a dead rat. Children need also to understand this basic rule in which they have the responsibility and right of expressing their emotions without compromising the expression of their peers.

Artistic materials are carriers of potent emotions and if children invest their work with emotion it can produce self-knowledge, acceptance of self, and open new pathways to learning. Children can then positively redirect their emotions in a safe and nonthreatening way. "In this way, the art expression becomes the first step in actually mastering behaviors, by virtue of working through emotions instead of simply acting upon them or—the other extreme—oppressing them" (Henley, 1992, p. 200). It might be a long journey toward this first step, for children with E/BD display such formidable defenses that their imagery is equally guarded and rigid. Their defense mechanisms are more appropriate for a young child since they have not had the opportunity to develop their ego. What can initially be expected is the autistic-like stereotyped imagery reflecting autistic-like behaviors.

> These mechanisms include autistic reactions, regression, perseveration or the fight-flight responses that often trigger acting-out behaviors. The more adaptive defenses such as identification with positive role models, rationalization, intellectualization and sublimation are often beyond the reach of these children. (Henley, 1992, p. 200).

Dialogue becomes critical in redirecting children toward more authentic, emotionally invested work. Henley describes the art teacher as becoming what Edith Kramer called the auxiliary ego for the

undeveloped ego of the child. In other words, following the tenets of the least restrictive environment, the teacher needs to provide whatever support is necessary for a more effective art making experience. Through thoughtful dialogue the teacher can remove obstacles in the way of the child's satisfying experience. Nancy Smith (1998), known for her emphasis on dialogue throughout the phases of development, shows teachers how to mirror back what children do rather than imposing an adult perspective onto their work. The teacher speaks to what children do so that they might see themselves in her commentary. Dialogue confirms what they do and allows them to develop a vocabulary to talk about it. In the same way, teachers may reinterpret or mirror back other behaviors in which children have handled social interactions well.

Similarly, parallel play is an approach that gently coaxes children to break through the protective shell of autistic-like repetitive and stereotyped behavior. The teacher simply repeats the activity at the child's side while not invading his space. This leaves open the possibility for interaction at the child's invitation. In this way the teacher can intuit when children seek more variation and human interaction.

The Multisensory Approach of the Arts

In our culture we are trained to value words and analysis over experience and gut feeling. We need to make the effort to allow for the growth of possible spaces for primary experiences, to develop confidence in the truth of our own responses, and our abilities to make sense of sensual information. If our goals are not framed so explicitly in terms of merely understanding, but towards opening our students to the possibility of immersion in new and unfamiliar experiences, we might move them toward greater engagement in a larger world.

—Koppman, 2002, p. 136

If E/BD is a sociocultural construction (as all labels are to greater or lesser degrees), then as James Paul (1996) says, a more comprehensive approach to curriculum is needed. Children with this disability demand from us our emotional commitment, and they respond to our authenticity more than they do our theoretical frameworks. The visual language of the arts is more effective with this population than verbal communication, which is so often veiled in bias, politics, inflexible belief systems, and remoteness from experience. Children with E/BD,

autism, and other disabilities, having been deprived of a full range of sensory and symbolic connections, are usually not ready to trust artistic and symbolic communication. The disabilities that prevent them from robust sensory experiences will usually lead them to make art that removes them from their experience by using premade media images or stereotyped, perseverative (repetitive) schema.

> Perseveration may echo deep-seated infantile needs for security, consistency and reassurance that stem from the primal relationship with the mother who is responsible for gratifying these needs. A child who perseverates may be attempting to reclaim these unmet needs symbolically. . . . Although perseveration is almost certainly pleasurable and reassuring for the child, it usually represents an aesthetic and expressive dead end in the child's creative and mental growth. (Henley, 1992, p. 221)

Children begin to grow when they feel secure with adults and peers. The job of the teacher is to cautiously return to earlier periods of their critical development without demeaning them. Henley describes the process of extending a child's limited frame of reference as revisiting the rapprochement stage in which a safe environment is made possible by an attentive mother. This kind of intervention is called the *third hand* in which the teacher lends her ego to support a child's fragile relationship with the world. In one example, Henley (1992) uses the third hand approach along with a compelling metaphor to encourage a depressed and suicidal young man. Henley and his student worked with the metaphor of climbing a mountain that the young man borrowed from a session with his psychiatrist who compared his depression to "climbing out of a deep hole" (p. 238). He chose to represent himself perilously climbing Mt. Everest as Henley struggled to keep him alive while he slipped and dangled from the mountain. Henley suggested many life saving strategies, such as ropes and more solid ground under his feet. "In the end both of us were exhausted, having painted and repainted this piece so that it served as a fitting, upbeat metaphor for his successful treatment of his depression" (p. 239). While not disparaging his student's ideas, Henley guided him to a successful resolution. The treacherous mountain that at first overwhelmed his small figure was a metaphor for what Henley recognized as the child's feelings of overwhelming depression. The image took on the *symbolic equivalent* of the depression and the painting's success, a life and death matter.

Reggio Emilia Schools as a Model of Sensory Learning

> If we believe in education for peace from the moment of birth, as a way of thinking, then children can teach us; they welcome everything. Listening is the best expression of the human being, a new way of living that sends the message that change is possible.
>
> —Rinaldi, 2003

The Reggio Emilia schools' strategies that reinforce and solidify the early and influential relationships between adult and child serve as a model for working with the E/BD population. A large part of the reason is that from the start they included the full participation of family and community. The significance of their emotionally based learning and the creation of child–centered interactions in multiple media, strengthen connections between emotional/motor-sensory responses leading toward purposeful, creative, higher order, complex thinking, and behavior. Words are only one of many ways with which children communicate and are sometimes less relevant than the visual languages: thus, Reggio Emilia's philosophy of "The Hundred Languages." Influenced by John Dewey, Jerome Bruner, Jean Piaget, Howard Gardener, and Lev Vygotsky, Reggio Emilia teachers provide conditions rather than structures for children to learn by discovery. "Put more simply, we seek a situation in which the child is about to see what the adult already sees. . . . We need to be prepared to see it, for we tend to notice only those things that we expect" (Malaguzzi, 1996 p. 80).

Reggio Emilia philosophy suggests that emotion is at the root of idea making, logic, and identity. Unfortunately, to a great extent traditional education disconnects the important relationship between emotion and logic, and emphasizes organization and logic without the affective referents that give them meaning. The Reggio teachers develop intelligence, social skills, and morality by practicing with children how to use what they affectively experience. They do this by developing the many languages of the arts through which they construct meaning from sensory experience. Children work cooperatively in small groups without the interruptions of bells or time constraints of rigid schedules in an extended family-like environment. Ideas mature in the time of children rather than the measured time of adults in a system based on their belief that human relationships and communication are fundamental in learning. These communications are tied to the human emotions of expectation, conflict, cooperation, and choice (Malaguzzi, 1996). The

undercurrent of communication reinforces the building of identity and autonomy through the child's feeling of belonging and the mastery of visual and visceral languages. "In fact, in Reggio we know that children can use creativity as a tool for inquiring, ordering, and even transgressing the given schemes of meaning" (Malaguzzi, 1996, p. 76).

The senses are essential in the construction of complex mental images, as defined in Greenspan and Shanker's research. We normally stop making art with children just as exploration becomes complex, says Reggio Emilia artist and educator Vea Vecchi, (2003). The nuanced grey areas of art making are often the places that if reached, can tap into biological and cultural memory. It takes in-depth inquiry and risk-taking that cannot be taught through a discrete set of skills and techniques. Rather, inquiry is embedded in emotionally invested and relevant art making.

Inquiry is possible only if the materials have un-predetermined outcomes. We patronize our children with glitter, cotton balls, and Popsicle sticks whose limited possibilities for transformation leave little room for experimentation. Unprescribed materials inspire invention and discovery, which is why found objects more easily lead to unexpected outcomes. We have all witnessed children creating exotic places and stories from ordinary living room furniture. The old story of children discarding the toy and playing with the box is a testament to their need to invent meanings from scratch. Reggio Emilia schools use the floor for its great potential as a work site that can be assembled and disassembled, and offers the possibilities of creating raised and burrowing areas. Materials cover the floor and are sometimes left midproject, proof that the children's work is more important than the adult need for control.

How do we introduce children with E/BD to this kind of natural and light-hearted play with peers that they have most likely missed? These seemingly simple acts are the stuff from which self-organization abilities and identity formation are made. The capacity for cooperative play, as we have seen, is usually out of reach for children with E/BD. How might we reintroduce ordinary objects and materials that suggest rather than dictate ideas? The following method serves as an example.

An Experimental Studio

Materials suggest sensory experiences that we reorganize to conform to our ideas and make concrete our emotions by transforming them into physical form (Arnheim, 1991). Once children invest art with

emotion they become self-motivated artists. When the senses stimulate emotions that stimulate ideas that then shape materials, thinking and feeling become indistinguishable. Arriving at this process might take months or years depending on the depth of children's defenses. Joseph Amorino (2009), Associate Professor at Keane University, used the art studio as a laboratory with several of the most troubled male adolescents in the Hudson High School in Jersey City, New Jersey. The boys, considered a "problem" by their teachers, were invited to join the experiment. As a former actor, Amorino was influenced by the Strasbergian "method" that uses sensory memory as motivation for original, creative thought and action. This sensory-based method was a critical part of the students' artistic process and shaped the nature of their studio engagement: what they said about their work, the questions they asked, and their revelations. Amorino's important contribution lies in the formal structure he gives the intangible, unwieldy senses, an important source of knowing traditionally avoided in the classroom.

In early exercises, referred to as *direct sensate work,* Amorino guides the students through relaxation techniques in which they sensorially experience tactile objects, such as bubble wrap, plastic bags, whisk brooms, steel wool, and any number of other materials. They learn to focus their bodily reactions to the textures as he asks questions such as, "How does it feel against your hand, your shoulder, your cheek?" Once relaxed and motivated (Amorino says that creativity cannot function under tension), the young men graduate to their desks where they deconstruct cardboard boxes or other found objects.

As months go by, their work deepens and the exercises become more complex as students engage in *sense memory work*. At this stage, Amorino invites them to use their (now-sharpened) senses to revisit a childhood memory, possibly involving a place, event, or someone no longer in their lives. From these experiences, they create two and three dimensional works, usually integrating unorthodox materials in ways that identify their personal stories. Their concentration and self-motivation grows with the expanding playing field and the broad range of student dispositions.

It is now conventional wisdom that destructive behavior arises from boredom and the gnawing sensation that school is not relevant. But when students are engaged in self-motivated projects, behavior issues disappear. Not only did inattention and restlessness disappear in Amorino's students, but the art work that arose from these laboratory-like studio explorations also exceeded the standards and expectations

for students who are gifted, let alone students with E/BD. Traditional artistic methodology and vocabularies can be useless for adolescents in turmoil, so Amorino devised a new vocabulary to describe adolescent angst, and the means to identify, reflect upon, and intelligently and aesthetically communicate it. He assisted adolescents in creating their own verbal and visual language to deal with issues of trust, mortality, spirituality, and conflict. Their psychic material, translated into art making also made their work more visually compelling. In other words, Amorino provides his students with the same experience that artists have by immersing them in a dimensional, constantly deepening, and intensive creative process. This type of learning requires a commitment on the part of the educator, and a reconsideration of traditional teaching and lesson plan formatting.

An example of the efficacy of Amorino's approach in excavating adolescent angst is shown in the work of Jose, a young Latino student who recalled a night his grandmother went alone to the grocery store during a blizzard. Unaware that she had left, he gazed through the window and noticed a solitary image struggling through the storm carrying heavy packages. Realizing at that moment that this figure was his grandmother, he saw what her life meant. "I was angry with her for not asking me to go . . . but at that moment I saw her whole life, and her struggle, and her love . . . I saw it all so clearly." She did not have an easy life and he wanted to show that in his painting. He depicts her as a tiny, bent figure in the far right corner of the canvas, walking against the unrelenting wind and freezing snow. His aesthetic decisions were based on his need to communicate the most salient aspects of his story. The question of placing his grandmother in the painting was one of the more important decisions. He settled on the far right because she would have to cross from right to left. We read from left to right, so she must walk in the opposite direction, uncomfortably against the viewer's instincts.

CHAPTER SIX

The Blind and Visually Impaired

What Do We See? The Story of Virgil

In a chapter entitled "To See and Not See" in *Anthropologist on Mars,*
Oliver Sacks (1995) shares astounding insights gleaned from a rare occur-
rence. An adult male, named Virgil, regained sight after being blind for
forty-five years. He agreed to surgery halfheartedly because he enjoyed
his life and felt uncompelled to replace what he no longer needed. But
his new wife encouraged him and he submitted. One would think that
at the moment sight is restored the lucky patient would leap for joy at
the miracle he sees before him; that the restoring of sight would be life-
enhancing. In truth, it was not. The reason lies in the fact that most of
us are unaware of what it means to see. It is only when we observe an
individual who cannot see that we understand the difference between
the seeing and nonseeing worlds. First, the spatial and temporal orienta-
tions to life are so vastly different that restoring sight after a lifetime of
blindness is nothing less than a culture shock of seismatic proportions.
The other reason for Virgil's unhappy transition into the sighted world
is that we do not see with our eyes alone. The visual cortex, which takes
up half of the space of the cerebral cortex, is the biggest player in helping
us to recognize and interpret what our retina sees.

R. L. Gregory (1971), a psychologist of perception, explains that the
information that eyes take in from the world is coded into the neural
language of the brain and then interpreted and stored as experience.
With time we have an infinite amount of neural activity that our brain
stores as our experiences of the world. To the brain, the code and pat-
tern of each neural activity represents the object itself. In other words,
says Gregory, there is no visual image of the object in our brain, only

the pattern of neural activity. The brain is always "on the look-out," searching to make order out of sensory data, even when there is none. That is why as we stare at a series of evenly spaced dots or lines we begin to group them into shapes. Or in Gregory's example, we see faces as we stare into a fire.

Hence, the seeing of objects is a complex matter. We not only retrieve past visual experience of the objects in the world when we see them for the second, third, fourth time, but we also retrieve the built-in experience of our other senses and emotions. Experience, in turn, affects our perception as it compares the information of one object to another. Recent brain research supports this hypothesis for it appears that experience shapes the brain, just as the brain shapes experience. "Objects are far more than patterns of stimulation: objects have pasts and futures: when we know its past or can guess its future, an object transcends experience and becomes an embodiment of knowledge and expectation" (Gregory, 1971, p. 8). A young artist, John Bramblitt (2007), who began painting after becoming blind later in life, writes about the emotional complexity of seeing in his series of paintings called *Perceptions*.

> If I were to look at my mother, for instance, I do not have the per-
> ception of just one thing. I perceive the love that she has for me,
> the love that I have for her, all of the birthdays and holidays that
> we have shared together, the arguments, the apologies, and the
> thousand other experiences and memories that we have together.
> All of these single events have a purity of their own and combine
> together to form the singular ever-changing form of my mother.
> (htttt://www.bramblitt.net, *Perceptions*)

Without the neural activity of the brain, objects would not have meaning for us. In other words, we would not have an affective experience of them. Understandably, as we shall see, Virgil was not able to find meaning in what he saw. The optic neural activity in his brain for all practical purposes was nonexistent.

Illusion: Real or Not?

One of Gregory's interests was in the newly sighted individual's apprehension of two-dimensional pictorial representation of reality that gave him a reliable way to examine the brain's visual-constructive abilities. In

terms of our own interests as artists and educators, his experiments along with Sacks's observation of Virgil cast light on our assumptions about such artistic conventions as perspective that create the *illusion of space*. Gregory questioned the illusion of photography, television, film, drawing, and painting: how do we agree that what we see is, in fact, a replica of the world? There was no such agreement in Gregory's patient, S. B., nor was there in Virgil's case. For example, S. B. did not see the appearance of converging "parallel" lines as they disappear into the distance; for him the lines remained parallel. In addition, he could not decipher the test in which a cube shifts in three-dimensional space. For him, the cube not only did not reverse, but it also did not appear to be three-dimensional. "In all these cases the illusion is 'seen' (even though the mind may know the perception to be illusory)" (Sacks, 1995. p. 131).

This phenomenon is startling because it shows us how unconsciously our brain reconfigures the world to make it more palatable and coherent. The fact that we can agree on such an illusion is even more surprising. As we shall see, our visual construction of the world is highly idiosyncratic. The visual world is not given to us when we are born (Sacks, 1995), but rather, we make the visual world from scratch, according to our inherent individuality and experience. Our visual cortex, therefore, is an agent in creating our identity.

Virgil "watched" television after surgery, albeit with sound as his guide. Yet he could not see people or objects in magazines; nor could he comprehend the notion of representation itself. Similarly, Gregory reported the following: "So far as we could tell, S.B. had no idea which objects lay in front of or behind others' in any of the color pictures. . . . We formed the impression that he saw little more than patches of color" (as cited in Sacks, 1995, p. 130). Sacks quotes the physician of another patient who recorded similar results.

> We thought he knew what pictures represented . . . but we found afterwards we were mistaken; for about two months after he was coached, he discovered at once they represented solid bodies, when to that time he considered them only as partly-coloured planes, or surfaces diversified with variety of paint; but even then he was no less surprised, expecting the pictures would feel like the things they represented . . . and asked which was the lying sense, feeling or seeing? (p. 130)

So it was with some curiosity that Sacks questioned what Virgil saw on television. Virgil appeared to be following a baseball game; he was

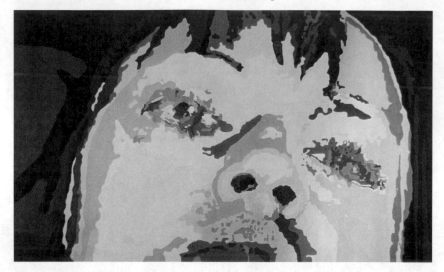

Figure 6.1 John Bramblitt. 2006. Title: Perceptions #13. Oil on canvas. 5'3 × 3'3 in.

able to tell Sacks who was at bat, and so on. Without sound, however, he was lost. What he in fact saw was light, color, and motion, and swiftly interpreted these "patches of color" with the help of sound. Thus, pictorial representation is an even greater challenge for a mind that has no precedent for it. It is, in fact, for Virgil and S. B. an illusion two times removed, or an illusion of an illusion.

Bramblitt who watched his vision deteriorate into complete blindness also challenges the tenets we hold about seeing. From his perspective seeing is not the complete and full apprehension of the world. Vision, he says, is at best second hand, the reflected light of objects. *Perceptions* addresses this illusory notion of seeing reflected light from the world rather than the object itself (see figure 6.1). He refers to Plato's *Allegory of the Cave* as revealing the many levels of perception in which sight might be a pale vehicle in grasping the extent of reality as only a reflection of the real. "For Plato the world of the real existed outside the cave; outside of the eye" (http://www.bramblitt.net).

What Is Innate in Seeing?

The reason that Virgil's sudden return to the seeing world was not a happy one is because we must *learn* to see. Seeing is the result of the

involuntary and unconscious coordination of brain and eyes early in life. Such accomplishments as our ability to recognize distance, space, and size are taken for granted. However, we inherit the potential for these abilities that we must then learn through experience. For example, if it were not for the long gestation that seeing requires, we would not be able to recognize a cube from a sphere without touching it. Without experience we would not have a connection between the tactile and seeing world.

The three-dimensional world presents many challenges for the newly sighted infant. She must learn by experience that a cat from all views is still a cat. Because of its dimensionality, our point of view from which we apprehend the object will determine what it *appears* to be. Without previous experience we would not understand that objects are constant despite the fact that they *appear* to change with the innumerable vantage points of the seer. It is because of the slow learning that accompanies the growing brain of the infant that we have a coherent experience of the world.

Then what, exactly, is out there? This question is somewhat existential because it inquires into the very nature of the external world. Through our evolution, we have constructed a world that adapts to the requirements of the environment so that we might feel relatively comfortable. Scientific theories such as quantum physics and the string theory suggest that we have created a finite structure within an infinitely unlimited universe. We know, in fact, that boundaries between so-called solid objects are permeable at best. According to quantum physics, objects *appear* to have variable characteristics depending on the nature and the vantage point of the observer. Our brains would rather not have us see this chaos.

So, is this the kind of universe that the few who have regained sight in their adult life see? Virgil describes what he saw when the bandages were removed as a confusion of light and dark, movement, and color. It was not until a questioning voice spoke that he found a point of orientation, distinguishing a human form among the chaos of reflected light. "He saw, but what he saw had no coherence. His retina and optic nerve were active, transmitting impulses, but his brain could make no sense of them; he was, as neurologists say, agnostic"[1] (Sacks, 1995, pp. 114–115).

And yet, Virgil saw color. Although he did have a vague memory of sight before losing it in childhood, visual memories had long since faded. Neurologists believe that color is innate, another mystery of the visual cortex. There is no corollary for color in the touch world,

and yet it was immediately recognizable to Virgil, albeit with confusion about how to identify each by name. He gave colors incorrect names and quickly forgot the few associations that he learned to make between the object and its color. Virgil's experience upon seeing color for the first time was described as explosive and emotional. Artists have been aware of the emotional impact of color for centuries, and it should not be dismissed as irrelevant for the visually impaired artist. We will return to this subject later in the chapter.

In addition, Virgil could readily see movement that, again, has no corollary in the tactile world. The first primitive eye evolved to see movement because of its importance for survival, alerting us that something out there might eat us or be eaten by us. This early evolutionary development still exists in the retina's edge, which is sensitive only to movement and not to shape or the identification of objects (Gregory, 1971). Virgil could see movement because its usability is not dependent on experience; it is autonomous.

Visual Concepts: Space, Size, Distance

We conceive of objects in space in terms of size, perspective, and distance. However, no corollaries exist for these *visual concepts*[2] in the tactile world of the visually impaired. This way of being in the world is incomprehensible to us (who see). Virgil spent his short seeing life connecting what he saw to the tangible things he touched, which was made easier in an uncluttered environment. In the cacophony of the city, with its buildings, streets, and cars, seeing with meaning was virtually impossible. The very existence of buildings was to him a mystery of engineering. The visual concept of cast shadows did not exist in his universe; rather, shadows appeared to be objects in themselves that he needed to maneuver around. Steps presented the same problem, and his ability to gauge the distance between them as a blind person was useless now that he could see. Bodily sensation has no "markers" for distance.

Perception for the sighted is spontaneous and simultaneous while it is sequential for the visually impaired. We, who can see, take in the world in one sweep. As we move through the world, we record general pictures all at once rather than in partial impressions. We see, in other words, the unity of the world and the infinite number and variety of visual concepts. Those of us with sight have learned to create unity within the chaos of life, the function of visual concepts. The visually impaired, on the other hand, perceive the world through touch

and, therefore, in sequential parts. The concept of the whole is rarely achieved even for the partially sighted who see only inches away. Thus, the sighted live in both space and time, while the visually impaired live in time alone. The world extends only as far as one's arms can reach and, therefore, the blind and partially blind have little, or an altered concept of space. The body becomes one's sole tangible environment in a vast and undifferentiated space.

As mentioned earlier, because people who are blind have a touch perception of the world, the visual concept of *appearance* is foreign to them. We understand how people and things change as they move—or as we move through space. Foreshortening, overlapping, concealing, and the myriad of perspectives possible depending on one's position made people and objects for Virgil too unstable to identify in all their manifestations. It is this *perceptual constancy* that we learn incrementally as infants experiencing the world, and Virgil shows us that it is the only way the world can be seen. No matter how long he studied the world of things, they were too varied to memorize mechanically. Although it is a job that human beings are wired to achieve, the potential for learning to see has an expiration date during the first months of life.

Agnosia, a condition in which one sees but without meaning, is not unlike the mental blindness of individuals with classical autism. People with agnosia and mental blindness share the same inability to see the "whole," or make visual concepts. For example, Temple Grandin had to learn how to differentiate cats from dogs. Since both have four legs and fur she needed to find a defining difference between them. Cats, she noticed, are smaller. This distinction only worked for awhile, however, because her neighbor bought a Dachshund, putting her at square one. After careful study she found that the defining difference between the animals is in the nose. How similar is the following description of Virgil's inability to synthesize parts to create a whole: "This was one reason the cat, visually was so puzzling: he would see a paw, the nose, the tail, an ear, but could not see all of them together, see the cat as a whole. . . . Even his dog, he told me, looked so different at different times that he wondered if it was the same dog" (Sacks, 1995, pp. 123, 129).

Seeing as Behavior

As we learn to see we adopt a "visual behavior." Because it is unconscious, we are often unaware of our body's participation in our

perception and interaction with the world. For example, sighted individuals focus on the speaker's face during social interactions. The seeing person is also attuned to visual nuance and cues from the speaker that contributes to the dialogue. Those of us with the full use of our senses are able to correlate them to make meaning. Again, this meaning is made, rather than given, from the building of memory and experience. The nonsighted person is not attuned to the world we have created through sight but rather to her own construction of the world. The body becomes the center of the universe, as Lisa Fittapaldi (2004) tells it, from which things come into being and disappear into undifferentiated space. Without the body and its immediate surrounds, the world can easily cease to exist for the seeing impaired unless they make an effort to reach out to it.

Therefore, the rare circumstance of regaining sight late in life enables us to probe the difference in behavior and neurology between seeing and nonseeing. Sacks describes these differences by making distinctions between looking and seeing. Looking, he says, is a visual behavior that includes seeing, but also involves movement, reaching out, and exploring. The visual behavior of looking might vanish even with the loss of sight late in life, as John Hull (1992) describes in his memoir, *Touching the Rock* and Lisa Fittapaldi (2004) in *A Brush with Darkness*. Sight memories disappear at a rapid rate so that after the first months of disorientation, one must reorient oneself with different behaviors. Sacks (1995) refers to a provocative statement from a patient who experienced such a cataclysmic identity crisis, "One must die as a sighted person to be born again as a blind person'" (p.141), and the reverse is certainly true. Virgil was stuck "between the two worlds, one dead/ The other powerless to be reborn" (p. 142).

The reestablishing of the identity of a newly sighted individual, which has few precedents, might be lonelier than the loss of sight, which has many precedents. But both demand such radical changes in neurological functions that they affect psychological functions, or identity itself (Sacks, 1995). On the other hand, according to John Hull (1992) who lost his sight late in life, although the loss might be terrible at first, it becomes less so as one makes deep compensations, "by which one reconstitutes, reappropriates, the world in nonvisual terms" (Sacks, 1995, p. 142). Other senses become more attuned. The sense of hearing of the visually impaired, for example, might be so acute that they hear sounds from great distances inaudible to the rest of us. Sacks (1995) explains the transfer from vision to hearing in terms of behavior that then shapes the contours of the brain. A hyperdevelopment of auditory-cognitive systems in the brain

occurs with constant use and increased sensitivity of the auditory system. Research has shown that two-thirds of those with adult-onset blindness achieve a high level of perceptual and symbolic awareness as opposed to only one-tenth of congenitally blind children (Fittapaldi, 2004). For Hull, living ceased to be terrible and instead became an alternative condition. Virgil's world, however, remained more mysterious the more he tried to master it.

Lisa Fittapaldi: A Painter Who Happens to Be Blind

Close your eyes and imagine yourself in a featureless space without any wall—say in the middle of a broad plain, but without cornfields or grass or blue skies. There is no up or down. You do not know if you are above or below the features of the landscape. There is no against or ahead, no along or among, or around or beneath or beside, no between or from or in front of or in or out, no off or through or toward or under, no within or nearby. All of these prepositions are abstract or metaphysical definitions, meaningless to someone blind.

—Fittapaldi, 2004, p. 87

When she was forty-seven years old, Lisa Fittapaldi (2004) became legally blind[3] with Verculitis. In the first stages of blindness Fittapaldi could see shadows but they later disappeared, replaced by a whiteness that made her sensitive to light. Verculitis is a rare autoimmune disease in which the immune system attacks the arteries causing aneurysms. But many aspects of the disease are still unknown, and it is difficult to diagnose because the symptoms imitate other diseases. Ironically, Fittapaldi lost her sight at approximately the age that Virgil regained his. Her descent (and later renewal) into the blind world teaches us as much about how we see as did Virgil's emergence into the sighted world.

We are visual creatures. Without seeing, "the brain is like a camera that has run out of film" (p. 12). We make most of the decisions about our lives—big and small—with our eyes. "We take in information about people on sight, and make snap decisions about whether to approach or retreat. We evaluate the weather and plot the steps to our destination. We are used to seeing things 'with our own eyes'" (p. 12). Lacking a continuous stream of visual reinforcement, memory of the world disappears at an alarming rate. The sighted have no need to memorize the contours and details of the infinite number of things in the

world. Seeing *is* our reminder, and once visual reminders are removed we become aware of the partialness of observation. For instance, many of us have had the experience that until we draw a face, even one we know well, we do not fully see it. The power of observation in daily life is sketchy because we see as much as we need to and no more.

In the first days of blindness, Fittapaldi felt the panic of losing the constant stream of information—the spontaneous apprehension of the world discussed earlier. The sudden lack of stimulation throws the body into shock and the mind closes down until forced to arouse it. Fittapaldi's loss, however, was later the cause for renewal. What at first felt to be life-destroying, led her toward a deeper connection to the world. Rebirth does not usually come after the loss of sight. A few individuals have ended their lives, and others descend into dependence and depression.

> When you first lose your sight, it's all you can do to breathe. Your body throbs with sensations that you can't escape for one second.... You become profoundly aware that your personal reality is dependent on context. But all context has disappeared, and you are struck by how insignificant you are in the total scheme of things. (pp. 25–26)

The world, in a sense, comes to us when we see, requiring little effort other than memory and experience. Blindness requires that we learn to reidentify the familiar and use the environment anew in the same way that Virgil relearned the world of sight. Relearning means the loss of independence, a frightening prospect, particularly for someone like Fittapaldi whose self-reliance prohibited her from asking for help. But by submitting to the intimate act of helping, she transformed denial into acceptance.

Art's Salvation

Fittapaldi's emergence from self-pity, denial, and eventual reintroduction into the sighted world began with her husband hurling a set of children's watercolors onto her bed.

> I was speechless. Livid! Stunned! I threw them back at him as he ducked out the door. "I can't see, in case you hadn't noticed. How dare you, how could you be so insensitive?"...My heart was in

my throat, my mind was racing. Breathing so hard I could have had my own heart attack, I groped, with the paints and pad, to the desk in the hall. In the bright light, with the hazy narrow band of central vision remaining to me, I could just make out the shape of a squat round jar on the hall shelf. In five minutes I dashed off a row of repeating jars just like it, one overlapping the other, each time stabbing my brush into a different color, colors I could no longer see. "Is this red, or green?" I ranted. (p. 58)

Her family and friends considered her first watercolor painting a miracle (see figure 6.2). With what seemed more to her like a conspiracy than good will, she was shipped off for two weeks of art school. Learning to be an artist also became a tutorial in being *blind in a sighted world,* a phrase she uses throughout her autobiography.

Being an art student was the pretext for getting a grasp of what space now meant. The point from A to B must be learned and then committed to memory, repeatedly day after day. The blind individual's construction of the world might be described as additive, building the world one wall at a time and turning a flat universe into a three-dimensional one. "Unless I make the effort to 'dimensionalize' them, the people, places, animals, and objects I recall now look more like the paper dolls I played with as a child, without depth or color" (p. 78).

Making art engaged her mind in so many ways that the sounds that once frightened and disoriented her now became sensory clues to spatial relationships. People became colleagues rather than unwanted witnesses to her helplessness. The sound of water dripping from the sink, a student's

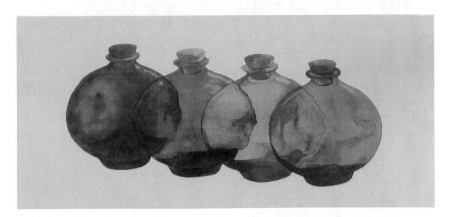

Figure 6.2 Lisa Fittapaldi. 1995. Title: Jars. Watercolor on paper. 11 × 30 in.

perfume, situated her in space. According to Fittapaldi, blindness late in
life does not make the other senses more acute. Rather, because she paid
more attention to them she was able to use data from sound, smell, and
touch more effectively. Similarly, Bramblitt not only found his other senses
more useful but also more truthful in perceiving reality. Unlike Fittapaldi
who uses representation to retain her memory of the world, Bramblitt
represents the visual world to uncover the ambiguities of perception.

 More importantly, Fittapaldi's experience revealed how interdependent
the senses are and how they work together with the brain. As she lost her
sight, she also lost her balance and her taste for food. The reorganization
of her body led to a more acute awareness of the visceral sensations of her
body, for example, when she was not in motion, things ceased to exist.
"I've learned that movement—of my hands or of my whole body—is
critical. Without my own movement to reinforce an object's three-
dimensional reality, I cannot get a sense of the whole" (p. 104).

 Making art was not only a motivating passion, but it also became
a blueprint of the world. By understanding the principles of art, she
mastered spatial awareness; in five years she was able to reconstruct
the world and hold it in memory. She found such principles as linear
perspective helpful in replacing her flat universe with depth. "Merely
imagining putting a horizon into my own mental maps was giving my
flat universe dimension" (p. 89). The concepts of art made concrete
sense in mapping the elusive placement and relationships of objects.

> For example, the apparent width relative to the length of a table
> will vary depending on where you are standing in a room, even
> though the actual size and shape of the table is fixed. The advan-
> tage to blindness is that in my world the table never changes pro-
> portions. It is always three feet by five. (p. 89)

Negative space has special meaning because, for the blind, it is as
tangible as positive shapes. She learned to use the concept of negative
and positive shape to strengthen her compositions and, at the same
time, imagine herself in relationship to other people and objects as if
framed in space. Creating a composition in two-dimensional illusionis-
tic space paralleled the configuration of the outer world.

> The shared edges where the positive and negative meet are my
> compositional reality. There is always a frame, or edge, to my
> navigational field, beyond which my knowledge ends. I place
> objects on the scene, within the frame, just as I have learned to

do on canvas....I was beginning to understand that the distance between the water bottle on my desk and the statue "out there" paralleled the distance between my dorm room and the bathroom, which in turn paralleled the distance between the two objects I placed at will in my paintings. (pp. 94, 96)

At home she used artistic devices to conquer the baffling arrangements of objects in space. When she could not work the microwave, she drew cubes. When she mastered the cube she was able to put a bowl into the microwave., transforming the two-dimensionality of paper into a representation of reality helped to situate her in the three-dimensional world.

Possibly her most important realization is that control is an illusion. Holding onto control is probably what throws human beings into denial at the onset of a life-changing illness or injury. The irony of realizing our vulnerability is that it also gives us freedom. For Bramblitt, losing his sight was his greatest fear and, as he says, it finally freed him.

Viktor Lowenfeld: Making Art with Children Who Are Blind

Viktor Lowenfeld lived in Germany during the rise of Hitler, and watched the inevitable militarization of schools. The build up to the war that necessitated his escape to New York in 1938 was instrumental in forming his humanistic philosophy of art education. His notion of "setting children free" must have been conceived as he witnessed children's spirits stifled by the war machine. For him, the phrase "setting free" meant overcoming obstacles that lie in the way of fulfilling the potential of children and setting them on a course toward their optimal development. Like the Reggio Emilia philosophy born from the same war, Lowenfeld envisioned a new generation of children who if nurtured by kind adults would create a peaceful future. Lowenfeld embraced this philosophy as the correct means of educating all children, but he was particularly passionate about the most vulnerable: "those who cannot make full use of their senses" (1987, p. 118).

Unifying Partial Impressions

Lowenfeld worked with children who are blind and partially sighted from 1926 to 1938 at the Institute for the Blind in Vienna. He

developed ways of working with this population primarily from observing children and following clues from their body language. One of his greatest contributions underlines the purpose of using art forms with the blind and partially sighted: to unify, or synthesize, their partial impressions of the world. A person who is blind cannot conceive the entirety of an object larger than her hand. However, through the memory of partial impressions, art can be used as a synthesizing device by concretely recording impressions and fashioning them together to create a whole. The impact of the successful integration of these partial impressions cannot be understated. As Lowenfeld says, the partial impression of the world is to a great degree responsible for the visually impaired individual's isolation. The sculpture or painting becomes the concrete physical support from which a relationship can be established between the artist's thoughts and the made reality of the work. "This ability surely is not confined only to the field of modeling but reflects upon the whole emotional and mental growth" (p. 119).

Because the world of the visually impaired is primarily received from the sensation of touch—particularly for those who have been blind from birth—distance and size is unknowable. The size of objects, therefore, have a different purpose and meaning for the visually impaired in their representations of reality. Choices of size are usually made according to artistic values rather than realistic approximation. Approximating reality is not a more valuable form of expression for this population or any other, nor is it the only way that children can synthesize partial impressions. Children synthesize partial impressions to create a mental image of the world where there was none before. Isolation is one of the most painful results of disability, and mental imagery helps to bring the world closer to them. It is helpful to keep that in mind as we set goals and objectives.

By suspending our own way of knowing the world and its representation through artistic materials we might find the approach that best attends to the needs of students who are visually impaired. Apparently, in Lowenfeld's time the instructors restricted the production of art made by this population with their "seeing taste," thereby not fulfilling the broader purposes of making art, such as locating, transmitting, and extending one's own way of knowing the world. The resulting art work might not be aligned with the aesthetic sensibilities of the instructor, but children's own ideas are "of greater value than the most effective imitation" (Lowenfeld, 1987, p. 119). These guidelines are necessary when teaching children with disabilities, but they should not

be considered as a special form of pedagogy. Rather, all children benefit when they are active agents in their art making. However, the lack of a full range of senses, a different organization of sensory impressions, and the inevitable isolation that results, put children who have visual impairments developmentally behind their peers. Their art work will not only reflect their developmental delay, but also reveal different concepts used to construct the world. Their need to experience their own autonomy is therefore even more crucial.

All young children begin drawing "designs" by exploring their materials. Like their sighted peers, children with visual impairments will eventually make a connection between the marks on the page and the objects in the world. However, unlike their sighted peers, they will not readily come to a unified image. The early representations of the blind and partially sighted are characterized by unrelated parts since their impressions come to them piecemeal through touch. Once a concept is found, however, they will not err as easily from established schemata. Lowenfeld says there is a second reason for their rigidity, which is a lack of confidence that quickly develops as they compare themselves to their sighted peers. The "fold-over" image is another schematic tendency of this population, characterized by two baselines, one at the bottom and another at the top of the page where a young sighted child will usually draw a skyline. The up and down on a page as conceived by a sighted child is apparently experienced as right and left for the visually impaired. This schema makes sense to children with visual impairments because they experience their body as central from which the world emanates.

The Visually and Haptically Minded

The two categories of visual and haptic perceptual orientation to the environment are particularly helpful with this population, because they play a large role in how children and adults choose to represent the world. How the instructor encourages and motivates his students should be informed by the category in which they lean. These labels are tendencies and most of us have characteristics of both while favoring one. Lowenfeld defines visual mindedness as a tendency to engage oneself in the world. Haptic mindedness, on the other hand, favors internal impressions and affective responses to the environment. They have a more inward, rather than outward expression of relatedness than the visually minded. The visually minded person thinks in details and brings them into a cohesive whole, while the haptically minded person

might begin with a concept of the whole but rarely develops it with further details.

The term "visually minded," therefore, is not an indication of how well a child sees. She might in fact have less sight than her haptically minded peers and will want to gather and understand visual information. Children of both orientations are engaged in creating unified impressions of reality. Haptically minded children, however, are more attracted to imagery that they find sensorially interesting, and they represent reality according to their sensory experience of reality.

> In impressionist art...*the surface structure triumphs,* whereas expressive art, originating from within...places the *self in a value relationship to its environment.* That which is perceivable in the external universe is contrasted with that which is experienced by the "inward senses." (pp. 121–122)

Whatever shadowy impressions remain of the world is either used or disregarded depending on the artist's orientation. For a visually minded child who was keen on collecting and representing his partial impressions into a synthesized whole, Lowenfeld used a branch of flowers that the student held and turned in his hand. With each turn of the branch he was able to apprehend the concept of roundness as he captured each impression in a series of small studies. Now that he had carefully observed the branch, Lowenfeld took it away so that he might draw from a newly formed concept of three-dimensionality. The final drawing is miraculous in that it documents the student's progression toward a new and otherwise unobtainable skill of conceiving a unified vision. In this instance he achieved the skill that had mystified Virgil.

Serious investigation of objects, which will be discussed further below, is an infallible way to bring the world closer to the child and the child closer to herself. If we define ourselves through our relationship with the world, then examination and observation are keys in establishing the identities of children who are disconnected from their environment. Rather than being encouraged to approximate physical reality, as mentioned earlier, children need help reaching their optimal *understanding* of physical reality and translating it into drawings that approximate their own developing perceptions.

A haptically minded, partially sighted student with greater vision than the child in the earlier example, had a different goal which was not to use his remaining sight. Lowenfeld shows that this child did nor use his sight to orient himself to the world or for artistic purposes.

Rather, he was driven by internal forces that he capitalized on for their affective value. As he painted what was probably a self-portrait titled, *The Cry for Help,* he began with his eyes and mouth, the most expressive features that reveal tension. Rather than searching for volume and continuity, as the visually minded child did, this student used light and dark for a symbolic purpose: to create the most tension in pictorial contrast. Lowenfeld describes his work as having "great educational significance because only through the self and the realization of it will the individual find real contact with the outside world" (p. 126).

The Importance of Stimulating Bodily Sensations

As discussed in chapter one, motivation through bodily sensation is the quickest way to inspire self-motivated art making. For children who are both visually impaired and deaf, the body is the portal to the rest of the world. With bodily sensation as one of the only ways for this population to apprehend the world, the mentor/teacher can help by having each project activate a real or remembered sensory experience. At the same time, two dimensional, and particularly three-dimensional art works become diagnostic tools that gauge limitations of imagination and bodily feelings.

In a remarkable example, Lowenfeld describes the importance of finding a point of departure that inevitably begins with the body. Touch becomes even more crucial in transmitting information about the world to children without sight and hearing. Reaching children with such limitations becomes a test of ingenuity, the powers of empathy, and the ability to suspend our own ways of knowing as well as our well-formed ideas about the purpose of art making. Lowenfeld used a series of lessons with clay to awaken a sense of self in an eleven-year-old girl, deaf and blind from birth. In the 1950s and earlier, children were not protected by federal laws, and instead, shut away in institutional settings that offered inadequate contact with teachers and peers. Because her language was undeveloped, Lowenfeld used clay to test the possibilities of connecting her with the environment and, ultimately, developing language. Bodily functions became the starting point for communication. Touching the girl's mouth he said, "You are sitting.... You are a sitting girl—a sitting girl" (p. 128). Her first clay sculpture indicated that she intended to portray her body sitting by emphasizing her legs and lower body but omitting her arms and face. By building on prior knowledge grasped in the first lesson, these omissions became the starting point for Lowenfeld's next lesson. He used an apple to make

her aware of her arms, hands, and mouth. "Putting it into her hand, I said to her.... 'Apple in your hand'...and repeated the performance several times, always closing her fingers over the apple" (p. 128). Her sculpture now included both arms and the hand holding the apple. By the third lesson the young girl spoke her first words.

> Instead of a symbolical lump of clay for a hand, she has made a hand with five single fingers cast in a definite position—that taken when reading a Braille book. "One, two, three, four fingers—five, thumb," she said while she worked, and she placed the thumb separately in its proper position.... She became conscious not only of the fingers but also of their kinesthetic functions in reading. (p. 130)

Lowenfeld accomplished his greater goal that was to extend beyond the experience of art making and into the larger world. For the first time she spontaneously initiated a second sculpture. As he worked with her, the awareness of her body became more evident in the detail and differentiation of the clay as her sculpture progressed from general symbol to a concept of form. Later Lowenfeld used his well known "candy motivation"[4] that inspires an awareness of teeth so often missing in children's self-portraits. Not only did she represent her teeth, but she also described the muscular sensation of her eyelids as she bit down on the hard candy.

The Blind Identity

Lowenfeld used art making as the catalyst for human development, and the acceptance of self as the starting point toward building a solid identity. Rigid imagery corresponds to rigid behavior and, in its extreme, ritualistic behavior. The acceptance of disabilities becomes evident in flexible imagery and will eventually appear in the children's interactions with the world, hopefully bringing them closer to who they are. The stories of Virgil and Lisa Fittapaldi invite us to pursue this question of identity. Although beginning with the same genetic hardware, we nevertheless each construct our worlds from scratch, a perceptual self with a will, orientation, and style of its own (Sacks, 1995). The potential with which we come into the world is realized through our interaction with that world, which in turns shapes how we perceive it. Our *body-self* is therefore built on highly individualized perceptions.

Lowenfeld's theory that disabilities acquired later in life are more difficult to adjust to than those that appear at birth has been debated. It has merit, however, given that we are the sum total of our experiences. If the structure of self is based on the transaction between our sensory system and the environment, what happens to the self when that system breaks down? As we see with Fittapaldi, what happens is nothing short of identity annihilation. We cannot know who we are in isolation, and according to Fittapaldi it is with sight that we best know the world. What happens when we lose that primary relationship with the world and must depend on the lesser used senses? "If this occurs, an individual not only becomes blind but ceases to behave as a visual being" (Sacks, 1995, p. 136). On the other hand, for Bramblitt sight no longer provided the most truthful way of knowing the world, which he realized only by losing it. Seeing has always held the central place in knowing the world, and seeing and knowing are unconsciously made equivalent in language with such phrases as "I see what you mean" even though, as he says, seeing is simply a chemical response to light passing through the eye's lens. He defies the "visualness" of the visual arts by using his other senses to arrive at a highly individualized way of conceiving and making art.

Virgil, however, had known the world primarily from touch. Now with the option to see, he did not know whether to feel or look. This crisis of identity did not have Fittapaldi and Bramblitt's happy ending. Virgil could not say he was a happier man, nor could all other documented individuals who had regained sight later in life.

Thus, by gaining or losing sight we adjust to another way of being by adopting a new philosophy. Virgil was unable to cross over to the world of sight, which must have been all the more devastating given the pressure from the sighted world. For the sighted, sight is best; but Virgil, on the other hand, wanted to renounce this world. Virgil once had a *blind identity,* a complete and sufficient world, as Diderot said in 1749. It is rather the dominant culture of the sighted that implies that the visually impaired are lacking a coherent identity. As Sacks points out, this sense of completeness and identity is truer in the Deaf community that shares a language, and thus a culture. Cochlear implants[5] have changed the landscape quite drastically, however, and the debate of its benefits—in terms of preserving identity, language, and culture—continues.

CHAPTER SEVEN

Traumatic Brain Injury and the Northeast Center for Special Care

> Courage, in its final analysis, is nothing but an affirmative answer to the shocks of existence, which must be borne for the actualization of one's own nature.
>
> —Goldstein and Scheerer, 1941, p. 240

No disability more than traumatic brain injury (TBI) reminds us of our own mortality. While the relationship between normality and disability is tenuous, we are reassured that by adulthood we escaped such childhood disabilities as autism and attention deficit and learning disorders. TBI, however, lives with us as a constant specter and we are vulnerable despite our caution. For example, although TBI occurs most often with risk-taking males, Erich Miethner is the inevitable exception. Miethner could not recall what caused his accident; one moment he was standing, the next he was on the floor paralyzed from the neck down. This example might be catalogued under "freak accident," but the trouble is that we are all vulnerable to the freak accident, unable to take precautions however slight the possibility might be.

When rehabilitation is no longer viable six months to a year after injury, the only alternative is the institution, usually a nursing home, which does not alleviate the disruption of loss but, rather, exacerbates it. As a result, TBI survivors find themselves bereft of their families, communities, and their roles in life. Institutional staff need to be aware of the humiliation that must be overcome each day as TBI survivors submit their most intimate daily needs to total strangers. Depression, confusion, and anger must also be addressed and included in care.

The Northeast Center for Special Care (NCSC) in Lake Katrine New York is not a typical nursing home. The alternative therapies such as painting, theater, poetry, and competitive sports, are an integral part of shaping new identities, and the overarching goal at NCSC. The neighbors,[1] as they are called, assemble together for therapeutic activities in the loft-like and light-filled rooms with towering glass ceilings. These "process therapies," which Program Director Gerry Brooks calls a "sneaky form of cognitive therapy" (G. Brooks, personal communication, 2003), develop intention, attention, social, and cognitive skills, and impulse control. TBI survivors lose track of where they are and what they are doing, and although considered an attention problem, disorientation is actually caused by a loss of *intention*. Brooks explains this theory by comparing loss of intention with the normative ability to hold an intention, move from one intention to the next while keeping them all in mind for long periods of time and, at the same time, withstand the predictable stresses that come with living. Therefore, in order to hold an intention we suppress impulses toward distracting exterior stimuli. Our intention enables us to pay attention and resist impulses. "It is always about seeking pleasure and avoiding pain. We don't seek pain but we tolerate quite a bit of it in the service of our intentions" (Brooks, as cited in Labbato, *Changing Identities*, 2002).

Intention and emotional drive must be stimulated in order for the complex and interdependent function of the brain to be recovered. Brain injury affects cognitive, emotional, and physical centers and results in disorientation and disconnection with self and the world. The process of recovery is, therefore, a redefinition of self. In light of current research, it could be argued that to take away the certainty of the body is to throw into doubt the relationship between identity and the environment, or one's entire existence.

> *As you sit there, you sit there with all of your past and sit there with the best intentions for your future; you sit there with your present as well. It's all there in that chair with you. Mine is here with me. I can immediately recall that I exist in this grand continuum. Not only am I connected to my past, this moment, this place, but I am aware of my house an hour away from here, my wife, my dogs. My life is rather large and expansive. What brain injury does is it makes you more immediate, it begins to rob you of your future and your past, until your only concerns, interests, your only needs exist in that moment. And the simplest, maybe not the best description of how the severity of brain injury changes you, is that the more severe the less awareness there is.* (Brooks, as cited in Labbato, *Changing Identities*, 2002)

A Loss of the Attitude toward the Possible

In a study conducted by Kurt Goldstein and Martin Scheerer (1941), the researchers reported that their subjects who had what they described as "impairment of integrative mental function" were unable to respond abstractly to external phenomena (p. 1). This attitude, or capacity level, makes unlikely reasoning and self-awareness. For example, their subjects were unable to symbolize, isolate, synthesize, and prioritize. "Thus, he becomes more or less reduced to a level of concreteness of situational thinking and acting so that he can perform only those tasks which can be fulfilled in a concrete manner" (p. 9). This capacity level also includes the inability to realize the potential function of an object as a representation of a class or category. The result is a vulnerability to stimuli that manifests as distractability as one is shifted passively from stimulus to stimulus. Ultimately, TBI survivors cannot only form conceptual categories of external phenomena, but impairment also affects inner experience as well, which is manifested in the inability to organize, direct, or willfully hold in check ideas and feelings. "He cannot detach his ego from his inner experiences; therefore he is rather a passive subject instead of an active master of them (e.g., obsession, compulsion, in functional disturbances—rigidity, etc.)" (p. 9). With a normative mind we can shift from the abstract to the concrete as the situation demands; we can transcend the immediacy of a situation and conceive of a condition that is not present. In other words, we are able to abstract ourselves from sensory impression. Goldstein and Scheerer considered the abstract attitude the basis for conscious and volitional behavior, all of which, they thought were beyond the reach of the TBI survivor bound to concrete reality.

Goldstein (2000) becomes more of a philosopher than scientist when he later amends the concrete-abstract attitude of human behavior by introducing the term "sphere of immediacy" (p. 20). Health is newly conceived by Goldstein as being in relationship with something or someone outside of ourselves.

> It shows that our existence is based not on objectively correct order alone but at the same time on comfort, well-being, beauty, and joy, on belonging together... the sphere of immediacy creates a deeper existence that affords not only the possibility of living in the static condition of the abstract-concrete sphere but also of tolerating uncertainty without losing our existence. This is particularly significant for the possibility of existence in spite of failure and reveals thereby a more central layer of human nature. The sphere of immediacy becomes apparent in many circumstances of

everyday life: in friendship, in love, in creative work, and the religious attitude, and it is not even lacking as part of our experience in scientific investigation. (p. 21)

Dissatisfied with the inadequacy of theory to improve medical practice, Goldstein questioned whether the field of biology could be understood on a strictly scientific basis. In taking apart the organism in order to study it, its psychic state was simultaneously lost. What was learned instead was how an organism behaves under isolated conditions, but not in relationship to the life process as a whole. Rather than the several drives that were traditionally believed to appear under specific external conditions, Goldstein hypothesized that the process of *self-actualization* is the single drive under which all life—sick and well—is determined. On the other hand, the sick organism uses all its energy in maintaining the status quo. Life is economized so that normal development, progress, productivity, and the seeking of further activity are diminished. It follows then when viewing the organism as a whole "that, with any change in one locality in the organism, simultaneous changes occur in other localities" (p. 173).

Probably one of Goldstein's greatest contributions in his search for a new neurology was to shift the meaning of what had traditionally been viewed as a damaged nervous system. In Goldstein's view what manifests instead are "attempted solutions the organism has arrived at, once it has been altered by disease" (Sacks, 1995, p. 11). In the body's search for homeostasis after its disruption, a new organized self is eventually achieved. The manifestation of this process is what is normally considered a chaotic state, but which Goldstein considers necessary in the search for equilibrium until a new identity is constructed. Goldstein describes the impetus of this search as an avoidance of catastrophic situations. Catastrophic reactions to stimuli to which the body cannot adjust take the form of shock and anxiety. For example, in almost all cases internal disorder manifests itself as a rigid clinging to external order, an expression of the TBI survivor's inability to shift attitudes of behavior. All of life and culture itself, according to Goldstein, are products of uncertainly and anxiety. However, for the healthy, anxiety is overshadowed by the joy of conquest, which means adjusting to the environment according to one's needs. The more creative the individual, the greater the amount of anxiety she must transform. Thus, for TBI survivors the introduction to creative solutions and choices build tolerance for their confrontation of uncertainty and anxiety albeit at a very slow pace.

This form of overcoming anxiety requires the ability to view a single experience within a larger context, that is, to assume the

"attitude toward the possible," to have freedom of decision regarding different alternatives.... Therefore, brain injured persons, whose change we characterized as a loss of the attitude toward the possible, as an impairment of freedom, are completely helpless when facing an anxiety situation. (p. 240)

Pounding on Walls

TBI survivors perceive time and space in highly idiosyncratic ways.[2] To make contact, the professional staff needs to begin in the time and space that survivors inhabit. Strategies that address their disturbed sensory perception help them make connections between the present, past, and future. Disoriented time causes a loss of identity, the most problematic result of TBI. If we are in fact the sum total of our experiences, as Oliver Sacks (1987, 1995) suggests, then it is the memory of experience that gives our life continuity, meaning and, ultimately, the sense of who we are. Although changing with time, our sense of self remains remarkably constant.

Alternative therapies, the majority of which involve artistic experiences, address the psychic, social, and emotional consequences of TBI. When making art we need to imagine, conceive, and plan what is not yet and what is not there, and to initiate and create an internal narrative. The canvas is the reminder of what the artist made happen before and suggests what he might make happen next. "This is a kind of prosthetic, if you will, for keeping your intention clear and present" (Brooks, as cited in Labbato, *Changing Identities,* 2002).

TBI survivors are unable to anticipate and imagine living in any other time than the present, so paper or canvas might function as an external memory or concrete reminder. In this scenario, painting can be approached as the carrier of thought, action, meaning, and purpose. Because TBI survivors are generally driven by momentary impulses and cannot see beyond immediate desire or repulsion, unless they can find meaning and relevance in what they do they will not endure the pain or boredom of a dead-end task. Therefore, traditional therapies are unsuccessful in eliciting their commitment. Painting, however, requires the suspension of immediate gratification, and once hooked a neighbor might work for hours. Only self-motivation makes suspension of gratification possible and, paradoxically, self-motivation is what is so elusive to this population. We, as "temporarily normal," are able to endure the anxiety of possible failure or humiliation because we understand what might be

achieved in the future, a notion incomprehensible to TBI survivors. For this population to be attracted rather than repelled, the possibility of an emotional investment has to be built into the therapy.

Former studio director of NCSC Bill Richards[3] addressed these needs by creating a serious environment of artistic inquiry that crossed physical, emotional, intellectual, and behavioral boundaries. The artistic process makes possible the connection among many aspects of self—past and present in relationship to what is outside self—and in doing so awakens the lost balance between the concrete and abstract attitudes. When one part of us no longer functions we need to call upon what is intact to mitigate the loss. Making art helps the neighbors participate in this process, and they will sit, lie, or position themselves in whatever way they can so that they can paint. Although groans will be heard—the frustrated beating on a table, a scuffle with aides restraining a convulsing neighbor—they are not stopped from the concentration of their work. Their work sometimes looks like maps of their evolution—not in a continuous movement upward, but in dips and detours as well as ascents—diagrams of their struggle to proceed despite the inevitable regression back to confusion and disorientation.

> *If I am the artist, that whole project connects me to an art studio, a Bill, to the other assistants, to a sculpture garden, to an outside and an experience, and to the people who have shared that experience with me. So I am being taken inextricably beyond the moment which stretches me beyond my interpersonal reference, my spatial reference, my time reference, and its work on that most important existential process who will be a "me" who will transcend the moment.* (Brooks, as cited in Labbato, *Changing Identities*, 2002)

Science and Art

Most scientists admit that the nature of consciousness still lies in the realm of the unknown. Neuroscientist, Antonio Damasio (1994) describes reality as the mind's experience of its own body, and not solely in the brain's domain, but a "structural and functional ensemble" (p. xvi). While still debated, Damasio (2003) theorizes about what to him seems obvious, the "body-mindedness" of the mind (p. 206). The mind exists in relationship with the body and mental images are the reflections of that interaction: the brain's reaction and its affect on

the body. The question remains, who is making this "movie in the brain" and where is this observer located who we think of as the self?

> I have suggested that the most basic kind of self is an idea, a second-order idea. Why second order? Because it is based on two first-order idea—one being the idea of the object that we are perceiving; the other, the idea of our body as it is modified by the perception of the object. The second-order idea of self is the idea of the relationship between the two other ideas—object perceived *and* body modified by perception. (Damasio, 2003, p. 215)

The self inserted into the flow of ideas and the body interacting with objects in the world, together are what create consciousness (Damasio, 2003). The sense of self is what gives us an orientation and integration of information from all centers of the brain. "The sense of self orients the mental planning process toward the satisfaction of those needs...critical for survival, not to mention well-being" (Damasio, 2003, p. 208). This theory is similar to the way art historian, Ellen Dissanayake (1995) describes what occurs when we make and perceive art objects as symbolic representations of self. Because our relationship with art making has its origin in our earliest space-organizing configurations, it has deep emotional roots in our ancient past. The arts as spatiotemporal structures carry these primitive ways of organizing our bodies in space. Their emotional affect on us is the origin of aesthetic experience.

> Most empathists held that bodily feelings were projected outward from the perceiver onto the art object. Current neurophysiological findings, however, suggest that the work of art writes itself on the perceiver's body.... The sensation (in bones and muscles, in the being) that the empathists wished to explain—of union or communion between viewer and object, listener and musical work, reader and poem—is real, not illusory or only metaphorical. They simply lacked physical models that could account for it. Yet now we can understand that the arts affect at once our bodies, minds, and souls, which themselves are aspects—processing modules in the brain—of an individual that apprehends as one. (p. 185)

The body's senses and emotions rather than being inferior or trivial are "the very stuff of which our life-in-world is composed and through which our thought is mediated" (p. 185). These are the same issues that Damasio challenges: assumptions about emotion and feeling and their

affect on human reason. Emotion and feeling not only serve as our internal guides, but they also help us communicate important information to others. "Contrary to traditional scientific opinion, feelings are just as cognitive as other percepts. They are the result of a most curious physiological arrangement that has turned the brain into the body's captive audience" (Damasio, 1994, pp. xiv–xv).

Damasio calls self "the background body state," background feeling being mostly about body states. The typical mind depends on updated information from body states to affirm that we are alive and well, and feelings give us the information we need to evaluate experience. The neural basis of self explains why subjectivity is a main function of consciousness; self depends on emotion to communicate meaning. If such arguments are well founded, then we interact with both body and mind in all circumstances. Restoring the connection and interdependence of one's mind and body is the leitmotif throughout the process of recovery from TBI.

In an address at the opening of the Centre for the Mind at the Australian National University in 1998, Sacks suggested that the search for the source of consciousness is overrated. He has long been an advocate of creativity where he believes the future lies in neurological research. Sensibility, talent, skill, imagination, and dreaming involve an unfathomable depth of unconscious. And not only does the creative unconscious have many depths, but it is also a richer, stranger, and more mysterious form of unconscious. He not only refers to artistic creativity, but also scientific creativity, athletic creativity, and so on.

An incident between Sacks and Harold Pinter reveals how a conscious intention can submerge into subconsciousness and then suddenly explode into the present. Pinter was so impressed with *Awakenings* when it was published in 1973 that he sent a letter telling Sacks that he would like to write a play about it. However, Pinter forgot about his idea until he woke up from a dream thirteen years later with the play's first sentence in his mind. He wrote the play in three days.

Sacks's anecdotes and theories underline the importance of tapping creativity for its ability to synthesize multiple parts of the brain's functions. Such theories also help us to understand how self is constructed through our lived experiences and the dauntless job that the TBI survivor has in its reconstruction. Traditional therapies are unable to awaken the creative unconscious whose spark might set off a chain reaction of intentional thought. Making art is, therefore, therapeutic because it brings the inside out and outside in, endowing the product made from concrete and physical matter with our psyches.

As TBI survivors languish for years in custodial-like institutions, president of NCSC, Anthony Salerno says they develop a resistance to treatment. They are, in fact, acquiring a disabled identity. "It's imprinted on them by everything they confront; by much of what they see and feel, inadvertently or directly by families, staff, peers, and other TBI survivors. How do you break through the institutional identity?" (Salerno, as cited in Labbato, *Changing Identities,* 2002). When TBI survivors become artists, their identities shift as families, staff, and peers acknowledge their work. The neighbors, however, are cautious of how shifting perceptions affect their self-image. The notion of being disabled and an artist might be a realistic possibility for some of us, but for the neighbors they are polar opposites. But once they surmount their disbelief and take on the persona of the artist, the artist always wins. "In that victory, individuals not only feel, but they also know that they can do anything...even the hardship of physical therapies" (Salerno, as cited in Labbato, *Changing Identities,* 2002). When they sell their work, their status changes from TBI survivors who make art, to professional artists. This change becomes more than a subjective feeling as the audience/buyer is complicit in their changing identity.

> *The fact that we are putting art out there and someone else likes it does far more than raise awareness, it bypasses the need to raise awareness. It is a de facto acknowledgement that these people have returned back to the world of the living. They are us. They are back with us again. I'm taking cash out of my pocket and putting it down on the barrel head and buying it. As long as we can talk about them as an abstraction, no matter how benignly or kindly, regardless of how much enlightenment we bring, as long as the labels are involved, we still have a problem. All is dissolved in the commerce and the making of the art itself, in the making of it and the selling of it and the hanging of it in someone's home. When someone is able to regard a work of art as breathtakingly beautiful, that has a direct and enormous and visceral impact, they realize that this is not a brain injured person, this is an artist; this is an artist at work.* (Brooks, as cited in Labbato, *Changing Identities,* 2002)

The Politics of Recovery

Because the field is in its infancy, TBI is often confused with mental illness, and many survivors find themselves in mental institutions. The distinction between mental illness and TBI is an important one.

TBI survivors have predictable cognitive problems, the most salient of which is a lack of sustained attention. Lack of attention limits intellectual and social interaction and, therefore, growth. With mental illness, social and intellectual interaction is more complex and less predictable since the source of the illness lies in conflicted emotions, phobias, and/or obsessions. The TBI survivor's inability to regulate emotion is usually manifested by an outside stimulus. The offending stimulus might seem benign to the rest of us, such as a flickering light bulb or a high-pitched voice. However, it is excruciating for the TBI survivor's raw senses. A knowledgeable staff is required to recognize patterns of behavior, and more importantly, find the cause and remove it. Often with its removal calm can be restored. A misdiagnosis of mental illness and an inappropriate remedy will inevitably bring increased frustration and rage to the TBI survivor.

The medical field holds little hope of substantial recovery after six months from the initial trauma. Once TBI survivors emerge from unsuccessful rehabilitation they lie in a grey area, unable to return to the community. However, patients need to be motivated to be successful in the first stage of rehabilitation in an acute care hospital. But to be motivated the patient must understand who the person is who is receiving physical, occupational, and speech therapies. Each of these treatments not only isolates a specific problem from other problems, but also from the individual himself. He also needs to control his impulse and apply what he has learned. TBI survivors, therefore, spiral downward into severe disorientation and fragmentation of self in a system that is not equipped to meet the special challenges of their injury.

The choices after acute care are extremely limited. Without the benefit of an alternative institution, this population is destined for the nursing home, which means that individuals, often in the prime of their lives, are waiting to die. At NCSC the paradigm has shifted in favor of aggressive experimentation and inquiry in alternative ways to make significant recovery. The quality of life issue looms large in their philosophy, and drives everything from the physical structure of the building to the carefully tailored daily schedules for each neighbor. NCSC fills the vacuum in a system that has not confronted the long neglected need to feel, and actually be useful to oneself and society. What is now needed is the patience to wait and see what comes first; whether bodies and minds will repair themselves or new and effective strategies emerge.

We consider this entire facility a community where people can practice being a person first. We don't call the folks here patients, we call them neighbors,

and that is quite intentional. We intend for them to shed the identity of patient as someone who is less than or as someone who has lost something. From the day they walk through the doors, we expect them to start to consider themselves back in society where they have both the expectation and the opportunity to be someone, to be a member of an admittedly small and protected community, but still one that offers a great deal of complexity, opportunity, and challenge in the way that the rest of us face opportunity and challenge every day. (Brooks, as cited in Labbato, *Changing Identities,* 2002)

The most apparent difference between TBI and mental illness is the extraordinary circumstances that create the injury "which might leave them on the side of the road someplace" (Brooks, as cited in Labbato, *Changing Identities,* 2002). From there, the survivor goes through a series of stages well documented in medical journals. Depending on the medical benefit, the journey translates into 100 days of acute rehabilitation in a facility consisting of a traditional approach to physical, cognitive, and speech therapy. The benefit system, Brooks says, requires survivors and their families to play a game of beat the clock. As time runs out, the decision must be made whether a TBI survivor will go home with community support services. However, if she is still dependant on a ventilator, or lacks control of her behavior, the home and community will not be able to provide sufficient care and treatment.

According to Brooks, the healthcare system is not intended to achieve the highest capacity from its clients; it is designed to contain cost. The more unfortunate omission in this plan is the quality of life of patients within the system. This is the moral dilemma that has motivated the NCSC project. With the extraordinary costs of healthcare, controlling cost must reign, and in order to control cost, limitations must be clear and boundaries imposed. This is not the situation that drove doctors and therapist to enlist in their fields, says Salerno. The war must be won with an ambitious plan, both humane and cost effective, which he has succeeded in doing through exterior funding.

The confounding thing about TBI is that it is a complex syndrome rather than a classified disease, and no two survivors are the same. As Salerno points out, the system is not built to accommodate complexity. It will, however, accommodate such necessities as food, shelter, support, and assistance. The difficulty of quantifying the effect of art prevents it from fitting neatly under the category of necessity. This makes the health care system a one way street, and Salerno has found that with TBI the institution needs to meet the neighbors half way. "They have to

communicate with us" is the expectation of most institutions. "We have to reverse that. Our problem is that we have to be able to communicate with them" (Salerno, as cited in Labbato, *Changing Identities*, 2002).

> *In theory you get X amount of money in a reimbursement system and use it on anything you want. You can spend the money on Certified Nurse Aids (CNAs). Everything begins and ends with CNAs; they are the essential ground work. They are where the rubber meets the road every day because they are interacting on all levels continually. Or you can spend that money on more expensive food, or you can spend the money on art. Art per se is not a line item that would appear on a reimbursement cost report. It will fall within activities or special events. It is considered a sub set of other things. The providers are confronted with the fact that they will either spend money on art or not. And when they do they have to decide whether they're going to spend a little or a lot, and what they want to achieve. It's very clear that if you spend it on staff you will never regret it. But what if you don't spend money on art? Individuals might never make a breakthrough, or their break-through will be less than what it could be. What is the long term cost to a system for an individual who doesn't make the breakthrough, and doesn't go to the less restrictive setting, who becomes a permanent fixture in the insti-tutional system? What is the cost to society and the individual?* (Salerno, as cited in Labbato, *Changing Identities*, 2002)

Because of the limitations of the regulations as they exist in New York State, NCSC was approved as a nursing home. However, their mis-sion is embodied in the Homestead Act, a decision first made by the Supreme Court and later signed by President Bush, which states that rules and regulations should be amended to accomplish the goal of reentry in the least restrictive environment. This message, Salerno says, has not yet penetrated the thick walls of institutions. The problem is that programs are built on existing regulations that makes them not about outcomes as much as they are about standards; nor are they about the goals patients have for leaving, but rather about the service within the facility. Most regulations are concerned with whether the food is hot or cold or if the patient is out of bed on time. NCSC is concerned with those base standards, but more concerned with the choices that the neighbors make for their own rehabilitation.

The ability to make choices is the standard by which rehabilitation is measured. Choice is considered a right at NCSC, in deep contrast to the custodial practices of nursing homes. The system built around custodial care is appropriate for the frail and elderly and inappropriate for TBI.

The typical neighbor is a thirty-five year old male who might present a number of issues. In the first stage of rehabilitation he is taken off medication so a baseline can be found. He must be able to tell the staff what he is working toward, and if he cannot he will need to work with the staff until he can. Sometimes the only indication of a neighbor's needs is in his paintings, such as in the case when a neighbor was unable to speak or write. A series of paintings conveyed that he was imprisoned, not only in his own body, but in the facility itself. The staff is trained to recognize the neighbors' needs within the limitations of their communications. Helping and preparing the neighbors to leave on their own terms is not as easy as dispensing medication, so the art studio has assisted the staff in this goal (Salerno, as cited in Labbato, *Changing Identities,* 2002).

Rehabilitation is therefore mutually challenging for both neighbors and staff. The neighbors will have to accomplish tasks that not only they believe they cannot do, but the staff might not believe they can as well. Progress is a leap of faith on both sides. Richards's task is even more daunting, but makes the breakthroughs all the more breathtaking.

The neighbors often need to be coerced into the studio during their elective activity time. They are understandably resistant when presented with an unknown and possibly humiliating task. The studio's process-approach, which means self-directed work, is also more challenging than prescriptive approaches with an end-point in mind. But Richards believes that it is the only way to uncover their potential. Therefore, he will not interrupt their work with his own notions about art, nor influence them in directions that are foreign to them.

As art does not come without resistance, each neighbor's success is achieved with ingenuity. Richards does not have a formula and so he explores all possibilities. One neighbor might find that color leads him toward a reawakening of a lost sensory perception, while another might find a change in canvas size to be inspiring. "As they engage with those materials they shape a reality. We do not know when it is shaped to their satisfaction. The individual is telling us that I can shape my own reality. That is the difference. Artists do that" (Salerno, as cited in Labbato, *Changing Identities,* 2002).

What We Need Is a Living Home: Not a Nursing Home

TBI presents an array of behaviors that first need to be understood and then addressed. Because it is a relatively new population with a specific set of issues, strategies that might be successful with other populations often

have little success with TBI. High functioning TBI survivors are critical in helping professional staff understand what they need. Making sense out of irrationality is essential in recognizing its validity as part of their identity. Kay Redfield Jamison (1997), a psychologist diagnosed with bipolar disorder as an adolescent, believes that tumultuousness leads to a wisdom about the world not available to the cool-headed majority. She emphasizes the importance of not only tolerating, but also appreciating the infinite variety of minds. Unfortunately the dominant group makes among other important decisions, who is capable of being helped, and what kind and how long help is available, bringing to the surface what it means to help. Helping can easily imply helplessness, and the degree to which one believes oneself to be helpless is often determined by treatment plans.

Brooks describes a distractible neighbor who was given a number of tasks, graded on those tasks, and then given the same tasks the following day. "The program failed him because he doesn't have the capacity to understand why he would engage in such an unnatural activity" (as cited in Labbato, *Changing Identities,* 2002). The problem is made even more complex because TBI survivors do not see themselves as they want to be and, therefore, do not feel that therapy is worth the effort or risk of failure, especially if there is no reason to recover. Physical therapy seems trivial, Brooks says, if moving a hand or walking again will not enable you to go back to work. We succeed at tasks only when we see their usefulness. While most therapies are structured to help at a later time, "Art bypasses all that because it's not about doing something at some future time.... That what your perception of what's going on in the inside and the outside is all that's important right now" (Brooks, as cited in Labbato, *Changing Identities,* 2002). As a high functioning TBI survivor and a NCSC volunteer, Annie Labarge emphasizes the need to be useful. This simple need, which most of us are able to satisfy daily, is a far off possibility, an unreachable goal inside the institution.

In a *New York Times* article, disability lawyer and activist, Harriet McBryde Johnson[4] (2003) blows the cover off institutions that purport to create comfortable and appropriate "special homes," but in fact are more often socially sanctioned alternatives to making the disabled invisible, and "leads us to evade rather than confront the problem of our relationship to the disabled by tempting us into weepy voyeurism and self-congratulatory smugness" (Fiedler, 1996, p. 44). Approximately 1.7 million individuals are lost to America's state-owned institutions every year, removed from their families and jobs within which self is embedded, and the means of knowing who we are.

After college, McBryde Johnson worked as technical support for institutions implementing the new Section 504 regulations.[5] Because

she uses a wheelchair the staff sometimes mistakes her for a patient, but they are usually set straight after studying the shiny braid falling down to her waist (which here would be cut in the interest of time and management), her pretty dress, and real gold bangle bracelets. She needs to use the bathroom, but not wanting to demand special treatment, "if they routinely show their nakedness and what falls into their bedpans, then I will too" (McBryde Johnson, 2003, p. 60). Privacy is a privilege, not a human right in institutions.

"In the gulag you have no power. The gulag swallows your money, separates you from your friends, makes you fearful, robs you of your capacity to say—or even know—what you want" (p. 61), which makes asking the question, "What is your goal?" paradoxical. Salerno and Brooks describe self-knowledge as the crucible that signals advancement beyond the formative stage of rehabilitation. Survivors have not only changed beyond recognition, but they also do not recognize where they are or remember where they came from.

The new disability rights movement, begun by activists with disabilities, are pushing for financial support for personal assistance over institutionalization, and challenging the right of some institutions to exist. Even in better situations, institutionalization robs basic choices with a structure that steals liberty at the price of professional care. At the time of McBryde Johnson's article, the disability rights movement was fighting for federal legislation know as MiCassa, the Medicaid Community Assistance Services and Supports Act, that would correct institutional bias in public financing, especially Medicaid that determines institutional policy (McBryde Johnson, 2003).

Painting, theater, poetry, pet therapy, competitive sports, and a work program alone do not make NCSC more than a nursing home, although as mentioned earlier, technically it is a nursing home. The underlying philosophy shared from the stakeholders to the staff makes for a paradigmatic shift in how TBI is perceived and labeled. Brooks does not find labels useful because, he says, they obscure more than inform. If he is to understand TBI survivors he must understand them in the same way he understands the complexity of his own life. The need neighbors have in identifying what is important is the same need we have. Although the urgency and the stakes are certainly higher, the need to make a commitment, to plan and establish goals, and the despair, frustration, and impotence that result from failure to meet those goals are also the same.

It could be argued that quality of life equals usefulness in society. Although highly subjective and relative, one's own level of contribution over the life span brings purpose and reason to live. TBI

Figure 7.1 Francois Deschamp. 2000. Photograph of Scott Hager.

survivors need to see a future in which their lives are useful to others. Self-motivation and socialization are built into the arts that possibly endure for a lifetime. Labarge describes the process as energizing, where the building of control, curiosity, interest, and attention span create a feedback loop whose side effect is the ability to interact with people. Self-centeredness and the resistance to the prodding of therapies, Labarge says, are nature's way of helping survivors to cope. She witnessed numerous times when making art began with resistance, frustration, and depression. But because painting is usually unlike anything the neighbors have done in their pre-TBI life, the newness of the experience awakens their lost *spirit of challenge*. The concrete and measurable materials launch them on a journey of confrontation with their newly rearranged sensory system. The transformability of materials invites the neighbors to use their atrophied sense of expectation and parallels their capacity to stretch out into the world (see figure 7.1).

> *Some people just see paint on a canvas, that's not all it is. It's just a feeling . . . it's freedom for me.* (Malloy, as cited in Labbato, *Changing Identities,* 2002)

TBI survivor, Paul Malloy says he begins painting with a feeling, sometimes with his eyes closed and his heart open. Death and life are metaphors Malloy uses to describe the difference between his former nursing home and NCSC. "If I could think of two words to describe each nursing home I've been in, it would have to be one dead, and the Northeast Center is alive with life" (as cited in Labbato, *Changing Identities*, 2002). While Malloy is aware that NCSC is considered a nursing home, he says it is more than that. "It's a home where people reside" (as cited in Labbato, *Changing Identities,* 2002). Therefore, it should be called a *Living Home* where people live rather than nursed indefinitely.

Enter...the Art Studio

Making art is perhaps as natural as learning to speak. I have never seen a child resist art materials. Learning speech, the mother tongue, is a combination of self-teaching and the timely and rhythmic input from others. This is how we approach art at NCSC, unlike the systematic paradigm utilized in traditional art therapy. There, art's function is to generate information about the patient's condition whereas we view its function as process, a vehicle for invention and communication. Art-making as process means accepting its propensity of being inherently continuous, always establishing conditions for its next evolution. (Richards, 2000, p. 76)

Richards shifts how we perceive and value people who have disabilities by making a few important premises and assumptions. One of these assumptions is that everyone is capable of making art, and possibly good art. However, the former is a slippery slope that invites the question, who decides what good art is? The paradigm shift raises questions about what art making means, who can make art, what kind of art is valued in society, and what art is for. What might be called "high art," or art with a capital A, is based on the history of art and the standards of the art world. The history of art is a relatively recent phenomenon; only in the last several centuries have artists become famous via the art historian. The "sanctification" of artists led many to believe that only geniuses who are trained in the conventions of our culture make good art. According to Richards's philosophy, making art is a behavior that is life affirming and can become life transforming when it communicates emotional meaning.

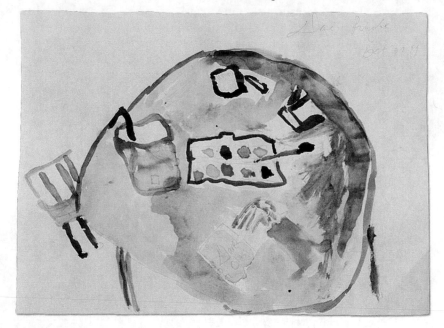

Figure 7.2 David Pringle. 2000. Untitled. Watercolor on paper. 11 × 14 in.

Comparisons to Outsider Art

TBI survivors show us that the purpose of art is somewhat of a mystery. Why do we make images? What is the need? Many would argue that if it were not a need it would not have survived its prehistoric roots. Suddenly we have Outsider Art, and suddenly untrained individuals making art are acknowledged and blessed by the art world. Ironically, the implicit message is that without the art world those artists would not have value. It is true that the art market has enabled these so-called outsiders, without intending to or dreaming of selling their work, to make a good living. The art work coming from the studio has been compared to Outsider Art because the neighbors are starting from scratch without knowledge of art history or technique. Looking at the work of artists who have never seen a Basquiat, Serra, or Kruger, has become intriguing to audiences. Their vocabulary and imagery often have no precedents in the art world with which we might use to compare them. They are not influenced by the current trends in the art world, their work often being highly narrative without the prescriptive vocabulary and discourse that come with the mainstream.

With the postmodern demise of official high art, the art world has been turned on its head as untrained and idiosyncratic work is embraced and appropriated. Paradoxically, it could be argued that along with the breakdown of the two-tiered, high-low art system, the art world having reached a refined level of sophistication had nowhere to go. Beginning with the Modernist artists, who while looking for alternative ways of perceiving the world, turned to such collections as Hans Prinzhorn's mentally ill patients and Jean Dubuffet's Art Brut. They saw in this work "the collapsing together of creativity and lived experience" (Rhodes, 2000, p. 116). Europe was influenced decades before America became fascinated with mainstream artists inspired by these collections such as Paul Klee and Max Ernst in Europe and Leon Golub in America.

The interest in Outsider Art has thus been beneficial for the neighbors, particularly with the professionalism that comes with selling work. For neighbors like Dennis Lamartia and Curtis Jenkins who lived in institutions all their lives, selling their work in galleries was their first experience earning money. With the first sale of his work Jenkins hosted a pizza party in the art studio.

Art in Unexpected Places

In the past we have made much of the idea of art as a mirror (reflecting the times); we have had art as a hammer (social protest); we have had art as furniture (something to hang on the walls); and we have had art as a search for the self. There is another kind of art, which speaks to the power of connectedness and establishes bonds, art that calls us into relationship. (Gablik, 2002, p. 114)

Art critic Suzi Gablik (2002) cites an emerging body of socially engaged art that builds community through "radical relatedness" rather than "radical autonomy" (p. 116). The radical autonomy of the art world has maintained the status quo with a credo of dominance, success, and mastery in a stratified society. These egocentric practices encoded in our culture can be challenged by "closing the gap between art and life" (p. 142). In alignment with Gablik's democratic notions about art, Richards opens a way for new ideas and models about how art might exist in the world. These new ideas are founded on the belief that art is intrinsic to life and often found where it is least expected. Art that emerges from a variety of situations needs to have presence

and viability. "All these experiences can not only broaden our idea of how art can be in the world, and how it can function in the lives of people, but it can also deepen our experience" (Phillips, as cited in Labbato, *Changing Identities*, 2002). Models founded on this notion have been suggested by Gablik who advocates for a discourse between artists and viewers, not only in the realm of verbal conversation, but also as an attitude of exchange through the artist's active listening and empathetic identification. This process, like Richards's, is not easily replicated because the individuality of the mentor is integral to this model. In Richards's case, time becomes the agent that accommodates the artists' idiosyncratic circumstances. His patient and freewheeling approach wears down resistance and opens the way for the neighbors to plunge into the unknown.

Richards embodies a well honed dynamic of support and challenge, knowing that at the right time challenge creates more optimal outcomes and, conversely, at the wrong time it can do damage. Art critic Patricia Phillips observes that while Richards does not have a specific therapeutic outcome, he is nevertheless interested in outcome in terms of its connection to the neighbors' lives, and the connection between the development of the work and the development of the artist. "So he's bringing this critical eye, he's bringing this compassionate eye. I think he is interested in outcome in the way he would with a group of fellow artists" (Phillips as cited in Labbato, *Changing Identities*, 2002).

Richards bluntly says that he does not teach painting in the style of basket weaving. Because he is an artist in his own right, he understands that art is a catalyst for change when approached as a serious commitment. Painter and NCSC volunteer, Joan Monastero sees little difference between the personal transformation taking place at the NCSC art studio and in a professional artist's studio. Good art, she says, communicates the personal transformation of the artist.

CHAPTER EIGHT

Community Outreach and Alternative Settings

The Experiences of College Interns at the Northeast Center for Special Care

Continued study of the literature may reveal additional techniques which may be effective for the therapist, but in the end we, as individuals, will probably learn most from those who we attempt to help.

—Spiegl, 2004, p. 8

From 2000 to 2003 students at New York State University at New Paltz interned with Bill Richards at the Northeast Center for Special Care (NCSC), a traumatic brain injury (TBI) facility discussed in chapter seven. Each semester four to fourteen students worked in morning and afternoon shifts with the neighbors. After a brief but rigorous screening and training, Richards used his infallible intuition to pair the students with a neighbor with whom they might have chemistry. And more often than not, chemistry prevailed.

Students met twice a month for debriefings and discussions of assigned reading. The first meeting began with a discussion of their backgrounds and interests that brought them to the course. Often students disclosed that a family member or friend with a disability had an enduring affect on their lives. Occasionally students' disabilities or illness motivated them to join the class as a way of making sense of that experience—not only for their own benefit, but also to contribute to others in similar circumstances.

At the second meeting we discussed *The Diving Bell and the Butterfly*, the autobiography of Jean Dominique Bauby (1997). Bauby, stricken with locked-in syndrome, wrote his book one letter at a time by blinking his eye in response to his nurse's alphabetic invention. His memoir is an eloquent and poignant record of his previous life as editor of the French *Elle* magazine and gives us insight about a man whose mind would not submit to a now useless body—as heavy as a diving bell. It is helpful to begin the course with such a powerful experience as Bauby's because it challenges our preconceptions of disability by breaking down unconscious judgments and the external and internal barriers that separate "us" from "them." As Bauby makes his inconceivable experience accessible and real to us, students realize that they cannot underestimate individuals with disabilities, nor take their own health for granted. This understanding leads to other discussions that are revisited throughout the course, such as: What makes us human? How much can be taken from us—how many limbs, how much memory and speech—until we are left as something other than human? But first, the students have to pass the hardest test: not to crumble at the sight of the neighbors walking aimlessly through the halls speaking in incomprehensible words, or crumpled in wheelchairs.

Students Face Their Demons

"Half a person...a shell of a person," these are the self-conscious hushed words that whisper through my head as I walk past the neighbors dotting the sidewalk in front of the Center. Many of them occupy wheelchairs while various metal contraptions and configurations, similar to the scaffold of a construction site, support others. Some of them watch me as I walk towards the building from my car. One man is smoking a cigarette that has been spliced to the end of a stick. I have to look twice as he holds the contraption in his shaky wrinkled right hand, and lifts the cigarette to his lips....Suddenly I become conscious of my own body parts. I have them all and they work well. I am conscious of my clean polished exterior. My hair is still damp and smells of the shampoo I used during my morning shower—a luxury the neighbors experience once a week. (Stevens, 2001, p. 4)

Dane Lucas (2001) wrote in his journal, "When I first entered the Northeast Center my heart was trying to get involved, but my eyes

were looking for the nearest exit" (p. 2). More severe reactions were nausea, headaches, and depression. The brave remained because they knew that important learning, different than classroom learning, could be had here. Each student devised a strategy to survive the first weeks. Dane built a wall of "red bricks" that he stacked up high enough to form his own universe inside theirs.

> It wasn't until September 26 when Bill Richards introduced me to Eugene that my wall came crashing down...I was a little afraid at first, but once we started it was like talking to an old friend. While I was helping him paint the picture that was trapped inside his head I asked Eugene where he was from. I let a good minute go by before looking at his monitor so he could work out the letters without feeling insecure about his typing abilities. He wrote a single word, *Bronx*, and that's the moment our friendship started. (p. 2)

The students revealed an unavoidable predicament in TBI care. Walls are built on both sides that impede already problematic, if not impossible, communication. TBI survivors build their walls for the most part involuntarily, a survival instinct to protect their profound vulnerability. Their bodies are laid bear to the raw sensory system that has not, and may never, completely recover from trauma. On the other hand, volunteers, staff, family, nurses, and doctors must also protect themselves from a different kind of onslaught, which is the laying bear of the caretaker's own vulnerability as a result of inescapable visual reminders. We, as temporary normals, step into *their* world, and the tenuousness of normality strikes us with such a blow that we hardly know what is happening to us. The impulse for flight is overwhelming, but because we still have the function in the brain to override this primitive instinct we remain until something else happens. For many of the students that "something else" can be life changing.

Deborah Denise, a student with prior experience in health care, is attuned to the paradoxes, if not hypocrisies, of caretaking. After several months of observation, she queries, what is the most fruitful way to *help* TBI survivors? "For a long time there was an unsaid general assumption in this industry that if you take care of the physical needs you have done the job. It paints a picture of a dull, joyless existence in my mind" (2003, p. 1). After the initial crisis response to a new and growing population, the field was able to step back somewhat and realize that quality of life issues were important to survival.

I remember my first impressions of the people I was meeting at the Center. I was taken aback with the truth of how fragile the human body truly is. At the same time I saw how totally indomitable was the spirit. There was such a sense of life at the Center. These people were engrossed in the affairs of living. How could the industry ever miss this point? (Denise, 2003, p. 3)

However, Denise says, "there is a strong tendency to standardize sites (this works here, so do it there). This allows for little individuality in care. Pigeon-holing clients is a problem in the field" (p. 2). Finding little difference between traditional[1] and what she calls "nurture care," Denise suggests that making and doing something that arises from the self along with the right stimulation that suits the individual is the surest way toward rehabilitation. Without stimulation the self ceases to exist. Lisa Fittapaldi (2004), who became blind late in life and learned to be an artist (see chapter six), describes how she experiences floating in undetermined space, disconnected from her body. This feeling must be like the one that comes with the loss of memory, speech, or the use of one's limbs. The issue of trust, however, arises when the caregiver uses stimulation as an augmentation of the senses and the mitigation of loss. To accept external sensory stimulation as a point from which to extend out into the world, the client must feel safe with the caregiver. "When a person feels secure she or he is more likely to try new things. To feel secure allows the flow of positive emotions. Success becomes possible. Failure stops being fatal" (Denise, 2003, p. 5).

Evan Horback was driven by more conceptual concerns: tangible answers to his questions about the efficacy of the therapeutic art process and, in particular, the role of the "therapist." If change comes from within, what role does a therapist need to play to encourage but not obstruct the slow reemergence of interest?

I commenced each early visit to the NCSC with the serious scrutiny of a bearded, pipe-smoking psychoanalyst. But it became clear very shortly that despite my fervent compulsion, I had a lot to learn. My rudimentary background in psychoanalysis, coupled with my artistic evolution (barely peeking through adolescence), was not going to be sufficient to "crack" the therapeutic code. (2001, p. 7)

Interns were at first impatient with what might be described as Richards's subtle approach in the studio. Evan, like others, learned

to take the tact of the patient participant observer, withholding prior knowledge and experience that led to inaccurate assumptions.

Making Friends

> There was something more. It is not something I can really define fully. It went beyond doing the best you could with what you had. It was also the search for something more. I had to wonder if I could have such strength and sheer will. For every person I encountered, existence was not the question. It never was the question. I am here—I do exist. I beat the odds and I am here....The question is finding the direction to becoming productive, complete and happy. By finding limitations and breaking through to whatever waits on the other side. (Denise, 2003, p. 7)

Lucas communicated with Eugene through a DynaVox[2] that he operated with his head. Like Bauby, he has locked-in syndrome, the severest of brain injuries that renders one completely and irrevocably paralyzed and unable to speak as a result of a simultaneous heart attack and stroke. Like Bauby, the only movement left in his body is in his eyelids that he uses for simple yes/no communication when the DynaVox becomes tiring. Through the use of his eyelids and the DynaVox, Eugene was able to tell Lucas that his favorite Beatles song was "Hey Jude," that he had a sixteen-year-old son, that he had been married for fourteen years, and that he was once an accountant for a radio station in New York City. "We traveled back in time when he used to take the bus to Jones Beach where he would play in the surf as a child. But for the past three years he has been locked inside a prison trying to figure out the combination to the lock" (2001, p. 3).

> When I paint with Eugene I am his paintbrush and I respond to his orders like a ballerina does to a choreographer. He is the artist and I am just the tool that he uses to transfer the image to the canvas. For a paraplegic this is the only option he has. It's either this or stare at a wall in the lobby of TBI3[3] where he is usually parked before I recruit him to the art studio. (p. 3)

Together they painted three buildings with more than 150 windows. Eugene is typical of locked-in syndrome with a mind that is entirely intact. Lucas tested Eugene's mathematical skills by asking how many

windows were in the painting. Lucas counted 146, but Eugene came up with 181. "Would you believe that I was wrong and his calculations were dead-on?" (p. 6). Most of Eugene's life is decided for him: from the hallway he will roll down to the time he eats or takes a bath. But at the art studio he can tell someone else what to do and watch his ideas come into being.

The students bring new meaning to the role of the participant observer. Lucas writes that to observe how a paraplegic paints one must participate. Emily Dermer (2003) writes that "the only way to truly be aware of what individuals need for their emotional and physical recovery is to spend time with them and find out" (p. 3). This kind of participation would do justice for all populations, but for those with TBI it is essential. Because of the wide ranging manifestations of trauma and the idiosyncratic nature of the brain, the rule book should be thrown out. In the art studio one might see mild, moderate, or severe physical disabilities, intellectual impairment, and healthcare needs. A neighbor might have a single impairment or a complex combination of many, a recent trauma or a disability from birth. One might see special assistive devices, ingenious adaptations such as helmets with protruding brushes, wheelchairs, or rolling beds. Inappropriate behavior might be moderate and curbed by medication, or rampant and cannot be medicated. Behaviors might be only occasionally visible, while for other neighbors, spasticity, tics, and verbal outburst are constant. Disabilities may appear, recede, increase, decrease, or remain ostensibly the same (Denise, 2003).

Lucas was also paired with Phillip who is probably the most savvy neighbor in promoting himself as an artist and selling his work. His relentless self-promotion made him sociable and eccentrically charming, and it was almost impossible for a guest to leave the studio without one of his paintings. Danica Ferrente (2003) had long conversations with him about the history of each painting and its price. As he talks he adopts the persona of an artist in his natural setting, and for all appearances it seems as though Phillip had come to the Center only to paint. Lucas (2001) observed Phillip from afar:

Phillip's objective for the day was to paint a wooden frame for one of his previous paintings. He started by covering the soft pine with a coat of white gloss. Then he picked up a tube of blue paint and squirt a little onto a paintbrush. He began to make little squares that ran around the face of the frame. After each square he squeezed out a little more paint straight from the tube onto the

tip of the brush to paint the next one. To my surprise, as soon as he finished all four sides he covered it all with a forest green that he mixed himself. Streaks of yellow popped out as he smeared the paint over the checkered pattern. Starting each time in the upper right corner, he painted half-inch purple diagonal lines. Phillip rarely uses a palette as he paints with a brush in one hand and a tube of paint in the other. He danced around the frame when he paints the top, and sits down when he decorates the bottom. He pays close attention to each mark he precisely makes on the surface. Now that he has changed the entire appearance of the frame twice, he walks across the room to evaluate his work. Constantly talking to himself, he soon decides to mark each corner with gold diamonds. What was once white and blue checks is now a dark purple. As soon as he finishes his third coat he goes off to find Bill's approval.... He waves goodbye to his frame and pushes in his chair indicating that he is finished for the day. After several minutes he is back in front of the frame contemplating whether or not he is happy. He picked up where he left off by brightening up the frame with gold stripes around the border. (pp. 4–5)

Until she was paired with Dennis, Cammy Balzano (2003) expressed great discomfort with the neighbors. But Dennis revealed his endearing personality as she worked more closely with him. "I learned that like everyone else, every neighbor had an individual personality, and like most people the neighbors mostly seemed to have a soft under-belly, and simply valued human interaction" (p. 5). Her description shows how labels entitle us to form stereotypes that strip those within marginalized groups of their humanity. We see instead general characteristics that relieve us of any obligation to pursue kinship through knowing.

Besides the claim that these people I encountered for the first time were supposedly being let back into society as normal, functioning people, they still scared me. For the most part, the neighbors were awkward in a social and physical sense. Some seemed very aggressive and others angry, while others seemed overly affectionate and clingy. Then there were the neighbors who ignored you. (p. 4)

Dennis was a constant and irreplaceable presence in the studio, and Richards had a particular affection for him. Dennis had an attention span of five minutes when he first arrived, but by 2003 he was entering and leaving the studio at intervals, working on his drawings for up to

Figure 8.1 Dennis Lamarita. 2000. Untitled. Marker on paper. 11 × 14 in.

one half hour at a time. Dennis shuffled in with his radio that never left his side, and "that he held close to him as if it were gold that someone might steal away. . . . He had gray hair and was balding, but the curls left on his head still stuck up with pride. He was always dressed in casual sweat suit attire of some sort, and always had his Velcro New Balance sneakers on" (Balzano, 2003, p. 5). Having lived in institutions all his life, Dennis was used to, and thrived on, its order.

A sketchy story tells how Dennis grew up in an orphanage in Brooklyn. He was probably abandoned by his parents after suffering from anoxia, the loss of oxygen to the brain, and later diagnosed with schizophrenia. At some point early in life he also sustained a head injury. After several orphanages he was placed in nursing homes before coming to NCSC. No wonder that he measured his activity literally by the clock. He timed everything with his watch that was as indispensable to him as his radio. Dennis shuffled to the same seat at one of the tables and waited for Richards or a volunteer to bring him his medium of choice: paper, markers, and crayons. His drawings have been described as representing the stained glass windows of churches and cathedrals, most likely because of his strong religious beliefs. Intern, Gwen Bardon

Figure 8.2 Francois Deschamp. 2000. Photograph of Dennis Lamarita.

Targia (2001), described Dennis drawing as his form of prayer (see figure 8.1). Richards, however, thought his art work was more about his compulsions, and the drawings he called his memories of stained glass windows were indistinguishable from drawings of electric poles.

Dennis frequently called out to Richards for attention, his most trusted friend. Once materials arrived, he mumbled incoherently as he worked. Because of his poor eyesight Dennis held each crayon close to his face to inspect its color. He worked a tangled web of lines over the surface of his paper, layering one over the other. He rarely changed direction or the shape of his lines, the layers becoming visible as they were enhanced by color. Occasionally random letters or numbers would appear (see figure 8.2). Dennis sometimes took a break while drawing by putting his radio to his ear. When fifteen minutes or half an hour passed, he called out to Richards that he was leaving, and shuffled out.

> There was something I loved about watching Dennis from afar. When I talked to Dennis myself I had a hard time understanding what he was trying to say. He grabbed my hand and held it close to his face as he did with most people. Sometimes he rubbed my hand against his face or kissed it. I found this behavior uncomfortable at times. I later learned that Dennis was looking for a ring

when he grabbed a hand—that he liked shiny things. One morning I told Dennis that I was going to bring him a ring with a large *D* studded with diamonds. (Balzano, 2003, p. 6)

Dennis had a tormented side rarely seen in the art studio. When beset with demons, he could not paint, his verbal and physical battles with himself lasting up to three weeks. Balzano passed Dennis weeping in the hallway as a social worker tried to soothe him. An unfortunate stimulation to which he was particularly vulnerable would heighten these irritable moods. The soft mumbling barely audible in the art studio became loud and agitated. At these times he was tormented by a demon that had a name; he shouted "Roman" and "Monster," which became known to the neighbors as the Roman Monster. Near the end of an episode Dennis could be coaxed into the studio. He reduced his rich palette, however, to only one color, sometimes writing "I want to draw my patterns," signifying the return to his other self.

Richards rarely witnessed aggression or confrontations among the neighbors in the studio. "They argue in the halls and get into fights waiting for the elevator, but never in the studio. This is a place of peace and relief for the neighbors" (Richards, as cited in Dermer, 2003, p. 2). Along with the engaging nature of the art materials, the studio itself is enveloped in sunlight. It is one of the 4 atriums that had been built with towering sunroofs—an undivided space of 3,600 square feet rising to 25 feet high, the perfect antidote to the trapped feeling of enforced institutionalization.

In November 2003, Dennis passed away in a hospital from complications of routine surgery. Because he did not have a family, the hospital was not obligated to disclose the nature of his death. At his memorial the staff, neighbors, and interns shared their memories about him, and everyone grieved his passing.

I had never known someone like Dennis. It was a feeling of mourning that I had never known. I cried for him living the life he did, for every negative treatment he had ever received and the unfairness God places on some people's lives. I then cried for the person who he was despite all his medical conditions and hardships throughout his life. I rejoiced in the joy and security Dennis ironically brought to the people around him with his eccentric yet consistent behavior. Finally I cried simply because I missed his presence in the art studio. He was an important member of the Center's family. (Balzano, 2003, p. 8)

While many of neighbors are, like Dennis, in their fifties, tragically several young men have been victims of vehicle accidents. Dermer (2003) worked with Victor, a young quadriplegic with limited movement in his left arm. When she first met him he sat in front of an empty canvas.

"What are you going to paint?" I asked him. He spoke slowly and had a hard time getting the syllables out. "No idea," he told me slowly and loudly. I asked him to close his eyes for a minute. Then I asked him what he pictured in his mind when he thought of the word love. He smiled and said, "my mother." He began clumsily stabbing at the canvas with his paintbrush. The painting Victor did touched me and others as well. Bill later told me that they have been trying to get Victor to paint for quite some time. He just needed an idea, I thought. (p. 6)

Dermer believes in the subconscious realm of dreams as a primal source of creativity. She cites passages from *The Diving Bell and the Butterfly* in which Bauby's dreams play a large role in resolving and forgiving the innumerable humiliations he had to endure. Like the images in the neighbors' art work, dreams also cannot be decoded by a glossary of symbolic meanings. Jung (1964) theorizes that the unconscious is the guide, friend, and advisor, and dreams are its messengers whose interpretations "can by no means be undertaken by rule of thumb" (p. 6).

As a result of their debilitating brain injuries, many of the neighbors are not fully in their conscious minds. Their fantasies emerge from their subconscious, but appear to them in their daily lives instead of their dreams, which cause them much confusion and agitation. The art studio allows the neighbors to utilize all the emotions that are deep inside of themselves to make art that has meaning to them. (Dermer, 2003, p. 4)

Victor, as with all the neighbors, was able to tap his unconscious that, for people with brain injury, often melds with the conscious mind in confusing and sometimes frightening ways. How might words, if one is left with the ability to speak, describe the changing landscape of the mind and its perceptions of reality? This dilemma invites a discussion of how to best encourage TBI survivors to use the visual languages. Unless it is asked for, is it necessary to teach artists, like the neighbors, linear or isometric perspective, or even

color theory and anatomy? Richards adamantly thinks it is not. This intentional omission is a departure from art education and art therapy, both having an agenda or curriculum. Responding to the needs of the individual, Richards starts from scratch with each new situation. "How do you know when you are helping and when you are hurting when dealing with someone with TBI? All you have to do is get to know that person and if you care he or she will tell you" (Dermer, 2003, pp. 8–9).

The question of helping versus hindering was also considered by Horback, who was on his way to receiving satisfying answers simply from patient observation. And as Richards's paradoxical answers began to make sense, Horback realized that his intention was for the neighbors to develop their own conviction and connection to the art process, which meant their own conclusions about what art meant.

> By doing this the neighbors' decisions invested in their paintings are actually not different from healing. All clinical goals of developing self-esteem, self-motivation, and the ability to plan with responsibility, were by-products of the artistic process. "How do you instill a sense of self in someone who suffers from TBI?" Richards asked me. "They have to make their own decisions and trust themselves in order to again assert their own identity." (2001, p. 8)

It would take long hours of conversation, however, for Horback to understand why Richards *chose* not to uncover unconscious and unspoken meaning and symbols in the paintings. Richards is not opposed to discussions of art work as it is needed by the artist, but he does think that initiating discussion as the therapist sees fit might interrupt creativity and produce a state of confusion. Horback later writes, "The real therapy occurs as one develops an autonomous desire to make art, not by analysis and interpretation" (2001, p. 13).

Sharing Boundaries

When I agreed to help as an intern I thought I would help the neighbors change for the better, but I would soon learn that they would teach me a more valuable lesson. In my entire studies of the arts, I never appreciated abstract painting until I watched one come to be. Mesmerized by the canvas, the painting engulfed a

neighbor's entire body as she so delicately placed each mark that decorated the surface. I was in true awe of her patience and the consistent effort that it took to stay focused in complete control of her motor skills. (Lucas, 2001, p. 8)

The interns witnessed that in the most severe circumstances we come out of our complacency and break through artistic conventions. Individuals who *need* to make art have the most to say, and say it in ways that are original and arresting. The visual arts have long played a therapeutic role in hospitals and institutions. But as children are mainstreamed into the public schools and regular classrooms, the boundaries that separate what we know as therapy and education in the arts have become unclear, necessitating a look at the critical space between them. I attempt in the second half of this chapter to describe how a community of artists of all ages in Vermont has contributed to this history by creating a practical bridge between the two.

Community building through arts organizations in the past few decades has been actively filling the institutional gap left between families and schools, particularly in economically disadvantaged neighborhoods. Art communities have proven to be invaluable in creating opportunities for mentoring, preparing youth to succeed in careers, offsetting poverty and lack of resources, and providing quality relationships among the generations in the too often isolated youth population.[4] Communities of artists with disabilities in the United States have been growing, beginning with the Creative Growth Art Center in Oakland California in 1962. These communities have also become resources for art collectors, turning once isolated individuals into "stars." Judith Scott, who was rescued by her twin sister from institutional obscurity and brought to the Creative Growth Art Center, is one such example.

As mentioned in chapter seven, the artists at NCSC have been labeled Outsider Artists by enthusiastic collectors. This terminology used for isolated and disenfranchised groups make for a complex web of definitions and cultural perspectives. It raises questions about what this terminology brings to bear on the art world and, ultimately, on art education. The Grass Roots Art and Community Effort (GRACE) described in the second half of this chapter challenges this terminology by structuring an environment that deconstructs expected roles normally played by professional staff, caregivers, and artists with disabilities. The flexibility of the roles encourages real-life learning not often found in traditional institutions or classrooms.

Grass Roots Art and Community Effort:
An Art Community for the Old, the Young,
and the Developmentally Disabled

True art is always where you least expect to find it. Where nobody thinks about it or utters its name. Art hates to be recognized and greeted by name. It makes its escape at once. Art is a personage with a passion for going incognito. As soon as he is detected and someone points a finger at him, he makes his escape leaving in his place a laurelled understudy who carries on his back a big label marked ART, and everybody regales him at once with champagne and lecturers take him from city to city with a ring in his nose. That is the false Mr. Art. That is the one the public knows, since he is the one with the laurel and the label. (Dubuffet, as cited in Thevoz, 1976, p. 15)

According to the American Psychology Association, a developmental disability (which include mental retardation), is an impairment of general intellectual and social functioning. Individuals with developmental disabilities have an intellectual quotient of seventy or less. Behavior is limited in at least two skill areas, such as in communication, self care, and health and safety. Normally developmental disabilities are not acquired through illness or accident unless the incident occurs so early in life that it interferes with social and cognitive learning and development. In the past, individuals with developmental disabilities were segregated in institutions and special schools. With recent federal laws, however, they are now part of our schools and communities. Originally formed in senior centers, GRACE in the Northeast Kingdom of Vermont is presently giving this population a voice.

Outsiders versus Outsider Art

Art is always better off without a name, when it can divest itself of the belts and corsets of categorization and expand comfortably into the vast domains of possibility.

—Lippard, 1998, p. 2

The sophisticated visitors who make their way to GRACE, where making art is "contagious rather than exclusive" (Lippard, 1998, p. 2) are often beset with questions concerning legitimacy, cultural

preferences, and the categories and distinctions made when viewing works of art. Individuals who never before considered themselves artists make strange and unfamiliar works that are so compelling that they remind the viewer of the endless debate concerning the subjectivity of defining and categorizing art. The artists at GRACE are unaware that they challenge the presumptions of the official art world's insularity of aesthetic standards of taste and quality (Krug, 1992).

What is known in the art world as Outsider Art deeply challenges that world in terms of our receptiveness as viewers of museum and gallery art. There has been Vernacular, Untrained, Folk, Visionary, and finally Outsider Art, the more recent and popular term coined by Roger Cardinal in 1972. For Cardinal, Outsider Art was something other "because it wasn't passed on or down in a regional, ethnic, religious, or occupational tradition. It wasn't fine art because it wasn't learned in an academic setting, and it wasn't commercial because it wasn't made to sell" (Krug, 1992, p. 107).

Journalists, educators, and other art professionals who make the journey, look and wonder about the GRACE artists, and often pronounce them "Outsiders" (Rexer, 1998b, 2001). The artists are not participants in the self-selected tradition of society's culturally dominant group (Krug, 1992). They are the poor, uneducated, mentally ill, elderly and physically frail, and developmentally disabled, as well as healthy children, teenagers, and retired adults. It is an unlikely bonding of humanity, gathered together to make art—a disenfranchised group whose artistic products are considered outside the orthodox art world. They are considered outside taste and quality, preferences selected by a dominant group wielding its own standards (Krug, 1992).

Outsider Art, with its unfamiliar vernacular, brings to consciousness our conditioned responses to curators and art critics. Museum and gallery art must then be the insider counterpart to the outsider. This leads to the convolution of terms and categories as Outsider Art is ushered into galleries and museums—albeit sporadically—when once its home was the institution, prison, or rural back road. In an art world where trained artists co-opt the naive charm of their outsider counterparts, these categories begin to sound counterintuitive. If Outsider Art is accepted by these same museums and galleries—and even imitated by their trained imposters—then what are we to call this other kind of art that challenges the very concept of orthodox art (Cardinal, 2003)? Perhaps the answer lays within a credo that founder, the late Don Sunseri,[5] adopted for people of all ages, classes, and states of health. He told the artists to "be yourself and do it your way" (as cited in National

Endowment for the Arts, 1995, p. 22). A New York artist of the 1960s and 1970s, Sunseri escaped the art world at the beginning of the boom in contemporary art (Rexer, 2001), embarked on a spiritual journey, and found himself in kitchen maintenance at a St. Johnsbury nursing home in Vermont. After informally inviting the seniors to draw with him, Sunseri proposed the idea of an art class to the institution's administration. He found here a kind of paradise where, unlike the art world, "people were connecting to each other and to a shared world...art became a bridge, not a wedge" (Rexer, 2001, pp. 19–20). GRACE officially began in 1975 from these humble beginnings. It now has a robust network of initiatives in several nursing homes, senior agencies, and mental health centers, as well as a weekly program that invites special education students from the local school system to their Hardwick headquarters. GRACE conducts 500 workshops a year within the 3,000 square mile region. In September 2000, a refurbished fire house in Hardwick became its long awaited permanent facility. GRACE did not grow with the self-conscious goal of housing a group of outsiders, but rather to cultivate the artistic voices of the region.

Three characteristics make GRACE a good alternative model to art made in hospitals and classrooms. First, the flexibility of the roles played by the facilitators and participants allow for mutual learning and the sharing of experiences. Flexibility allows for real-life learning not often found in traditional institutions or classrooms. Second, the conventional learning frameworks that are commonly taught in secondary schools and universities are not practiced at GRACE. This feature places it squarely within the art of the self-taught. Contrary to what we see at GRACE, however, Outsider Artists characteristically work in isolation. The community of artists opens up the possibility of a social art that has meaning, content, and accessibility, begging a new definition (Lippard, 1998), and leads to the third, and probably the most important of GRACE's characteristics: the strong social relationships formed within the community.

Facilitators, Caseworkers, Curators

An alternative perspective to the dominant cultural definitions formed by knowledgeable viewers of art emerged in GRACE. Peter Gallo, a facilitator, caseworker, and curator from 1989 to 2001, questioned the cultural definitions formed by purveyors of art. As a professional artist he lived in two worlds and managed to make sense

of both. His perspective of the "marginalized" artist challenged the perceptions of the logical and rational art world, with its affinity for definitions and categorizations. He does not make clear cut distinctions between Outsider and "Insider Art," and he is an example of how the roles of staff and artists are permeable. Gallo and other staff members influence their workshop participants, but at the same time, they are influenced by them. Sunseri used the artists' work as reference in his studio, and the artists believed that Dot Kibbe's well-known painting, *Take My Hand* had healing powers and circulated among them.

Gallo calls himself a "grass roots curator," and his life both inside and outside the mainstream is also evident in his exhibitions. In 1992 he curated *Insider Art* that included GRACE artists and art found on Vermont lawns and garages. He forged them together with the art of Elizabeth Murray and Joel Shapiro. "I mix up the classes without any kind of conscious regard of their stature in the art world" (P. Gallo, personal communication, July 29, 2001). At the same time he is aware of the self-consciousness of that statement by acknowledging the impossibility of denying one's own class and status and, thus, making judgments from an "insider's" perspective. "Modernism has given us the eyes to see this art work: the flat picture plane, the flat colors and patterns" (P. Gallo, personal communication, July 29, 2001). I experienced this bias first hand when I came close to disrupting an artist at work because of preconceived notions about what the work *looked* like. David, a severely developmentally disabled artist at the Howard Center was undergoing stylistic changes. He laid a beautiful yellow ground on paper over which he painted Terry Winters-like looping lines. As he was about to cover them with more paint, I suggested that he step back and look at his work before proceeding. Luckily he did not pay attention to my attempt to take him in a direction that was not his own.

Even GRACE's philosophy of nonintervention is under Gallo's scrutiny. "Of course the point is not to intervene in the conventional sense, but there's plenty of my own intervention in terms of suggestions" (P. Gallo, personal communication, July 29, 2001). Teaching is not the goal of the facilitators and the artists do not receive formal instruction. Making art has a greater purpose at GRACE that Lyle Rexer (2001) believes to be communication. "In fact the GRACE teams don't teach, they provoke, protect, and enable. In broader terms their intervention expands the social definition of communicative forms, thereby increasing the potential for human exchange and

recognition" (p. 20). The Grace artists have an equal impact on the facilitators, many of whom are artists, and both share in the development of each other's work.

Along with some of the better known artists, such as Gayleen Aiken, GRACE has produced a body of work that is considered collectable yet unrecognizable art. "It's really hard to place what it is that we're seeing and I think that it's with that kind of work that GRACE has been very good at being disruptive" (P. Gallo, personal communication, July 29, 2001). The GRACE artists' view of their own work as compared to the facilitator's perspective is also a paradox, full of conflicting messages and meanings. Gallo and other facilitators have a long view of the artists' development over time and find that while some elements of their work remain the same, others change.

Stylistic sameness is a characteristic of artists with developmental disabilities, a function of the need to bring order, regularity, and continuity to the world. David likes to paint in a series of repetitive designs that he organizes on the floor as quickly as he can paint them. He is such a fast painter that his caseworker encourages him to use both sides of the paper, which also invites variation. But the variations are also predictable. On one side he draws linear and circular designs with color pencils or cray pas, and on the other he paints shapes in watercolor.

Sometimes the artists perceive themselves as conduits, only partially aware of what they do.

> I don't know what I'm doing, I just put it down and that's what I do (M. Russell, personal communication, July 29, 2001).
> Some of these I don't even know why I painted them. I just sit down and do them (D. Kibbee, personal communication, July 29, 2001).
> I started doing one thing and something else comes out (T. Lakus, personal communication, July 29, 2001).
> I didn't think I'd get to draw like this, and it makes me feel good inside (R. Burnor, personal communication, August 14, 2001).

"This Is Not a Formula"

Sunseri did not intend GRACE to become an inflexible methodology to be applied dogmatically (Rexer, 1998b). The reciprocity between facilitator and workshop participant blurs distinctions between them. The artists' experiences and interests guide the workshops and make

them flexible structures. But given the artists' frailty, a safe environment is constructed through consistent procedures.

Sunseri created a hybrid that has the characteristics of art education and art therapy, and yet, like Richards's approach, are neither. Answers to art problems are not found in artistic conventions, theories, or demonstrations, and the result is a spontaneous and idiosyncratic form of expression. The caseworkers, homecare providers, and facilitators describe how their clients begin making art spontaneously without previous knowledge or experience. "She sat down and did a drawing of a house...a very elaborate drawing" (P. Gallo, personal communication, July 29, 2001) or, "He walked in and said, 'I have never done any art,' and sat down and started making these beautiful paintings" (E. Anderson, personal communication, August 2, 2001). Anderson calls this the classic GRACE situation. Role reversals are also typical, such as when artist, Gary Bryce pushed his caseworker's, Jim McCarthy, papers aside, put paint in front of him, and said, "Here...paint" (J. McCarthy, personal communications, August 7, 2001). He has been painting ever since.

The consistent participation of the artists creates the personality of the workshop and its logistical needs lead to routine seating arrangements, painting set-ups, and access to materials. The requirements of workshops in rural areas are different than at their urban site at the Howard Community Center in Burlington,[6] but in both locations the two hour workshops are pivotal in the weekly schedule organized for the artists by their caseworkers. 70 percent of GRACE participants are white elderly females. The Hardwick workshop, however, consists of a diverse group in gender, age, and ability. Several teenagers are brought by their parents or relatives of caseworkers, and a faithful group of retired female artists are a strong and supportive presence for their lesser abled peers. For example, Dot Kibbe knew many of the participants in her former life as a nurse, and she is respected for her advice about health and art. The primarily developmentally disabled population in Burlington requires a greater need for personal attention from caseworkers, homecare providers, and facilitators.

The bonding between staff and the participants is the motivation for better art work as well as the augmentation of the participant's socialization. The caseworkers were particularly fruitful in understanding their clients, and several have such enduring relationships that their clients become members of their families. The following pages describe the dynamics of these friendships and how they inspire both art and quality of life.

The Howard Community Center, Burlington Vermont

<u>*Alice Wing and Facilitator Emily Anderson*</u>

Just after 9:30, August 9, 2001, Alice Wing is discussing the drawing she started that morning using Degas's *The Bellelli Family* as reference. The following is a dialogue between Emily Anderson and Wing.

Anderson: (pointing to the dress on the figure), That's a rich dark black.... What about a black magic marker?

Wing: (pointing to a chair in the reproduction), That's a blue.

A: Is that a blue or a black? It's the chair.

W: In between, and this color is funny (pointing with her pencil along the rug in the reproduction.

A: Well, it's a rug, so it has a bunch of different colors in it.

W: And I have a blue here and yellow over here.

A: How about the wallpaper?

W: That's the blue I have.

A: What about this? (pointing to the texture in the wallpaper). Are you going to use the pencil for the background?

W: I think so...and this I can make up with whatever (points to something behind the figure).

A: What do you think that is?

W: Something from my time. I was born in 1922.

A: (Laughing) That is way before your time...that's from 150 years ago.

W: Oh my!

A: OK, well that's the black over there you can use for the dress.

Alice Wing is an elderly woman with a developmental disability. When I met Wing a week earlier, she was drawing from a book of Picasso's blue and rose periods. I thought how much I liked her version of *A Child with a Bird*. Anderson, commented on her art work.

She has established her style and has a pretty set routine of what she's going to do. She comes in, she gets her pencils in order, figures out what she's going to draw and then uses a regular pencil and fills in what she's drawn with color. She's very concerned with

getting the right color. She does what she can with the color pencils to develop a similar idea that she sees in the painting. (personal communication, August 9, 2001).

Using artists as reference is part of her routine, evidence of the need for predictability and order. But it is not the only art work she does. Drawings on the Howard Center walls show birds in flight, carousels, and airplanes. They are as unpredictable as her referenced drawings are predictable. I asked her to tell me about them. "There are all kinds: dancing girls, and the birds up there and the airplanes. And way up there is something else. It's a difficult one. I did so many" (personal communication, August 7, 2001).

Larry Bissonnette and His Caseworker, Ann Cahill

Sonic Sensitivity, placidity in personal relationships, loose personal hygiene, language processing problems, primitive plastic social skills, kooky behaviors, activities limited by obsessive routine.... Rote learning habits. This is a summary of autism's daily impact on my life.

—Bissonnette, in Bilken and Rossetti, 2005

When Larry Bissonnette was two years old, a high fever caused severe damage to his nervous system. At eight he was committed to the now defunct and infamous Brandon Training School (BTS), where "he often jimmied his way into the locked workshop to draw, paint, and build through the night" (Sunseri, 1994, p. 2). A defining characteristic of Outsider Art, according to Roger Cardinal (2003), is that confinement will not contain artistic impulses for long. "Impulses weigh out the imprisonment... albeit with obsessive/compulsive behavior" (symposium, American Craft Museum). There he was diagnosed as mentally retarded, schizophrenic, clinically insane, and finally, autistic—"saddled with every label except the one that would restore his humanity— 'artist'" (Rexer, 2001, p. 21).

Bissonnette's introduction to Facilitated Communication (FC) revealed his poetic nature. Originally developed for people with developmental disabilities in Melbourne, Australia, it is now having success with people who have limited or no speech. Bissonnette communicates a strong and poetic understanding of his identity as an artist as well as his role as an advocate for disabilities.

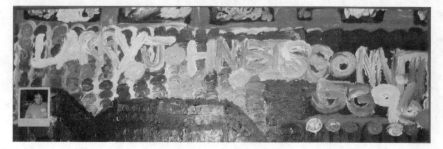

Figure 8.3 Larry Bissonnette. 2002–2003. Title: Playful Larry Looks Out. Mixed Media on Board. 14 in × 44 in.

Among other cryptic communication, he has given titles to his work, particularly the paintings of BTS (see figure 8.3), such as *Utterly Grey Day at BTS* and *Pell Mell Mainland of Rolling Fortress of Painting of Monastery of Brandon Training School, VT*. Others are more generally psychological and political, such as *Dominating Jack the Artist Ripping of Truths,* and *Eating Artistic Theories Tanked Up in My Head.*

Bissonnette's paintings often depict walls, doors, and windows in ominous blacks, grays, and browns. They are paintings of the mono-lithic and hostile architecture that contained his life for ten years. However, he will also playfully attach a Polaroid snapshot of him-self, smiling, dead center in the painting. The roughness of his own constructed frames, with nails bent and protruding, make even more apparent the forbiddingness of BTS.

Bissonnette entered the community center at 9:30 in the morn-ing on August 9, 2001 accompanied by Ann Cahill who has been his caseworker since 1989. She has witnessed his growth as an artist, particularly how painting about BTS has helped to temper his anger and aggression. Like several other caseworkers and homecare provid-ers, she had no prior experience or training in the field. Bissonnette gets to work, preparing his materials with confident precision. He religiously paints in the morning and draws thank-you cards with colored pencils in the afternoon. He draws his cards with the same purposefulness as he does his paintings. He likes to fold them when he's done, but occasionally a facilitator will intercede, hoping to pre-serve them as drawings in their own right. Unlike his paintings, his drawings are inspired less from memory and more from spontane-ous sensory motor experience (Bissonnette, in Bilken & Rossetti, 2005).

Bissonnette sets up his paints, lays a wooden board on the table, and begins his painting with a thick ground of white acrylic paint that he spreads over the surface with both hands. He then pours on red and blends it with white until it becomes a viscous pink. All the while he speaks in an autistic monotone, reciting phrases that apparently come to mind, or words he hears and repeats echolaically. Toward the end of the two hour session, Bissonnette finished his work by carving into the many layered paint with his fingers. While massaging the letter "S" he repeated the "S" sound. I asked him if he was spelling Brandon Training School. "Yes, Yes, Yes, Yes," he said. Every move is deliberate. He puts his finished painting aside, packs up his paints, and lays out his colored pencils in preparation for the afternoon.

Bob Blake, His Homecare Provider, Donna Therian, and Her Grandson, Jacob

While Bissonnette is painting, across the room five-year-old Jacob stands on a chair and watches with fascination. He wants to paint with his hands too and he does, to his grandmother's exasperation. Donna reminds him that he has finger paints at home. Jacob returns to his watercolor painting that he punctuates with loud and forceful bang dots. He and his mother work together at a table and Bob sits on the opposite side. Jacob and Bob share paints that at times Jacob moves closer to his painting. Bob does not seem to notice. Every once and awhile Jacob reaches over and paints on Bob's painting or on Bob's hand. Donna admonishes him but, again, Bob does not seem to mind.

Donna has been providing a home for Bob for sixteen years, and "he'll probably stay with me forever," she says (personal communication, August 9, 2001). Donna was a wallpaper hanger before she met him and had no experience in the field. Bob, like his eight siblings (two died at birth), has fetal alcohol syndrome and cerebral palsy. His mother lives in a group home and his father's whereabouts is unknown. By chance, one of his brothers also attends the Howard Center, but there is no recognition or understanding between them.

Donna's four children grew up with Bob, and he "learned a lot from the kids...of course they've grown up and gone by him" (D. Therian, personal communication, August 9, 2001). Jacob was living temporarily with Donna, which tightened his bond with Bob. "He really likes my grandson and you can tell by their interaction that Jacob really loves Bob. He'll take his hand and help him to walk but because of the fact

that Jacob is so short, it makes it harder for Bob" (D. Therian, personal communication, August, 9, 2001). At home they play with Jacob's games and Bob's puzzles.

Tim Jones and His Caseworker, Charlie Messier

The morning session ends and the afternoon begins after a two hour break. Tim Jones is at work on a drawing in his recognizable style. Charlie Messier, who is employed by Jones's mother, has worked with him for three years. He is funded for twenty hours a week and they make use of the funding with a full schedule of sports, literacy classes, and performance workshops. One of the few times Jones socializes is at lunch gatherings on Thursdays in the Howard Community Center. From there they go directly to the art studio and then to literacy class in the library where Jones learns to read.

Jones organizes his drawing paper into sections in which he classifies objects that interest him with their appropriate titles. Messier reads the text out loud: "Ice cream cone, four bunches, toast, napkin, bread, potatoes and...party hats" (see figure 8.4). They look like McDonald hats and Jones nods that they are. Messier explains that every line he makes needs a name.

> It's less abstract...he likes to name things, be certain of things...very concrete. He's oriented to concrete things. He was just saying we don't have enough time to draw a picture. I said, well, we have some time for one picture. He said, well, OK. He always wants to jump ahead to the next thing and know what's going to happen. So I think that has something to do with drawing and giving it a name. One of his first fish drawings was a Square fish. I asked, "What's a square fish, like the kind you find in the freezer?" He said, "yes." He's done a Jar fish in a jar, a Lamp fish with a lamp shade on it. He's into fish, but not today. (C. Messier, personal communication, August 9, 2001)

Messier shows me a finished painting divided into three sections. He explains the contents: "We still don't know what a Green Toboutier fish is. This is a Space Ball. I said, 'what's a Space Ball?' He says, 'like a planet'" (see figure 8.5) (C. Messier, personal communication, August 9, 2001). Another drawing has gloves, a hat, a bowling ball bag, and a lamp.

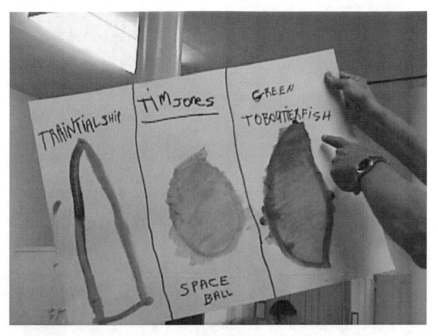

Figure 8.4 Tim Jones. 2001. Untitled. Watercolor on paper. 18×24 in.

The Hardwick Workshop at the Old Firehouse

Gary Bryce and His Caseworker, Jim McCarthy

Gary Bryce stands in a white hospital coat. His blue and black abstract painting is tacked to the wall and he is considering his next move. McCarthy hangs the canvas for him and Bryce points to the colors he wants. After awhile McCarthy asks if he wants to continue. Other than this question, McCarthy does not make suggestions and he tries not to interfere. Painting is Bryce's most important activity, apparent by the seriousness with which he works and his contemplation of the unfinished painting. He is able to focus for an hour of intense work. "He really knows where it's going," says McCarthy (Personal communication, August 7, 2001). Bryce works in layers and his painting changes dramatically as it progresses. McCarthy observes that his application of paint is not arbitrary, but rather he has a concept of the finished work in mind.

Bryce's limited speech was caused by a brain stem injury when he fell down a flight of stairs at the age of five. He stops painting and sits down to be part of the conversation. I ask him, "How long have you been working on this painting?" McCarthy answers after Bryce hesitates. "five weeks."

I ask him if it is almost done. He wheezes and breathes heavily. "yes."

"What do you think it needs" I ask. Bryce answers in one word, and I am not sure what it is. McCarthy understands, however, typical of caseworkers who have spent a long time with their clients. "More? It needs more?"

In 2001 Bryce was at a critical juncture after leaving a family with teenagers. Feeling that his presence was intrusive, Bryce's life became increasingly circumscribed. He was unable to let McCarthy know he was in crisis, which motivated McCarthy to learn new ways to communicate with him. Finally, at an annual meeting of the Individual Support Agreement (ISA) he communicated his need for an all adult male living situation. The turning point came when Bryce found new

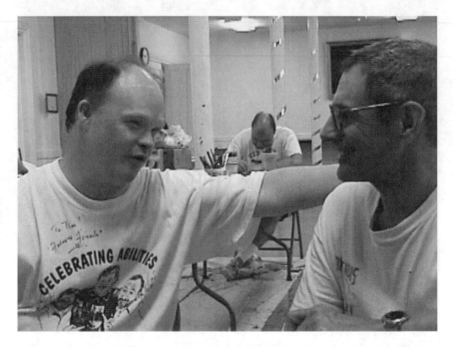

Figure 8.5 Alice Wexler. 2001. Photograph of Tim Jones, Charlie Messier, and Larry Bissonnette.

homecare providers, Richard and Charlie, whose friendship has stabilized him and helped him become more independent.

Merrill Densmore and Kathy Stark

Merrill Densmore[7] lived independently with a developmental disability, and he is well known in Vermont for his colorful paintings of landscapes that he invests with narratives from his imagination and memory. His paintings are woven with bold flat shapes that form quilt-like, unified patterns (see figure 8.6). On an afternoon in August 2001, Densmore arranged his recent paintings on the floor and tables in the Hardwick Firehouse for a critique by the exhibition director, Kathy Stark. The tutorial was once officiated by Sunseri before he passed away and his absence was deeply felt by Densmore. Some of his smaller works look hurried—perhaps, I thought, in anticipation of the tutorial. Stark suggests that this might be a problem of adjusting to a smaller sized canvas. She remarks that "They look crowded, with little air to breathe." Sometimes Densmore submits to Stark's suggestions,

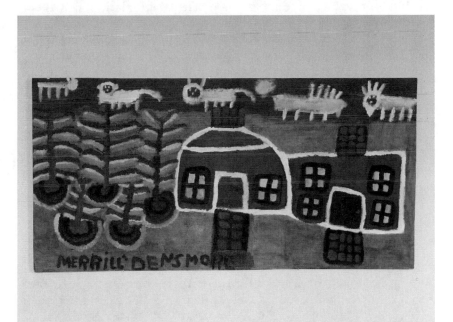

Figure 8.6 Merrill Densmore. 2003. Untitled. Acrylic on board. 24 × 48 in.

while at other times, he defends his choices. For example, in one of his small paintings, birds fly above a landscape at dusk. Alternating tones of dark colors represent light reflected in the clouds. Stark worries that the birds disappear into the night sky, but Densmore thinks it logical because of the fading daylight. Kathy singles out two paintings that still need work, the others, she says, are "good." I thought that "good" must mean that he achieved a unity of bold shapes and colors that was lacking in the others.

Later I asked Densmore for a short interview. I learned that he began working with GRACE in 1992 while living in Greensboro. When he met Sunseri he was working in coloring books and paint-by-number kits.

> Don said, "look out the window...look at the trees...look at how they are." I think I did a good job on that and looking at leaves. He said, well, "look at houses, look at buildings" I memorized them, then take them home, make the details, make the sky, make the deer or the moose. My paintings were not very good. Now my paintings come out pretty good. Don said mix your paints in together, like a blue or green. I take black and white and make the color gray. Sometimes I make the sky gray, like it's going to rain. I make the houses on the bottom, make the grasses. I like to draw houses, horses, dogs, and cats. I get a thought in my head—details—when I get done I usually go back and look at them. I usually paint during the day, two hours or three hours in my room. I like to draw things on TV. At nighttime I paint and watch "Who Wants to be a Millionaire," listen to John Denver on the CD once in a while. I kind of miss Don. He's my teacher. I wish he was here today. He could have seen all my different paintings I do. So Don, if you're listening to me, I'm here.

Questions Concerning Teaching, Learning, and Aesthetics

Although their art work and personal histories have little in common, Bissonnette, Jones, Bryce, and Densmore have someone in their lives who recognizes their needs as well as their gifts. These men, in their middle years, did not have the federal protection that has been made into law in the last few decades that individuals with disabilities now enjoy.[8] When once the men lived in isolation, they now work in an

unrestricted environment made possible by their caseworkers. At the same time, several caseworkers such as Cahill and McCarthy make their own art work as a result of their participation at GRACE and speak of the enrichment their relationship with their clients brought to their lives. Because the facilitators and the caseworkers do not act as experts, the artists feel a sense of equality that makes possible the production of such rich art making. What seems to matter is the facilitators' responsiveness: listening to the needs, shifts and changes that take place and communicated through their artwork.

The conversations of the artists bring up aesthetic questions concerning the quality of GRACE art. Aesthetics beckons the discussion of a dominant social order that makes distinctions between itself and the "other," of categories of quality, and the "good product" based on so-called universal standards of taste (Krug, 1992). Then how do we make sense of the visual autobiographies that are as persistent as the spirits of the artists who make them? They show us that the necessity for making art is not only unimpeded by disability, but might possibly be its cause. The angst and existential ambivalence that seem so germane to the art profession does not inhabit GRACE. But even here life seeps in, and qualitative judgments are unavoidable. Artists such as Bissonnette and Densmore stand out.

Something happens in a community of artists who are empowered to learn from each other through the exchange of ideas. The artists conceive their own standards that they impart with meaning. Their commentary shows that they achieve a reflective distance from their work and make their own decisions. For example, Bryce knows when his work is complete and Bissonnette's deliberateness makes it clear that he is in control of his product. Although they may be highly idiosyncratic, Densmore is able to make convincing arguments for his own choices.

Unnecessary Segregation:
The Implications for Our Schools

The overarching themes at GRACE are the relationships and the sharing of knowledge, experiences, and ideas about aesthetic choices that shape ways of thinking about art only possible in a community. A social art develops from the weaving of relationships among the artists, a richness generally missing in school communities. The need for continuity and connection among the generations, the sense of community so

lacking in the public schools is highlighted when compared with the intergenerational learning at GRACE. It is ironic that in the creation of a community of people considered marginal, a model for what might be a democratic society has emerged. In it individuals are respected for their distinctive roles and the contributions they make.

> Their goal is not occupation but redemption, the forging of human bonds through the fashioning of form. The power of self-taught art to produce a "third world," a space where artist and audience may communicate freely, is often strongest when closest to home where iconography and experience is shared. And yet GRACE artists have produced work that transcends barriers of time, place, and personal circumstance, to include us all. (Rexer, 1998a, p. 62)

The question of the equitable representation of heritage, culture, and identity might be solved by returning to the local communities, "closest to home," where they arise. The intersection of land, history, culture, and politics in the community inform art from the point of view of participation rather than exclusion. Art as inseparable from its context takes on new meaning as narrative is written into place by its people. In a global world, "the local" has a quaint sound, an anachronistic concept whose relevance in education is questionable (Lippard, 1997). How can the concept of art in a social context find its way back into art schools and university art departments that, for the most part, have constructed firewalls that separate art education from public life?

The outsiders in the Northeast Kingdom are, in some paradoxical way, more in touch with a wider spectrum of humanity than their coeval self-appointed insiders. Deborah Meier (2002) and John Gatto (1992) are two educators who have contributed to a conversation that deserves attention: the segregation of the young into schools and the old into senior centers. The presence of the young and the old are all but absent from daily reality. How much more absent, then, are the disabled from life and the public imagination. The involuntary alienation of the young, old, and disabled in our educational and cultural conversation has consequences.

Until now, the art world's defining characteristic might be its individualism and, thus, we bring this value to the classroom. On the other hand, Suzi Gablik (2002) describes what she calls empathetic art, "like a window on the dream-broken soul of our society" (p. 113). Empathetic art addresses the need for a greater public purpose. It calls artists and the

public into a "relational experience with listening" (p. 114). We have had art as a mirror of culture, art as social protest of culture, art as a search for self, says Gablik. It is time to conceive of a broader purpose.

As we continue to reach beyond the values of Modernism, we will be looking for a model that embodies the intersubjectivity and relational experience of community. Is it possible that these "outsiders" have created a model of what learning might look like if we were connected to each other and the world?

CHAPTER NINE

Lesson Plans

Overview

Lesson plans for children with disabilities need to emphasize dialogue and process, integrity of materials, sensory motivation, and self-reflection. Whether in a self-contained or inclusion classroom, all children benefit from lesson planning that hold these values as priorities. As discussed in chapter one, strategies with students with special needs and regular students are different in intensity rather than in kind. All children need lessons that emerge from the culture of the classroom and the individuality of their lives.

In the chapters that have preceded, I have emphasized sensory knowing as the shortest path to engagement. The subjects of this book are children who are not only isolated from their peers and the larger society, but also from their own bodies as an effect of the former, and in many cases the result is the diminishment or chaotic organization of the senses. Studio projects that emphasize the bodily processes unique to the individual child rather than art skills and techniques as an external body of knowledge, will make vital connections where there were none before, and more than likely produce the desired aesthetic outcomes as a result.

In the course *Art for the Exceptional Child* that I teach at the State University of New York at New Paltz, I replace traditional instructional procedures with dialogue. I find that with the former teachers tend to direct students to perform in predictable ways. Through dialogue teachers lead with subtlety, guiding children toward the teacher's objective while allowing for the surprise that comes with the mutual construction of the journey. The following is the template I use for the

course. The most important segments of the lesson will be analyzed later in the chapter.

Lesson Plan Guide: Toward IEP Goals

Elementary, Middle School, And High School

Title of Lesson/Grade Level(s)/Name of teacher
Overview of Lesson: A brief summary of the lesson. If the lesson takes more than one day, explain how the phases of your lesson develop over several classes.

1. What are your *objectives* for the lesson plan? They should be **concrete** and **measurable: use action verbs**. An objective should be (if successful) accomplished within the lesson. Break it down into the following three components: Skill, knowledge, and attitude. (Or physical, cognitive, and social/aesthetic growth)
2. *Characteristics of the disability:* What is the present level of the student(s) in terms of skill, knowledge, and attitude in artistic/aesthetic, cognitive, and physical performance?
3. *Rationale:* Why is this lesson plan significant for this population? How will this lesson achieve physical, perceptual, social, cognitive, emotional, and creative growth? You need not address all of them, but specifically those that are significant for this disability.
4. Materials/Teacher Resources
5. Motivation Dialogue:

Topic Question: Begin your lesson with a question that captures children's imaginations by relating to their interests and experiences.
Student Responses:
Association Question(s): Extend student response to the topic question with questions that enrich and clarify the discussion and require more thinking, memory, details, and ideas.
Student Responses:
RECAP: A statement synthesizing the ideas of the children is very helpful for children with disabilities who need support interpreting information for meaning as well as keeping it in memory.
Visualization Question(s): The critical juncture in which materials and the project are introduced by the teacher, helping students to translate discussion ideas into materials.

Student Responses:

RECAP:

Transition Question(s): How will children begin? This is an important consideration for a population that might not know how to realize intentions and initiate action.

Student Responses:

Summary: This is the critique of the finished work in which the teacher and students share ideas. What kind of questions will you ask students to reinforce learning, deepen understanding, and prepare for future learning?

6. *Cleanup Procedures:* What procedures or "rituals" will you use to make the smooth transition to the end of class? What considerations need to be made for the specific disability? How will you allow for the maximum independence of students?

7. *Evaluation:* How will you assess what children have learned? Create a simple rubric that identifies behaviors you will be evaluating. Like task analysis, break down procedures into simplified parts. Again, go back to your objectives: you are evaluating whether or not you achieved them.

8. *Extensions:* How will you continue to challenge this population as they acquire new skills, knowledge, and attitudes?

9. *Standards Addressed:* Which State or National Standard does your lesson address?

Sensory Motivation and the Integrity of Materials

In the pages that follow we will look at how dialogue encourages the development of language, reflection, and critical thinking. In addition, in situations with severe disabilities in which verbal language is not present, dialogue can be constructed so that it reinforces primary sensory knowing originating in preverbal memory. The way to tap into this primary knowing, according to Lowenfeld (1987), is through one's own body. A special tribute was given to Lowenfeld in a 1982 issue of the National Art Education Association's journal *Art Education.* Robert Saunders, a student of Lowenfeld at the University of Pennsylvania, reminisced about his greatest contribution: his well-known sensory motivations. Encouraging children to draw knowledge from their own experience acknowledges their value and, as Saunder's writes, "to dispel such anxieties [about what to draw] when the child is confronted

with making a picture" (p. 28). This strategy is foundational in implementing Lowenfeld's notion of having a *point of departure* from which to begin, for the point lies within the child's level of functioning. We must begin where the child begins: the sensory knowing of her environment. Saunders shows how Lowenfeld encouraged his students to make passive knowledge (dormant in one's body) active by physically performing the memory embedded within. As mentioned previously in this book, Lowenfeld famously encouraged a group of youngsters to explore the physicality of their mouth by inviting them to chew on hard candy. This ordinary experience will activate not only physical but also emotional memory and set the stage for self-motivated art making.

Saunders broadened Lowenfeld's strategies by describing and then adding to the *what, where, when, and how* of his motivations. Saunders uses the example of the *what* as brushing one's teeth, an experience that on the surface might seem too mundane to motivate a group of youngsters. However, *where, when, and how* make the ordinary exciting when discussed and acted out with peers. *Where* do you usually brush your teeth? Children can conjure the details of their bathrooms: how the sink looks when full of water, the scent of the tooth paste, the reflection of a sleepy face in the mirror. *When* do you usually brush your teeth? The sensory memory of falling reluctantly out of bed, sleep walking to the bathroom in pyjamas, and looking for slippers. Or, after a full day, sleepily thinking about the day's events and then, looking forward to sleep, tumbling into bed. *How* do you usually brush your teeth? This question invites children to show their peers and remember all its muscular sensations: The mouth full of tooth paste, the bulging cheeks, the feeling of clean teeth, spitting out the tooth paste, and finally rinsing.

For children with severe disabilities, these ordinary activities are not taken for granted. Daily living skills need to be rehearsed, communicated, and sometimes become the subject of art work. Children with classical autism or severe learning disabilities need to be reminded of the steps taken to complete the task. Making a tangible representation of the process insures further that knowledge of the task becomes internalized. To *"what, where, when, and how,"* Saunders contributes *"who and why."* *Why* is the purpose of the lesson, in this case to enrich the child's concept of his body, particularly his mouth, teeth, and hand–arm relationships. The *who* of the lesson is, of course, the child himself, who is ultimately being encouraged toward self-identification.

In the following paragraphs I offer examples of how students used these strategies in their lesson plans. The vital segments of the lesson will be analyzed: the objective, rationale, and the components of dialogue, and evaluation. The objective and its rationale need to be used as the organizing principle when constructing a plan because while the teacher will take children on a journey full of detours and distractions, she will need to keep an eye on where they are going.

Objective and Rationale

The objective and rationale are the heart of the lesson from which everything grows, and which eliminates the potential for arbitrariness. Without this compass we can easily get lost and choose ineffectual materials, dialogue questions, and evaluations. We must know what our purpose for the lesson is to make effective choices.

The objective is the measurable and immediate goal of the lesson. I ask students to think of the objective in terms of skills, knowledge, and attitudes, the language of Individualized Education Plans (IEPs). In this way students are reminded that learning aesthetic skills and techniques is not the only purpose for making art. As discussed, the successful lesson addresses the needs of the child in her entirety: social, cognitive, emotional, physical, perceptual, as well as aesthetic growth. The teacher must ask which materials will best accomplish these objectives. How will I construct a dialogue that will lead children to this outcome? How can I reinforce the objectives in the critique of the student's work? How will I construct a rubric that will reflect the purposes of the lesson and determine whether I have achieved them?

The rationale reminds the teacher of the greater significance of the lesson. Why this lesson with these children at this time? The teacher must be able to answer those questions. If he cannot, then his choices were made arbitrarily. The teacher must think of the children in terms of their growth at a specific moment in time, and how what is done in the present relates to their past and future.

In a "Bubble Exploration" lesson for a visually impaired, haptically minded male in early adolescence, Laura O'Gorman and Lisa Provenzano write the following objectives:

1. Students will learn how to incorporate all the senses in the artistic process.

2. Students will be able to gain confidence in developing the use of their entire body to execute a visual process.
3. Students will be able to gain self-awareness.

The following rationale for this lesson describes the importance of a sensory exploration replete with stimulating dialogue. As we will see later, the preservice teachers design the dialogue to reinforce sense-memory.

> At this critical stage in development, the early adolescent faces identity crisis. Losing sight within recent years complicates this crisis, as the student now has to establish himself as a blind person in a visual world. This lesson is planned to build confidence in the student by having him explore different methods of "seeing" by incorporating past experiences and memories with exploratory uses of the other four senses. If the student realizes he can succeed in art, something considered a purely visual process, then he will heighten his perceptual growth.

Laura and Lisa sensitively address the most salient issue of this population: that the seeing world can be represented so that students who are visually impaired participate in a visual experience. John Bramblitt and others explain that seeing has meaning for the blind by reinterpreting vision through the other senses.

Sarah Taft and Kaitlin Van Pelt write objectives that address the skills, attitudes, and knowledge that a middle school student with attention deficit hyperactivity disorder (ADHD) needs to develop. Learning to participate in a community of peers is the overarching theme of this disability. Under this umbrella come other learning needs, such as an awareness of one's boundaries and limitations, one's effect on others, and the ability to understand one's own emotions and empathize with those of others.

> Students will be able to express emotion through the art-making process as well as create a record of this emotion via drawing and printing media. The students will learn to channel and use emotion as inspiration for art-making. This, in turn, will create a relationship between expression and personal emotions that the students can relate back to in any art-making circumstance down the road. The activity will also promote cooperation with classmates and positive social interaction skills. Being given the

opportunity to draw from life will encourage the students to draw what they see as opposed to what they think a drawing of a face *should* look like.

The rationale for this lesson in the following text aptly underlines the importance of achieving the objectives at the present moment and projects what this learning means across the lifespan.

This lesson will encourage cooperative interaction and awareness of others' feelings. It will also give students the freedom to express whatever emotion they may be feeling. In this way, students can express their own emotion without vulnerability. Students will also be brought to realize the importance of other classmates' emotions. This will help students to grow creatively, socially, and emotionally. Multiple social characteristics of their disability will be challenged in order to confront and improve them.

Amy Mottola asks middle school students with emotional disturbance/behavior disorders (E/BD) to write about a memory of a place and then connect that memory to sensory experiences before constructing their Identity Box (a three-dimensional work contained in a box-like structure that represents oneself). At the end of the lesson students write descriptions "about the person and place as the artwork depicts it." This extra layer of the art process is an effective strategy in sealing in learning. The more modalities the teacher uses, the more the possibility that students will internalize learning. Amy's objectives highlight the metacognitive potential of making and thinking about art:

Students will identify themselves aesthetically through the making of containers and collections of objects that reflect a personal memory. Collage and construction encourage students to work intuitively and physically integrate various materials that come to symbolize intense sensory and memory experiences. Peer written analysis will promote students' awareness of aesthetic interpretations of identity and the influence of geography on the construction of identity.

Amy's rationale further emphasizes the significance of construction as a metaphor for building self-knowledge and identity.

Identity boxes act as a concrete manifestation of emotional experiences. The process can be very cathartic and intuitive as material

choices are varied. This ability to choose specific materials that represent one's sensory expression is crucial for E/BD students. The container/box concept gives the project a sense of structure and security that acts as a metaphor for these students' fragile sense of self in the environment. Connecting one's senses to physical representation reminds oneself of one's own physical existence and encourages a stronger self-confidence.

Amie Laino and Amber Novack also use the identity box lesson plan with middle school students with E/BD. Their rationale in the following text reinforces the importance of the learning discussed in Amy's rationale. In addition, they analyze the psychology of the project.

Creating an identity box is a way, perhaps, of exploring the nether regions of the mind, resulting in a catharsis from which the student can learn and grow. Students get to tell us what they want in their own way; they can choose what will be incorporated and how much of it the viewer is allowed to see. Sometimes just getting something off one's chest or bringing issues to the foreground of thought can begin the healing process. Much can be learned by looking at the work of an artist, especially work that is loaded with personal imagery, objects, and other relevant components. Additionally, the artists are given a chance to contemplate their own work and discover things about themselves.

Dennis Fougere continues to explore the need for cathartic release possible while constructing an identity box. In his lesson he works with high school students, a critical stage that exacerbates the related issues of E/BD. Dennis writes his rationale with great empathy and sensitivity.

Perhaps the greatest point of growth in human development is the ability to get through a challenging stage of life. Often during these times we face physical and emotional tests that help us identify our strengths and weaknesses, making mistakes and learning from them. In the case of students with E/BD, they do not know how to deal with these challenges because of the abusive conditioning they have been taught by their parents, siblings, guardians, and those who do not understand what it is they are going through. Often, the student with E/BD is encouraged to suppress emotions, ideas, and memories in order to protect him/herself from further abuse or pain.

It is the purpose of this lesson to help free some of the baggage that has been locked away in the student's mind by giving each concept a physical identity and separating it from the student by putting it into a container where it can later be analyzed and openly discussed with peers. It is this kind of action that begins a new habit of recognizing these feelings as being ones that all humans feel, and that by identifying and sharing them, they lose their power to oppress.

This Rationale illustrates the strategy of externalizing psychic material into physical form so that it can be fixed in time and space in a containable and accessible location. An adolescent can reconcile disparate and conflicting emotions more easily when they are given a new context.

Dialogue and Process

Much has been said thus far regarding the importance of knowing and understanding the child rather than deferring to labels, theories, and other generalizations that often diminish more than they illuminate. Knowing the child's specific characteristics and how she lives with her disability gives us the ability to construct lessons that create compelling moments to make art. Rich dialogue is the method I use to not only entice young people to communicate through the visual arts, but also as a way of co-constructing the lesson with them, allowing them to lead while keeping an eye on my purpose and objectives.

When we talk of dialogue we must also be aware of the problematic issues that arise with verbal communication in many of the disabilities. Therefore, nonverbal communication such as facial expressions, body language, sound effects, movement, and repetition, might need to be included in lessons. Dialogue is the antidote to verbal *directions* because when used well, it equalizes the playing field. The authoritative figure disappears when teacher and students equally engage in the exploration of ideas and then translate those ideas into artistic materials. It is important not to let time constraints allow this crucial part of the lesson to be expendable. For children with severe disabilities, very often dialogue with supporting sensory motivation *is* the lesson. Therefore, dialogue should not be reduced to a check list of questions that elicit uninspired responses. Rather, every effort needs to be made to cajole children who are often not trusting, to let us into their lives through a shared interest in art and how it might become a vehicle for expressing what matters.

Most importantly, dialogue should lead children seamlessly toward the objectives of the lesson. Although the objectives are the organizing principle that shape dialogue, children will invariably bring unexpected ideas with them that, if the teacher is alert, can enrich his original intent. I use a format for motivational dialogue introduced by Nancy Smith (1998) in *Observation Drawing with Children*. The following are sections of the lesson Smith uses that help the teacher to stay on course. They will flow from one to the next if the questions are thoughtfully constructed.

Topic Questions

The dialogue begins with a *Topic Question* that introduces the theme of the lesson. The question needs to be broad enough to engage many children, but not so broad that it is vague. If the teacher has some knowledge of her students then she may ask a question that relates to their experiences and interests. Much can be learned from careful listening during the lesson so that future lessons might target more accurately the students' concerns. Planning lessons in this way allows for the inevitable shifts and changes that arise when teachers learn from their students.

A few engaging topic questions that have been written by preservice students are as follows.

Teacher: "Have any of you taken the time to stop and look at the clouds?"
Teacher: "What is a shadow?"
Teacher: "Today when I was getting ready to come to school I dropped my coffee all over my shoes: How do you think I felt?"
Teacher: "I'm feeling odd today. I can't quite put my finger on it. Can anyone tell me what mood I look like I'm in?"
Teacher: "What place makes you feel safest?"
Teacher: How are we like a box?
Teacher: Do you remember blowing bubbles?

The topic questions above lead students with a variety of disabilities to think about an experience they might have had in the recent or distant past. The teacher is preparing them to ponder their experiences and bring them into the present so that they might be remembered

with new meaning and as possibilities for art making. Two preser-
vice teachers included their own experiences in the topic question, a
good strategy in gaining trust from children who might need to hear
their teacher's experiences before they are willing to talk about their
own. Amy asks elementary school students, "Today when I was getting
ready to come to school, I dropped my coffee all over my new shoes.
How do you think I felt?" Michelle Hersh asks sixth graders, "I'm
feeling a little odd today. I can't quite put my finger on it; can any of
you tell me what mood I look like I'm in?" These two topic questions
were asked in a hypothetical inclusion class directed to the students
with ADHD, although they would be appropriate for all children with
dysemmia who must practice recognizing emotional signals. We will
revisit Amy's topic question and see how it develops into a lesson later
in the chapter.

Association Questions

After hearing responses from—if not all—most of the children, the
teacher then asks another question in response to their answers. Smith
calls these the *Association Questions,* critical ones because their purpose
is to extend the children's initial ideas and require them to think in
more detail. For example, if one child responds that she notices clouds
on nice days, the teacher might ask, "What did their formations suggest
to you"? If a child answers that he can see shadows when it is light out,
the teacher might then ask "When *can't* we see shadows?" If children
tell their teacher that they would probably be sad or mad in response
to an unpleasant situation, the teacher's next question might be "If you
were mad, how would your face look?" The student might show the
teacher and say, "Like this..." and the teacher responds, "Did every-
one see how his eyebrows pointed down to his nose? What else did
you notice about how his face showed anger?" Children might tell the
teacher that their tree house or their aunt's house makes them feel safe.
The teachers might then ask, "Describe your tree house. What sounds
do you hear, what sort of smells do you smell, textures do you feel?"
Amy imagined her young student would respond as follows:

> *Student*: "It's very quiet up there. All I hear is the wind through
> the leaves and sometimes I hear the clock tower's bells. It smells
> like wood and pine needles. I like to go up there after it rains
> because everything smells fresh."

Teacher: "What can you see from there?"
Student: "I see the tops of everyone's houses, even the school's.
There's even a bird's nest on the branch right next to my tree
house so I can watch the birds come and go."

Laura and Lisa followed their topic question, "Do you remember blow-
ing bubbles?" with the following questions. They posed the questions to
a haptically minded middle school student having recently become blind
and thus with memory intact. In their lesson plan they use the young
man's other senses to actualize his memory of blowing bubbles:

Teacher: "How did you use your body to make the bubbles?
Did you blow strongly? What are other ways you have made
bubbles?"
Student: "I used to make bubbles in my milk when mom wasn't
looking."
Teacher: "What did they look like?"
Student: "I made small and big circles."
Teacher: "Were the bubbles opaque or transparent?"
Student: "If my drink was a color, like milk, then the bubbles
would have that color. But I could always see through the bub-
bles in some parts."
Teacher: "Were you able to hold the bubbles?"
Student: "Only for a second before they popped."

Amy and Sarah Rondon follow the topic question, "What is a super-
hero?" to a group of young children with Asperger's syndrome (AS)
with the following association questions:

Teacher: "What other kinds of powers might superheroes have?"
Student: "They might be super strong and lift cars up."
Student: "Or they could jump over buildings and fly really high
like Superman."
Teacher: "Are superheroes mostly good people? What are the kinds
of good deeds they do?"
Student: "They save people from burning buildings or if they fell
off, they would swoop down to catch them. Superheroes are
good because they don't want to hurt anyone, unlike their evil
nemesis."
Student: "They also would fight against the evil guys and stop
them from blowing up the world."

Teacher: "Why would they fight evil?"

Student: "Superheroes like to make sure everyone in the world is safe"

Teacher: "If you were a superhero, how would you make sure everyone was safe?"

Student: "I would fly over the world and keep an eye on the bad guys. I would make sure that they weren't planning any evil crimes."

Teacher: "What sort of evil crimes would you stop?"

Student: "Stealing or kidnapping anyone that was my friend."

Recaps

I suggest that the preservice students continue to embellish questions to form strong tangible ideas that prepare children well for the next phase of the lesson, which is to translate their ideas into materials. Before transitioning to the next phase, however, a recap enables the teacher to tie up the dialogue by synthesizing the children's ideas and thereby bringing them to another level of learning. As mentioned earlier, repetition is vital for understanding, particularly for children with such disabilities as learning disabilities (LD) and autistic spectrum disorders (ASD), who do not readily process verbal communication. For example, Lindsey Brown and Christine Daya end their idea formation section in a lesson for self-contained middle school students with AS by saying,

> All of you said that you have looked up into the clouds but everyone has seen different things. Some have seen animals, faces, monsters, and different designs, but not everyone sees the same thing when they're looking at the same cloud.

This extra layer of dialogue reinforces for children with ASD the notion that we all have unique perspectives and they enrich our lives. The teacher encourages the children to enter another's thoughts, ideas, and feelings.

Kimberly Sandler asks ninth and tenth grade students with E/BD how they are like a box, a potentially perplexing question. Once the dialogue was completed she recapped the responses:

> So we are like boxes because we have an outside and an inside. You can't know what is going on inside of someone unless she

chooses to share it with you. We can only see what is going on around her. The outside of the box is our outer world where other people can influence us and change the way we think about others and ourselves. The inside of the box is our inner world where we have our own goals and aspirations, where we keep our secrets and who we are without anybody else influencing us.

With very few words Kimberly synthesizes and extends the discussion bringing it to a more complex level in which the box effectively becomes a metaphor for the students' lives. She is leading them to a sophisticated project, the identity box, in which children will construct the outside and inside of a container in such a way that they represent the social image they present to the world and the internal reality of their life.

Amy's earlier topic question that asks children with ADHD to guess how she is feeling leads her to recap dialogue about emotions in the following way:

So, different situations often result in different emotions and expressions. Sometimes we might even feel two emotions together. What we feel inside might be very clear to everyone else because of how we show it on our faces. Other times it might be harder for others to see if we are feeling several emotions at once.

Like children with E/BD and ASD, children with ADHD also suffer from dyssemia. In this recap Amy skillfully and unpatronizingly empathizes with the difficulty of understanding one's own conflicting and complex emotions as well as detecting those of others.

Laura and Lisa follow up their dialogue with a tangible recap for a rather intangible subject:

So there are many ways to blow bubbles. When you use a bubble wand you have to be careful how hard to blow it so it doesn't pop. When you blow bubbles in your drink you are able to blow stronger and create bubble mass.

The preservice teachers are speaking to the student's haptic-mindedness. They know that he is more interested in how things feel, the sensations provoked by tactile and visceral stimulation, and the memories associated with them. Rather than using a more tangible object that would invite realistic representation, the preservice

students insightfully use a less visual and more tactile "object" for a two-dimensional art project.

Amy and Sarah have led their students with AS in a complex and animated dialogue about superheroes. By doing so the teacher slyly guides them to talk about their fears, beliefs, and ethics. Here is how they recap:

> We've been discussing what superheroes are and what they do. We all seem to agree that superheroes do good things so that they can keep the people they love safe from any evil. They also use their special powers of super strength or speed or flight to help them fight evil. It seems from what we've been saying that superheroes also have the powers of love and intelligence to protect others. We may not have the ability to fly or shoot fire from our hands but each and every one of us has the ability to love and want to protect those we love. Each of us can use our intellect— our brains—to solve problems and make decisions that could help others.

Visualization Questions

The *Visualization Questions* help the pre-service teachers to transition into the studio project. Here they must skillfully introduce the materials and the activity while helping children make connections between the ideas the class discussed and their implementation. Maura Willock and Dawn Mueller began the transition into visualization by asking second graders with AS what they knew about shadows to lead them to a drawing activity. Rather than following the previous dialogue with teacher directions, Dawn and Maura ask students to activate their memory, experience, and imagination to conceive how they might "capture" their shadows.

> *Teacher*: "Who remembers Peter Pan?"
> *Student*: "I do!"
> *Teacher*: "He was always chasing his shadow, right? So, what if I told you that today we are going to capture our shadows? How do you think we would do it?"

Amy follows her recap about conflicting emotions with the following visualization questions. Again, rather than nudging students

toward a preapproved direction, she asks them to remember what they observed and then consider how color might be used for their own purposes of expressing emotion.

Teacher: "If we were to draw our sad face how would we start? What parts of our faces would we draw?"

Students: "The mouth would be a curvy line facing down, like a rainbow."

"I would draw tears in the eyes."

"Someone said her face was long so I would make her cheeks long."

Teacher: "So which parts on the face show the most change when we are happy or sad or mad?" (Teacher demonstrates facial expressions).

Students: "Your eyes go from open to squinty."

"Your mouth goes down and your lips get thin."

"You have lines on your cheeks that show when you smile."

Teacher: "So, we must pay attention to specific body parts when we're drawing expressions. If you were to use a specific color to describe my sad face what would it be?"

Attending to the needs of the visually impaired population, Laura and Lisa followed their recap with a more teacher-directed dialogue. Their goal is to create a predictable environment that makes for an optimally enjoyable experience. Lessons are enjoyable when maximum independence is achieved for students, according to the least restrictive environment policy:

Teacher: "In front of you I have set out a piece of paper, a paint set and a cup of water to clean your brush. To your left is the larger paintbrush and to your right is the smaller paintbrush. Directly in front of you I have set a cup of soapy water and a small bucket of soapy water. Each container has a straw in it for you to blow bubbles. Do you think you will be able to blow bigger bubbles in the bigger bucket?"

Student: "Yes, there is more room to blow bigger bubbles."

Teacher: "Try blowing bubbles with strong breaths. If you keep one of your hands in the bucket you can feel the bubbles as they form. What do you feel happening?"

Student: "I feel the bubbles forming around the bucket. There are a lot of them so I believe they are small, not big."

Teacher: "Now try blowing bubbles in the cup the same way. Do you feel the same things happening?"

Student: "I feel bubbles spitting at me. My face is close to the popping bubbles. I have to try not to overflow the cup, but the bubbles are the same size as they were in the bucket."

Teacher: "Now you have felt what it is like to exhale and blow the bubbles, how they feel as they pop and rise to your hand, and what the soapy water smells like. Try painting what you think about as your senses react to the bubbles. Are you reminded of other objects because of the scent and texture? Then try painting the formations you are able to create in the cup and in the bucket. Imagine how the different formations are created and what they look like when they pop."

Because their student is haptically minded, Laura and Lisa encourage him to reflect on the sensory experience of the materials rather than toward a realistic representation. Their choice of transitory materials was also deliberate so that the student would stay in touch with his immediate experience.

Amy and Sarah transition from their recap about superheroes and into the activity with questions about what they wear:

Teacher: "Is it possible that superheroes could be just regular people too? Maybe we have a superhero amidst our classroom right now! Let's talk about superhero costumes and powers. What do they wear and why?"

Student: "They wear bright colors and capes. Spiderman wears red and blue, but Batman wears all black. Sometimes they might wear a mask so people won't recognize them."

Teacher: "How about their powers? Where do they come from and how do they use them?"

Student: "They come from inside their bodies. Some superheroes are born with their powers and others get theirs through some accident."

Teacher: "How might you pose if you were using these powers? Show me with your body how you might release your powers."

Student: "I would use my arms out wide to fly or point my fingers so the electricity or fire comes out. I would flex my muscles to push and fight."

The preservice teachers are using the sensory motivation techniques described earlier. By experiencing the feeling of flying in their bodies,

the students are making passive knowledge active. After explaining that it is a nice sunny day and they will choose a partner and draw her shadow on the sidewalk, the teacher asks questions that will encourage the students to concretely organize and plan in greater detail.

Teacher: "How are you and your partner going to decide how to pose?"

Student: "We will need to talk and see what he likes, what kind of powers he wants to have."

Teacher: "What colors will you choose for your partner's costume? What kind of special symbols or accessories like gloves or helmets or boots will your partner's costume have?"

Student: "That depends on what the superpowers are. If they had firepower, I wouldn't use blue because that's too much like water."

Transition Questions

The *Transition Questions* follow the introduction of the art project. The questions are transitional in the sense that they help students transition from thinking to doing. Many children with disabilities who have difficulty translating abstract ideas into physical practice need additional encouragement. In the same way that task analysis helps to break down an action, the transitional question helps children to organize how they will approach their goal: what they need to do first and what will inevitably follow to arrive at a final product. Amy checks for understanding as she asks her students the following questions about how they will approach their printmaking project in which they draw their partner communicating an emotion through facial expression.

Teacher: "What is the first task you will have to complete?"

Student: "Read the situation and figure out what expressions to make."

Teacher: "What comes after that?"

Student: "Drawing the emotions."

Teacher: "How will you and your partner figure out which emotions to draw?"

Student: "We'll take turns, or he'll draw three and then I'll draw three."

Teacher: "How will you decide which expression you'll use to print?"
Student: "Whichever one comes out looking like the emotion."
Student: "I think I would talk with my partner about which one is best."
Teacher: "What would happen if you each did a print of the same emotion? Or each of you did a print of a different emotion?"
Student: "We'd each have a different way of describing emotions."

Rather than asking questions, Amy might have given the children directions. The following paragraph suggests how that might sound:

Teacher: Your first task will be to figure out what expressions you want to make. Then you will need to take turns with your partner drawing three different emotions. Then you must decide which one you want to print. You may either print the same emotion or different emotions.

Asking questions insures that the ownership of the project remains squarely with the student. The autonomy of students is protected when they make decisions about the planning and implementation of their projects. Children are often given more directions than they can internalize, and for children with ADHD and LD, the internalization rate is even lower. Particularly for children with ADHD, if directions come from an external source they might not only tend to ignore them, but also become oppositionally defiant. If directions are ostensibly one's own, they have more value, relevancy, and meaning. In addition, this process leads to self-motivated art making which is the overarching goal. Discussed throughout the book, visible change in children's sense of self takes place only when they become active agents.

Summary

The ability to reflect, so critical to learning, is often lacking in many children with disabilities. Children on the autistic spectrum in particular need help in becoming conscious of their choices and the meaning of what they do. Children with ADHD often barrel on to the next activity before fully internalizing what they have done previously. Children with LD have difficulty globalizing specific learning

and therefore need to hear a narrative from their peers and teachers about the relevancy and meaning of their work and, particularly, how it builds on previous learning and lays the foundation for further learning. Therefore, the summary closes the lesson by having children look, reflect, and verbalize what they have done with their peers. It is also an opportunity for teachers to check for learning and whether their own objectives have been met. It is helpful for the teacher to look again at the objectives when preparing provocative and stimulating summary questions for students.

The following are summaries that closed two shadow drawing lessons with children with AS. The first, written by Amy and Sarah, completes the superhero theme with the following questions.

> *Teacher*: How did you and your partner decide on your two superheroes? Was it difficult or easy to trace the shadow? How did you overcome any challenges? What powers did you give your hero? Which pose did you use to show your superhero's powers? Which colors did you use for the costume and why did you choose those colors? Did you give your hero a symbol or special name? Does your superhero resemble you in any way? How might the two superheroes that you made with your partner fight crime together? Would they work as a team?

Here Sarah and Amy cleverly lead the children from the discussion of ideas and the action and process of drawing to the metaphor embedded in the project. Lessons are most successful when they are constructed on two levels: the physicality of the work and its metaphorical equivalent. For children with AS, working in a team poses multiple problems. With the nonthreatening nature of the art project, teachers can subtly introduce the important learning that is needed for the children. "Fighting crime together" is almost irresistible for a young boy or girl, and it is in this clever way that teachers can show the benefits gained from working in a social network that might be unachievable on one's own.

Maura Willock and Dawn Mueller intended to reinforce the objectives of the lesson by enhancing socialization and cooperation, as well as emphasizing the "feeling" of the drawing materials and how the lines and shapes change as the students' poses changed.

> *Teacher*: What did your lines look like when you were crouching in this one? How did it feel to draw them? You were really stretching in this one! Look at that long line! Was it hard to

hold still for your partner to draw you? What other materials could we have used to draw our shadows? What do we think of how we presented all these shadows? What could we do differently?

The summaries in the "Identity" lessons with E/BD children were perhaps the most crucial. After processing through often-troubling psychic material, the students were in need of closure. The following is Lindsey and Christine's summary of identity portraits with high school students.

> *Teacher:* What have you learned about yourself from creating your personal identity box? Did you interact with others as you were working to find out what objects they were using in a symbolic way? When discussing and looking at other classmates' boxes, what identity portrait did you find most interesting? What did you learn about that person's portrait by looking at it more closely?

Shani Perez and Danielle Marino concluded their identity box lesson with students with E/BD with a rather direct summary. This directness is effective only after working with students for quite awhile and knowing that the teacher has their trust:

> Did working on this project help you to understand who you are? Did you draw connections between your environment and how it has influenced your well-being? Do you feel personally connected to this artwork now? Would you feel comfortable showing other people, or do you think it is too private?

Dennis concludes his identity box lesson with high school students with E/BD by asking them to reflect on their choices:

> What is the main theme of your identity box? If you had to choose an item, which has the most significance to your box, which would it be? Why? Does the shape/style of your box have a role in reflecting your identity, and if so, how? What were the factors you used in arranging the objects in your box? If you arranged them in a different way, would the box convey a different message? How did you work through the parts of this assignment that you found difficult?

Dennis brings home the overarching goal in the rationale of the lesson by bringing to consciousness how the students worked on the two

levels of the materials and their representation of identity. Their formal aesthetic decisions contain potentially significant psychic material, so he asks students to analyze their choices.

Evaluation/Assessment Rubrics

Evaluation and assessments are innately problematic for all children, and more so for children with special needs, particularly if they lead to grades, sorting, and ultimately graduation. But notwithstanding this caveat, when used wisely and for teaching efficacy, evaluation and assessments can help teachers improve their own lesson plans as well as analyze how each student is progressing. Several models are used depending on their efficacy with the disability. In general, a rubric should reflect the objectives of the lesson, for as the final instrument it will be used as evidence of learning and successful teaching.

The Arts Propel handbook, edited by Ellen Winner and Seymour Simmons (1992) with support from the Pittsburg public school system, speaks of the dual purpose of assessment: to profile student learning and inform instruction or, in other words, as learning for both student and teacher. Arts Propel's important contribution is their philosophy that assessment should not be an afterthought, but rather an integral part of learning. Therefore, assessment as a tool needs to be tailored to the subject matter, a nonstandardized approach emerging from the nature and needs of the classroom.

What do we value? This is the first question that should be asked, say the creators of Arts Propel. Like the schools of Reggio Emilia in which documentation is ongoing and as much a motivation for learning as it is a tool for assessment, Arts Propel promotes the documentation of process. With the process valued, students take ownership of their own growth through self-assessment and the shared creations of standards for critiquing work.

For students with ADHD, AS, and E/BD who need intensive practice in reflective thought, self-evaluation aptly measures and increases this ability. Melissa Cosman and Maryann Maffei use a rather thorough self-evaluation for a printmaking lesson plan for middle school students with ADHD. All together, the category headings capture the purpose and objectives of the lesson, which were as follows:

1. The students will be able to identify and express particular feelings by making an image of their favorite activity.

2. The students will learn the planning skills used in printmaking, that is, the beginning, middle, and end processes.
3. The students will be able to use color and shapes to depict feelings and moods.

The objectives emphasize attitudes as well as organizational skills. Therefore, their category headings intend to determine whether the student is aware of the important learning of the lesson.

Rubric/Self Evaluation for Printmaking Project

Name: _____Period: _____

Presentation/Neatness:

4 = My prints are neatly done. The image is clear and centered on the paper.

3 = My prints are clear, but they are crooked. The borders are not even, but overall I think they look good.

2 = My prints are complete, but the images are not clear. I could have spent more time on each step.

1 = You can tell that I did not take my time on each step, and I have unwanted marks on my prints. I only did one print.

0 = I did not finish one print.

Creativity/Technique

4 = My prints really express the emotion I was trying to capture and is enhanced by my color choice.

3 = My prints show emotion but my color choices might have been better.

2 = Emotions are not expressed. I chose colors randomly.

1 = The lines are not clear. I only used one color, and my prints are messy.

0 = I did not do one.

Not only does this rubric help encourage the reflective skills of children with ADHD, but it also addresses their need for a realistic assessment of themselves. Their impatience and frustration with others is only a thin veneer that covers relentless self-criticism.

Laura and Lisa use a similar strategy after a mural lesson plan with middle school children with AS. This strategy wisely encourages pre- and early adolescents to find their peers interesting. Interest in peers is universally experienced with typical children. However, as the preservice teachers point out in their rationale, children on the autistic spectrum lack social or emotional reciprocity, so we must take advantage of their heightened interest in social interaction as a result of physical development. This lesson is planned to create an indirect means of social interaction by creating interaction on paper through personal interviews. The preservice students use friendly questions that will hopefully engage a pre- or early adolescent.

1. What is your favorite color?
2. What do you like to wear? (e.g., jeans, shorts, or skirts)
3. Do you like wearing hats?
4. Do you wear shirts that have pictures or logos on them? (e.g., a name of a band, place, or team)
5. Do you have different types of clothing for different outings?
6. Do you like to add accessories?
7. What kind of shoes do you wear? (e.g., flip flops or sneakers)

In a similar way, Andrea Neiman uses a self-interview following a printmaking lesson with seventh grade students with ADHD. Andrea begins with an onomatopoetic word and asks students to act it out by using their bodies. This strategy not only appeals to the strong intellect and curiosity of young adolescents with ADHD, but also to their need for physical participation in learning. Students are then asked to answer the following questions about their experience.

1. What did I learn about creating a printmaking design using a word?
2. What did I have the most trouble with, or what was the most difficult part for me? How did I overcome it?
3. What was the best part of this project for me?
4. If I were to do this again, what would I do differently?
5. What could my teacher do to make this lesson better?
6. Who did I help and what did I help him/her with?

Questions two, four, and six deliberately provoke a reflective attitude about the vulnerability of the student with ADHD. Question four asks him to reflect on his lack of foresight coupled with impulsiveness, and question six, his lack of interpersonal skills. Most importantly,

however, question two asks the student to make a realistic assessment of her obstacles and suggests that the solution lies within her.

Sarah Taft and Kaitlin Van Pelt's assessment tool for an identity box lesson with middle school children with E/BD reflects the purpose of the lesson, which is to make art in the service of social and emotional growth as well as the aesthetic care of the product. Their rationale for the lesson is as follows:

> This lesson will allow students to express their individuality, which is very important and often difficult during adolescence. Asking students to represent the self via mixed media challenges them to think metaphorically and to be more self-aware. Metaphor, through the visual arts, or otherwise, is a safe and constructive way for students to channel their emotion. With these capabilities, children will be better prepared to face a world of symbols, metaphors and, moreover, the world they as individuals are a part of. This lesson will also allow students to get to know other students in their class and promote community in a group setting while maintaining their individuality.

The preservice teachers address important issues for adolescents with E/BD. Metaphor neutralizes the difficult psychic material by discussing it in its manifestations as visual and symbolic forms. They also introduce the concepts of community and individuality, and the necessity to understand the personal benefits involved in protecting and serving a community while maintaining one's individuality. The assessment rubric is as follows:

Artwork Assessment Form

Teachers Name: _____
Artist's Name: _____
Categories: Good/Average/Needs work

Growth

Description

How does this work compare to previous work by the same student?
Does it show more feeling and expressiveness in its use of symbol and metaphor?
Does it show more reflective thought?
Does it show more skill both artistically and behaviorally?

Creativity

Description

How Original, innovative, and daring is the work?

Does it extend or change the artist's self concept from past work done by the same student?

Fulfills Assignment

Description

How well does the work solve the problems outlined in this assignment?

Are the variations from the assignment made for a valid reason?

Care

Description

Is the making of the work appropriate for the style of art being made?

Did the student pay attention to consistency in the work?

Helpful

Description

Was the student cooperative and generous in discussions and in helping others without doing it for them?

Were reflective questions asked? Were the questions of other's respected and valued without interruptions?

Work Habits

Description

Did the student stay on task? Did the student help others to stay on task by not interrupting them?

Were conversations with classmates about the artwork, not other topics?

Composition and Design

Description

How are principles of design and composition used to make the visual elements work well?

Is the work free from arbitrary choices that distract from the unity and effectiveness of the whole?

Lesson plans can be prescriptive and formulaic or carefully constructed to inspire joyful learning in children. In 1961 Jerome Bruner insightfully suggested that the most authentic knowledge is that which we discover for ourselves. With provocative questions, children will find that their own experiences are the foundation for learning and building their own theories. In the act of discovery, a relationship is formed between the knower and the known, which is what makes knowledge authentic. The lesson plans of the preservice art teachers reveal that the purpose of asking questions is not to elicit the right answers but rather to provoke a multiplicity of theories. Although the need to form theories is part of the human condition, we can destroy this condition with our expectation of quick answers, implying that correct answers exist. In an era in which logic and certainty is under scrutiny, continuing this approach seems anachronistic and unfruitful. Recent evidence that each brain is differently wired renders much of our pedagogical practices ineffective. How might we accommodate children who are all differently abled? With this question, says Carlina Rinaldi (2004), "we can find the roots of creativity, the roots of philosophy, the roots of curiosity and the roots of ethics" (p. 2). Social dialogue is crucial in establishing identity for children within a community of peers, and even more crucial for children whose differences cause them to struggle in an often intolerant society.

NOTES

One Overview

1. The Diagnostic and Statistical Manual of Mental Disorders (DSM) is the standard classi-
fication of mental disorders used by mental health professionals in the United States. It is
intended to be applicable in a wide array of contexts and used by clinicians and research-
ers of many different orientations (e.g., biological, psychodynamic, cognitive, behavioral,
interpersonal, family/systems). DSM-IV has been designed for use across settings: inpatient,
outpatient, partial hospital, consultation-liaison, clinic, private practice, and primary care,
and with community populations and by psychiatrists, psychologists, social workers, nurses,
occupational and rehabilitation therapists, counselors, and other health and mental health
professionals. It is also a necessary tool for collecting and communicating accurate public
health statistics. The DSM consists of three major components: the diagnostic classification,
the diagnostic criteria sets, and the descriptive text.
2. Lakoff and Johnson (1999) have found what they call "metaphor," as cross-domain concep-
tual mapping (p. 57), to be universal. This is not true for ASD and, particularly, classical
autism as we will see in chapter two. This divergence is the conundrum for children with
classical autism who make meaning through unusual mental associations.

Two Autistic Spectrum Disorders

1. Sue Rubin is a prime example of how successful FC can be in assisting individuals without
speech to communicate. See the documentary *Acceptance versus Cure* on the CNN Web site:
http://www.cnn.com/CNN/Programs/presents/shows/autism.world/notebooks/sue/note-
book.html. Larry Bissonnette (see chapter eight) is another example, and who is also the
subject of a documentary, *My Classic Life as an Artist,* which can be purchased at http://www.
myclassiclifefilm.com
2. Theory of Mind is a term coined by Simon Baron Cohen. He writes by *Theory of Mind in
Normal Development and Autism* (Prisme, 2001 [34] 174–183), "theory of mind we mean being
able to infer the full range of mental states (beliefs, desires, intentions, emotions, etc.) that
cause action. In brief, having a theory of mind is to be able to reflect on the contents of one's
own and other's minds." (http://www.autismresearchcentre.com/docs/papers/2001_BC_
normdevelopment.pdf)
 The term has since been reconsidered as less than accurate because it does not account for
the "neurotypical's" inability to understand individuals with autism. In other words, it is a
two way street as Judith Bluestone makes clear (personal communication, May 24, 2008).

3. It must be noted that the first edition of Clara Park's *The Siege: The First Eight Years of an Autistic Child* written in 1967 was the first book of its kind. Because of this fact and the paucity of information about autism, it is a courageous account. Park invented ingenious ways to bring her child closer to the world and her book continues to be a touchstone for educators and parents.

4. For example, it is typical for children and adults with autism to put pieces of complex puzzles together in record time without needing to see the picture.

5. It is interesting to note that until the age of six and one half, Jessy's paintings were predominantly nonrepresentational. Her interest in representation correlated with her acquisition of speech, and this correlation appears to be true in the normative growth of children. The greater the use of speech, the greater is the possibility for symbolic representation. This situation is not necessarily true, however, for some autistic savant artists, such as Nadia, who lost interest in representational art as she developed language.

6. The Individualized Education Plan (IEP) is mandated in Part B of the Individuals with Disabilities Education Act (IDEA) for all children in public schools identified as needing special education services. A Committee of Special Education (CSE) consisting of teachers, parents, administrators, and in some cases the student, meets at least once a year to assess, modify, and adjust the plan according to the needs of the student. See http://www.ed.gov/ parents/needs/speced/iepguide/index.html

7. The process of expanding concrete categories into abstract categories is called reclassification.

8. Verbal overshadowing describes how the verbal description of previously seen visual stimuli can actually impair visual recognition or create a verbally biased memory of the original visual memory.

9. ASPIE is no longer in operation having lost funding in 2006 when a new superintendent came to the district and cut the program.

10. Object constancy is the prerequisite for healthy object relations. Once the individual develops a strong sense of self, ego, and autonomy early in life, then she/he will be able to conceive of others as separate entities.

11. If the teacher needs a more controlled environment, then shadow drawing might also be accomplished with a projector.

Three Attention Deficit Hyperactivity Disorder

1. Dysemmia, or dysemmic behavior, is the inability to decode facial expression, bodily gesture, tone of voice, and other social behaviors.

2. David Henley discussed this project as a visiting lecturer at SUNY New Paltz in 1999.

3. The names of the children have been changed to protect confidentiality.

4. The early phase of presymbolic art making usually arrives shortly after a child experiments with materials and soon realizes with his/her developing speech and ability to categorize, that his/her shapes and lines share similar properties to the objects in the world.

Four Learning Disabilities

1. Thomas Hehir (2002) defines ableism as devaluing the child as a result of his/her disability to the extent that society would rather see him/her walk rather than wheel, use cochlear implants rather than sign, and so on. Society perpetuates the values of the dominant group.

2. The Individuals with Disabilities Education Act of 1990 replaced the Education of all Handicapped Children Act (EAHCA) of 1975. The key provisions of the act are the Free and appropriate Public Education (FAPE) for all children and the Least Restrictive Environment (LRE). It also implemented the Committee on Special Education (CSE) which must meet at least once a year to assess the IEP. Further amendments were made in 1997 and 2004.
3. The presymbolic stage, which Jean Piaget calls the preoperational stage, occurs after the sensori-motor stage of movement and sensation, and generally begins at approximately two years and ends at approximately six years. The stages of development when applied to artistic development are more useful if conceived generally as mutable phases.
4. The evaluation of teaching and learning helped through continuous student feedback is called diagnostic-prescriptive teaching.

Five Emotional Disturbance and Behavioral Disorders

1. What Educators call E/BD has been written into federal law in 1975 under IDEA and called serious emotional disturbance. It is described as follows.

Serious Emotional Disturbance: A condition exhibiting one or more of the following characteristics, displayed over a long period of time and to a marked degree that adversely affects a child's educational performance:
 - An inability to learn that cannot be explained by intellectual, sensory, or health factors
 - An inability to build or maintain satisfactory interpersonal relationships with peers or teachers
 - Inappropriate types of behavior or feelings under normal circumstances
 - A general pervasive mood of unhappiness or depression
 - A tendency to develop physical symptoms or fears associated with personal or school problems. http://www.ericdigests.org/1999-4/ideas.htm
2. Shirley Brice Heath and Laura Smyth's *Art Show* details the communities she researched. The resource guide and documentary can be found at Partners for Livable Communities, www.livable.com

Six The Blind and Visually Impaired

I use the term "blind" throughout the chapter. It is not intended to offend the community. Rather, I use the term because it is often used within the "blind" community. I also use the term when it is necessary to distinguish between full and partial blindness.

1. Agnosia, or visual agnosia exists when the optic nerve is actively transmitting impulses but the brain is not making sense of them (Sacks, 1995).
2. Visual concepts are not tangible but rather visual appearances understood through experience, categorization, and memory, and enable us to perceive such phenomena as shadows.
3. Legal blindness is defined as having a visual acuity of 20/200 or less in the better eye, with or without corrective lenses. Partial blindness is usually defined as between 20/70 and 20/200 in the better eye.
4. In this motivation Lowenfeld offers children candy while he asks questions such as how does the candy feel in your mouth, on your tongue? He would then ask children to bite down on the candy to feel how hard it is, how their teeth and cheeks feel while chewing, and so on.
5. Cochlear implants do not restore hearing but rather provide a representation of sound that helps in understanding speech. Unlike a hearing aid Cochlear implants do not amplify sound

but bypass the damaged parts of the ear and stimulate the auditory nerve. Signals are then sent through the auditory nerve to the brain that recognizes the signals as sound.

Seven Traumatic Brain Injury and the Northeast Center for Special Care

In memory of Erich Meithner, Curtis Jenkins, Jurgen Blanc, and Dennis Lamarita.
Special thanks to the producers of Changing Identities: A Story of Traumatic Injury and Art. Distributed by Fanlight Productions. Phone: (800)937-4113, Order # DD-476. Direct link to Changing Identities: http://fanlight.com/catalog/films/476_ci.php

1. NCSC calls their patients "neighbors" in order to avoid an institutionalized identity. The term also suggests the equality of each of the residents, and that they reside in a community in which each person is cared for as if a close neighbor.
2. The phrase "Pounding on Walls" is taken from Abigail Thomas's memoir, *A Three Dog Life* (2006), in which she writes about her husband's brain injury and his subsequent life at NCSC. She quotes a neighbor who transferred to assisted living, "What is art, anyway, except not pounding on walls" (p. 154).
3. Bill Richards retired in 2004. Previously he was the founder and art director of the Harlem Horizon Art Studio at the Harlem Hospital Center in New York City.
4. Harriet McBryde Johnson a spokesperson for disability rights and the opponent of the "charity mentality" passed away from complications June 4, 2008. She wrote several articles and two books, *Too Late to Die Young* (2004), and *Accidents of nature* (2006).
5. Section 504 of the Rehabilitation Act of 1973 is one of the first significant federal laws to protect individuals with disabilities. It prohibits discrimination by federally funded agencies.

Eight Community Outreach and Alternative Settings

Reprinted with Permission from the National Art Education Association, RESTON VA. Alice Wexler, *GRACE Notes: A Grass Roots Arts and Community Effort* (2005) 46(3) pp. 255–269.

1. Traditional care is usually comprised of physical and occupational therapy.
2. DynaVox Technologies is the largest manufacturer of speech-generating devices and communication software. It allows expression through technology referred to as augmentative and alternative communication or AAC. These speech-generating devices (SGD) help people unable to speak to communicate messages through this device. SGDs generate audible spoken words from a user's input. Depending on cognitive abilities, the input may use symbols, letters, or text.
3. NCSC is divided by neighborhoods. Neighbors who are dependent on ventilation are placed in the ventilator unit. Neighbors potentially dangerous to themselves or others are placed in the neuro-behavioral unit. When social interaction improves they are transferred to TBI 2. TBI 1 houses the most severely injured. TBI 3 is primarily a geriatric unit, and TBI 4 is a neighborhood for higher functioning individuals in the process of leaving the facility.
4. For more information about art organizations see Shirley Brice Heath and Laura Smyth's (1999) *ArtShow: Youth and Community Development,* published by Partners for Livable Communities.
5. Don Sunseri passed away July 19, 2001.

6. Workshops at the Howard Community Center take place in a spacious basement community room of the First Unity Methodist Church in Burlington. The workshops are contracted by Howard Community Services, a division of the Howard Center for Human Services. The services assist individuals with developmental disabilities and their families (Sunseri, 1998).
7. Merril Denismore died in May 2006. He was sixty-three-years-old.
8. Federal law protecting individuals with disabilities against discrimination based on disabilities was enacted with the American with Disabilities Act of 1990.

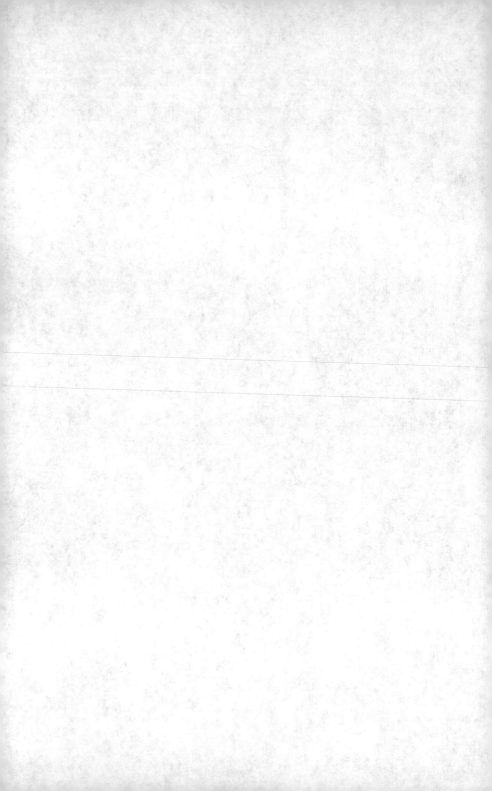

REFERENCES

Abram, D. (1997). *The spell of the sensuous.* New York: Vintage Books.

Ackerman, D. (1991). *A natural history of the senses.* New York: Vintage Books.

American Psychiatric Association. (1994). *The diagnostic and statistical manual of mental disorders-fourth edition.* Arlington, VA: American Psychiatric Association.

Amorino, J. S. (2009). The artistic impetus model: A resource for reawakening artistic Expression in adolescents. *Studies in Art Education. 50* (3). 214–231.

Arnheim, R. (1991). *Thoughts on art education.* Los Angeles, CA: The Getty Center for Education in the Arts.

Balzano, C. (2003). *A rainbow in the clouds.* Unpublished manuscript, New York State University at New Paltz.

Bardon Targia, G. (2001). *Madness and creativity: Is there a parallel?* Unpublished manuscript, New York State University at New Paltz.

Bauby, J. D. (1997). *The diving bell and the butterfly.* New York: Vintage Books.

Bilken, D. (Producer/Director) & Rossetti, Z. (Director). (2005). *My classic life as an artist: A portrait of Larry Bissonnette* [Documentary]. New York: Syracuse University.

Bluestone, J. (1998). *Spurious diagnosis, specious treatment:* NIH ADHD consensus conference. Retrieved November 19, 2008, from http://www.handle.org/index2.html.

———. (2005). *The fabric of autism: Weaving the threads into a cogent theory.* Seattle, WA: Sapphire Enterprises.

———. (2008, May). Symposium conducted at the State University of New York at New Paltz, New York.

Bower, E. M. (1996). A brief history of how we have helped emotionally disturbed children and other fairy tales. In B. L. Brooks & D. A. Sabatino (Eds.), *Personal perspectives on emotional disturbance/behavioral disorders* (pp. 24–35). Austin, TX: Pro-Ed.

———. (1960). Defining emotional disturbance: Public policy and research. *Psychology in the Schools, 19,* 55–60.

Bramblitt, J. http://www.bramblitt.net. Retrieved August 12, 2007.

———. (July, 20, 2007). *Perceptions.* http://bramblitt.blogspot.com.

Brooks, G. (2002). In *Changing identities.* Labbato, D. (Producer). Unpublished raw data.

Bruner, J. (Winter, 1961). Act of discovery. *Harvard Educational Review, 31*(1), 21–32.

———. (1979). *On knowing: Essays for the left hand.* Cambridge, MA: Belknap Press of Harvard University Press.

Cardinal, R. (2003, May). The intersection of art and psychiatry. Symposium conducted at the American Craft Museum, New York.

Carley, M. J. (2004, May 5). Interview on WNYC Radio, Fresh Air.

Cramond, B. (1995). *The coincidence of attention deficit hyperactivity disorder and creativity.* (tech. Rep. No. RBDM9508). Storrs, CT: University of Connecticut. The National Research Center on the Gifted and Talented.

Damasio, A. (1994). *Descartes error: Emotion, reason, and the human brain.* New York: Avon Books.

———. (1999). *The feeling of what happens: Body and emotion in the making of consciousness.* Orlando, FL: Harcourt.

———. (2003). *Looking for Spinoza: Joy, sorrow, and the feeling brain.* Orlando, FL: Harcourt.

Denise, D. (2003). *Art of necessity.* Unpublished manuscript, New York State University at New Paltz.

Dermer, E. (2003). *Self expression heals.* Unpublished manuscript, New York State University at New Paltz.

Disannayake, E. (1995) *Homo aestheticus: Where art comes from and why.* Seattle, WA: University of Washington Press.

Dissannayake, E. (1990). *What is art for.* Seattle, WA: University of Washington Press.

———. (1992). *Homo aestheticus: Where art comes from and why.* Seattle: University of Washington Press.

Dressel P. (1957). Facts and fancy in assigning grades. *Basic College Quarterly,* 6–17.

Dubos, R. (1972). *A god within.* New York: Charles Scribner's Sons.

Erikson, J. M. (1985). Vital senses: Sources of lifelong learning. *Journal of Education, 167*(3), 85–96.

Fiedler, L. (1996). *Tyranny of the normal: Essays on bioethics, theology and myth.* Lincoln, MA: David R. Godine.

Fittapaldi, L. (2004). *A brush with darkness: Learning to paint after losing my sight.* Kansas City, MI: Andrews McMeel.

Frith, U. (1995). *Autism: Explaining the enigma.* Oxford, UK: Blackwell.

Gablik, S. (2002). *The reenchantment of art.* New York: Thames & Hudson.

Gatto, J. T. (1992). *Dumbing us down: The hidden curriculum of compulsory schooling.* Philadelphia, PA: New Society.

Gregory, R. L. (1971). *Eye and brain. The psychology of seeing.* New York: McGraw-Hill.

Goldstein, K. (2000). *The organism.* New York: Zone Books.

Goldstein, K., & M. Scheerer. (1941a). *Abstract and concrete behavior: An experimental study with concrete tests.* Retrieved September 10, 2008, from http://gestalttheory.net/archive/goldstein41.pdf.

———. (1941b). Abstract and concrete behavior: An experimental study with special tests. *Psychological Monographs, 2* (53).

Goleman, D. (1995). *Emotional intelligence: Why it can matter more than IQ.* New York: Bantam Dell.

Grandin, T. http://www.grandin.com/inc/visual.thinking.html.

———. (1995). *Thinking in pictures: And other reports from my life with autism.* New York: First Vintage Books.

———. (2005). *Animals in translation: Using the mysteries of autism to decode animal behavior.* New York: Scribner.

———. (2006a). *Thinking in pictures.* Retrieved August 26, 2007, from http://www.grandin.com/inc/visual.thinking.html.

———. (2006b, August 14). WNYC, Interview on *Morning Edition.*

Greenspan, S., & S. Shanker. (2004). *The first idea: How symbols, language, and Intelligence evolved from our primate ancestors to modern humans.* Cambridge, MA: DeCapo Press.

Ferrente, D. (2003). *Therapeutic properties of art and how they are used in different settings.* Unpublished manuscript, New York State University at New Paltz.

Fiedler, L. (1996). *Tyranny of the normal*. Boston: David R. Godine.

Haddon, M. (2003a). *The curious incident of the dog in the night-time*. New York: Vintage Books.

———. (2003b, June 26). Interview on WNYC, Fresh Air.

Hallowell E., & J. Ratey. (1994). *Driven to distraction: Recognizing and coping with attention deficit disorder from childhood through adulthood*. New York: Touchstone.

Hartmann, T. (1997). *Attention deficit disorder: A different approach*. Grass Valley, CA: Underwood Books.

Heath, S.B. (2000, Spring). Making learning work. *Afterschool Matters. 1*(1), 33–45.

Heath, S. B., & L. Smyth. (1999). *Art show: Youth and community development*. Washington, DC: Partners for Livable Communities.

Henley, D. (1992). *Exceptional children, exceptional art*. Worcester, MA: Davis.

———. (1998, August). Art therapy in a socialization program for children with attention deficit hyperactivity disorder. *American Journal of Art Therapy, 37*, 2–12.

———. (1999, November). Facilitating socialization within a therapeutic camp setting for children with attention deficits utilizing the expressive therapies. *American Journal of Art Therapy, 28*, 40–50.

———. (1999, October 13). Symposium conducted at the State University of New York at New Paltz, New York.

———. (2001). Annihilation anxiety and fantasy in the art of children with Asperger's syndrome and others on the autistic spectrum. *American Journal of Art Therapy, 39*, 113–121.

Hehir, T. (2002, Spring). Eliminating ableism in education. *Harvard Educational*.

Heiss, A. (1992). *Dennis Oppenheim: Selected works 1967–90*. New York: The Institute of Contemporary Art, P.S. 1 Museum, and Harry N. Abrams.

Horback, E. (2001). *Role of the therapist*. Unpublished manuscript, New York State University at New Paltz.

Howell, D. (1977). The sensuous self—an undercover struggle in the making of art. *Art Education, 30*(6), 21–27.

Hull, J. (1992). *Touching the rock: An experience of blindness*. New York: Vintage Books.

Humphrey, N. (2002). *The mind made flesh:* New York: Oxford University Press.

Jamison, K. R. (1997). *An unquiet mind: A memoir of moods and madness*. New York: Vintage Books.

Johnson, J. L. (1996). The field of emotional disturbance and behavior disorders: An appraisal from a black humanistic perspective. In B. L. Brooks & D. A. Sabatino (Eds.), *Personal perspectives on emotional disturbance/behavioral disorders* (pp. 152–169). Austin, TX: Pro-Ed.

Johnson, H. M. (November 23, 2003). The disability gulag. *New York Times*.

Jung, C. G. (1964). *Man and his symbols*. New York: Bantam Doubleday Dell.

Kakutani M. (2003). NY Times Books of the Times, Math and Physics? A Cinch. People? Incomprehensible. Retrieved June 13, 2003, from http://query.nytimes.com/gst/fullpage.html?res=9402E5DA1E39F930A25755C0A9659C8B63.

Kivnick, H. Q., & J. M. Erikson. (1983). The arts as healing. *American Journal of Orthopsychiatry, 53*(4), 602–618.

Kohn, A. (1999). *Punished by rewards: The trouble with gold starts, incentive plans, A's, praise, and other bribes*. New Jersey: Baker & Taylor.

Koppman, D. (2002). Transformation, invocation, and magic in contemporary art, education and criticism; Reinvesting art with a sense of the sacred. In Y. Guadelius & P. Spiers (Eds.), *Contemporary issues in art education* (pp. 130–140). Upper Saddle River, NJ: Prentice Hall.

Krug, D. (1992). Cultural interpretation of the symbolic production of self-taught artists. *Working Papers in Art Education* (11), 103–124.

Labarge, A. (2002). In *Changing identities*. Labbato, D. (Producer). Unpublished raw data.

Lakoff, G. & M. Johnson. (1999). *Philosophy in the flesh: The embodied mind and its challenge to western thought*. New York: Basic Books.

Lebost, B. (2008). *The universal properties of acceleration: Did Einstein look the wrong Way?* Bloomington, IN: Author House.

LeDoux, J. E. (1996). *The emotional brain*. New York: Simon & Schuster.

Levine, M. (2002). *A mind at a time*. New York: Simon & Schuster.

Lippard, L. (1997). *The lure of the local*. New York: Free Press.

Lippard, L. R. (1998). A state of grace. In L. Rexer (Ed.), *States of grace* (pp. 2–6). Hardwick, VT: Offset House.

Long, N. J. (1996). To those who will continue the struggle. In B. L. Brooks & D. A. Sabatino (Eds.), *Personal perspectives on emotional disturbance/behavioral disorders* (pp. 196–213). Austin, TX: Pro-Ed.

Lowenfeld, V. (1957). *Creative and mental growth*. New York: Macmillan.

———. (1987). Therapeutic aspects of art education. *American Journal of Art Therapy, 25*(5), 111–146.

Lyon, G. R., J. M. Fletcher, S. E. Shaywitz, B. A. Shaywitz, J. K. Torgesen, F. B. Wood, A. Schulte, & R. Olson. (2001). Rethinking learning disabilities. In C. G. Finn, A. J. Rotherham, & C. R. Hokanson (Eds.), *Rethinking special education for a new century*. Washington, DC: Thomas B. Fordham Foundation and the Progressive Policy Institute.

Lucas, D. (2001). *The ultimate placebo!* Unpublished manuscript, New York State University at New Paltz.

Malaguzzi, L. (1996). History ideas, and basic philosophy. In C. Edwards, L. Gandini, & G. Forman (Eds.), *The hundred languages of childhood* (pp. 41–89). Norwood, NJ: Ablex.

Malloy, P. (2002). In *Changing identities*. Labbato, D. (Producer). Unpublished raw data.

McBryde Johnson, H. (2003, November 23). The disability gulag. *New York Times*.

McIntyre, T. (1994). Reflections on the new definition for emotional and behavioral disorders: Who still falls through the cracks and why. *Behavioral Disorders, 18*(2), 148–160.

———. (1996). Entering uncharted waters with tattered sails and a broken compass. In B. L. Brooks & D. A. Sabatino (Eds.), *Personal perspectives on emotional disturbance/behavioral disorders* (pp. 232–249). Austin, TX: Pro-Ed.

Meier, D. (2002). *In schools we trust*. Boston, MA: Beacon Press.

Merleau-Ponty, M. (1962). *Phenomenology of perception*. London, UK: Routledge & Kegan Paul.

———. (1964). *The primacy of perception*. Evanston, IL: Northwestern University Press.

Mithen, S. (May 1998). Report. *New Scientist*. No. 16.

Monastero, J. (2002). In *Changing identities*. Labbato, D. (Producer). Unpublished raw data.

Morse, W. C. (1996). Involvement in the E/BD field. In B. L. Brooks & D. A. Sabatino (Eds.), *Personal perspectives on emotional disturbance/behavioral disorders* (pp. 250–271). Austin, TX: Pro-Ed.

Nash, M. (2007). The gift of mimicry, in Nash M. *Time Magazine,* January 29.

National Endowment for the Arts. (1995). *Lifelong journey: An education in the arts. New York Times,* February 9, 2007. Retrieved September 22, 2008, from http://www.nytimes.com/2007/02/09/health/09autism.html.

Page, T. (2007, August 20). Parallel play. *The New Yorker*, 36–41.

Paradiz, V. (July, 2005). Exploring neurodiversity. *SGI Quarterly*, 6–9.

———. (2002). *Elijah's Cup: A family's journey into the community and culture of high-functioning autism and Asperger's syndrome*. New York: Free Press.

Park, C. (1982). *The Siege: The first eight years of an autistic child*. New York: Little, Brown & Co.

REFERENCES 243

Paul, J. L. (1996). Educating children with emotional and behavioral disorders: Reflections on our history and mine. In B. L. Brooks & D. A. Sabatino (Eds.), *Personal perspectives on emotional disturbance/behavioral disorders* (pp. 290–318). Austin, TX: Pro-Ed.

Phillips, P. (2002). In *Changing identities*. Labbato, D. (Producer). Unpublished raw data.

Rexer, L. (1998a, winter). Acts of recognition. *Raw Vision, 25,* 60–63.

———. (Ed.). (1998b). *States of grace.* Hardwick, VT: Offset House.

———. (2001). A bridge over troubled waters: Vermont's GRACE program. *The Outsider,* 5(2), 19–21.

———. (2002). *Jonathan Lerman: Drawings by an Artist with Autism.* New York: George Braziller.

Rhodes, C. (2000). Outsider art and the mainstream. In J. Berge (Ed.), *Marginalia: Perspectives on outsider art* (pp. 102–117). The Netherlands: De Stadshof Museum for Naïve and Outsider Art.

Rhodes, W. C. (1996). Postmodernism and disturbance/disorder. In B. L. Brooks & D. A. Sabatino (Eds.), *Personal perspectives on emotional disturbance/behavioral disorders* (pp. 320–338). Austin, TX: Pro-Ed.

Richards, B. (2000). *Neighbors.* Unpublished manuscript.

Ricoeur P. (1981). *The rule of metaphor: Multi-disciplinary studies of the creation of meaning in language.* Toronto, Canada: University of Toronto Press.

Ridley, M. (2003). *Nature via nurture: Genes, experience, and what makes us human.* New York: Harper Collins.

Rinaldi, C. (2003, March). Symposium conducted at the North American Reggio Emilia Seminar, Reggio Emilia, Italy.

———. (2004). The relationship between documentation and assessment. *Innovations, 11*(1), 1–4.

Sacks, O. (1987). *The man who mistook his wife for a hat: And other clinical tales.* New York: Harper Perennial, Avon Books.

———. (1995). *An anthropologist on mars: Seven paradoxical tales.* New York: Vintage Books, Random House.

———. (1998). Symposium at the Centre for the Mind at the Australian National University.

———. (1998). Retrieved August 27, 2006, from http://www.abc.net.au/rn/scienceshow.

Salerno, A. (2002). In *Changing identities*. Labbato, D. (Producer). Unpublished raw data.

Selfe, L. (1995). Nadia Revisited. In C. Golomb (Ed.), *The development of artistically gifted children: Selected case studies* (pp. 197–236). Mahwah, NJ: Lawrence Erlbaum.

———. (1977). *Nadia: A case of extraordinary drawing ability in an autistic child.* New York: Academic Press.

Smith, N. R. (1998). *Observation drawing with children: A framework for teachers.* New York: Teachers College Press.

Smith, S. L. (2001). *The power of the arts.* Baltimore, MD: Paul H. Brooks.

———. (1988, Spring). The role of the arts in the education of learning-disabled children. *Pointer, 32*(3). 11–16.

Solomon, P. (2003). *Learning and the public school classroom.* Unpublished manuscript, New York State University at New Paltz.

Spiegl, S. (2004). *Development of self-motivation through art therapy.* Unpublished manuscript, New York State University at New Paltz.

Stevens, S. R. (2001). *Art of necessity.* Unpublished manuscript, New York State University at New Paltz.

Sunseri, D. (1994). *Constructions and personal insights: Larry Bissonnette.* VT. [Catalogue].

Tammet, D. (2006). *Born on a blue day: Inside the extraordinary mind of an autistic Savant.* New York: Free Press.

Thevoz, M. (1976). *Art brut.* New York: Rizzoli International.

Townsend, B. L. (1996). "Sankofa" in the field of emotional/behavioral disorders: Returning to the past in order to move forward. In B. L. Brooks & D. A. Sabatino (Eds.), *Personal perspectives on emotional disturbance/behavioral disorders* (pp. 378–397). Austin, TX: Pro-Ed.

Vecchi, V. (2003, March). Symposium conducted at the North American Reggio Emilia Seminar, Reggio Emilia, Italy.

Vygotsky, L. S. (1986). *Thought and Language.* Cambridge, MA: MIT Press.

Wagner, M., Blackorby J., Cameto R., & Newman L. (1993). *What makes a difference? Influences of postschool outcomes of youth with disabilities.* Report from the National Longitudinal Transition Study of Special Education Students. Washington, DC: U.S. Department of Education.

Weiss, L. (1997). *A.D.D. and creativity: Tapping your inner muse.* Latham, MD: Taylor Trade.

Winner E., & S. Simmons. (1992). *Arts propel: A handbook for visual arts.* Cambridge, MA: Harvard Project Zero and Educational Testing Service.

Winnicott, D. W. (1996). *Playing and reality.* London and New York: Tavistock/Routlege.

INDEX

ableism, 89
Abram, David, 19, 87–88, 94, 96
abstract
 concept, 1, 96
 language, 94
 loss of attitude, 155, 158
 symbol, 103
 thought, 99, 103, 222
Ackerman, Diane, 7–9, 19–21, 95
aesthetic
 decisions, 16, 132, 201,
 205, 226
 emotion, 16, 25
 empathy, 12, 31, 211
 experience, 31, 34, 159, 211
 growth, 128, 206, 209, 229
 see also aesthetic value
 objectives, 17, 209
 standards, 187, 201
aesthetic value, 97, 146
agnosia, 137, 139
American Psychiatric Association, 56
amygdala, 115, 121–122
analog thinkers, 79
anxiety
 annihilation, 62
 autistic, 48, 61–62
 disorders, 71, 74, 156–157
 separation, 14, 77, 115
Art Brut, 171
Arts Propel, 226
Asperger, Hans, 27, 55

assessment, 86, 89, 92, 226–227, 229
auditory
 cortex, 9, 88
 deficits, 91
 distractions, 69
 learners, 79, 80, 98
 system, 140–141

Bauby, Jean Dominque, 174,
 177, 183
behavior
 autistic, 113, 126, 193
 contract, 71–72
 disorders, 71, 107–111, 123, 131,
 178, 186
 fight/flight, 114–115
 intentional/volitional, 155
 learning, 91
 management/control, 70, 74–75,
 78–80, 82, 108–110,
 123–126, 163
 modification, 71–72, 123–125
 ritualized, 27, 36, 57, 61–62, 150
 rule governed, 68
 visual/seeing, 139–140, 150
bias, 127, 167, 189
 see also racism
Bluestone, Judith, 4, 29, 41, 45–46,
 65, 116, 223
body image, 17–18
 see also self concept
Bower, Eli, 107, 109, 111